CW00967987

Pre-Raphaelite Art
in the Victoria and Albert Museum

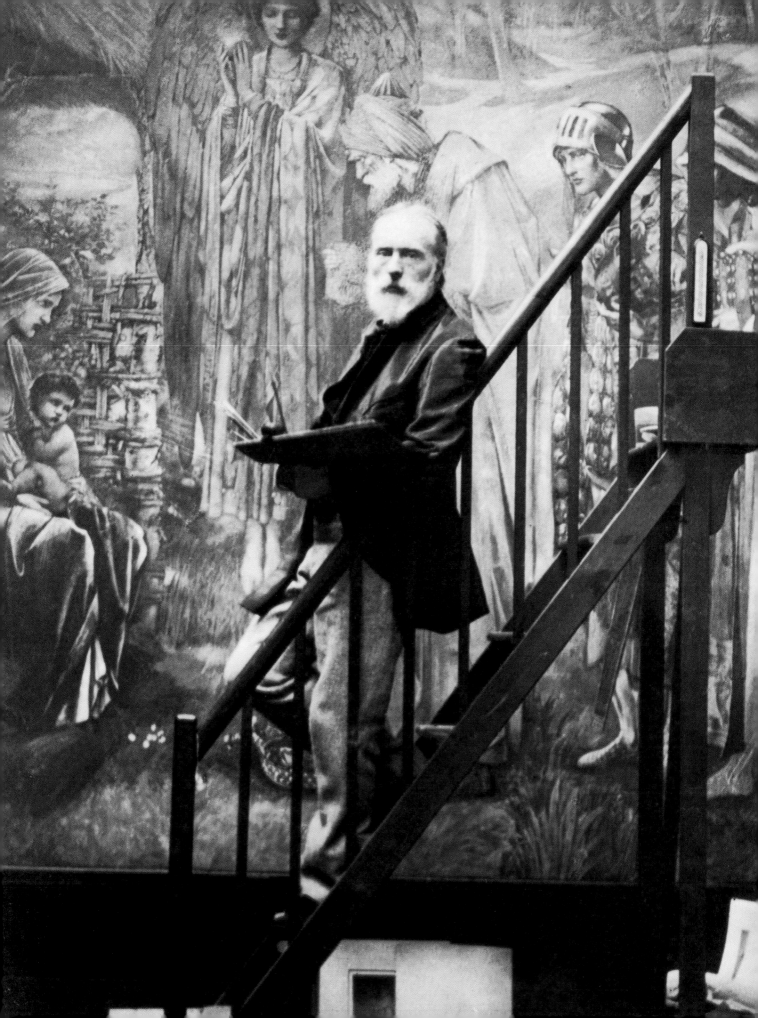

Pre-Raphaelite Art

in the Victoria and Albert Museum

SUZANNE FAGENCE COOPER

V&A Publications

DISTRIBUTED BY
HARRY N. ABRAMS, INC., PUBLISHERS

Acknowledgements

First published by V&A Publications, 2003

V&A Publications
160 Brompton Road
London SW3 1HW

Distributed in North America by Harry N. Abrams,
Incorporated, New York

© The Board of Trustees of the Victoria and Albert
Museum 2003

Suzanne Fagence Cooper asserts her moral right to
be identified as the author of this book

ISBN 0-8109-6611-5 (Harry N. Abrams, Inc)

Library of Congress Control Number 2003104130

Designed by Roger Davies

V&A photography by
Ian Thomas of the V&A Photographic Studio

All rights reserved. No part of this publication may
be reproduced, stored in a retrieval system, or
transmitted in any form or by any means electronic,
mechanical, photocopying, recording or otherwise,
without written permission of the publishers.

Every effort has been made to seek permission to
reproduce those images whose copyright does not
reside with the V&A, and we are grateful to the
individuals and institutions who have assisted in this
task. Any omissions are entirely unintentional, and
the details should be addressed to V&A Publications.

Front jacket illustration: Edward Burne-Jones, *How
Galahad sought the Sangreal* (plate 85)

Back jacket illustrations: John Everett Millais, William
Holman Hunt, John Ruskin and Jane Morris (plates
2, 1, 8, 138)

Frontispiece: Edward Burne-Jones working on *The
Star of Bethlehem* (plate 195)

Printed in Hong Kong

HARRY N. ABRAMS, Inc
100 Fifth Avenue
New York, N.Y. 10011
www.abramsbooks.com

I am grateful to Buckinghamshire Chilterns University
College for sponsoring my Research Fellowship at the
museum. My thanks also go to the many V&A staff who
have helped me, especially in the Print Room, Photo Studio
and Picture Library, in particular Martin Barnes, Charles
Newton, Sonia Solicari, Ian Thomas and Ken Jackson;
Jennifer Taylor and Claire Longworth for their assistance in
the early stages; the Publications team, especially Ariane
Bankes and Juspal Bansal; Rachel Connolly for her editing
skills; my parents for their unfailing encouragement and
hospitality; and finally to John and little Rosalind for the
many blessings of this eventful year. This book is dedicated
to you both.

Contents

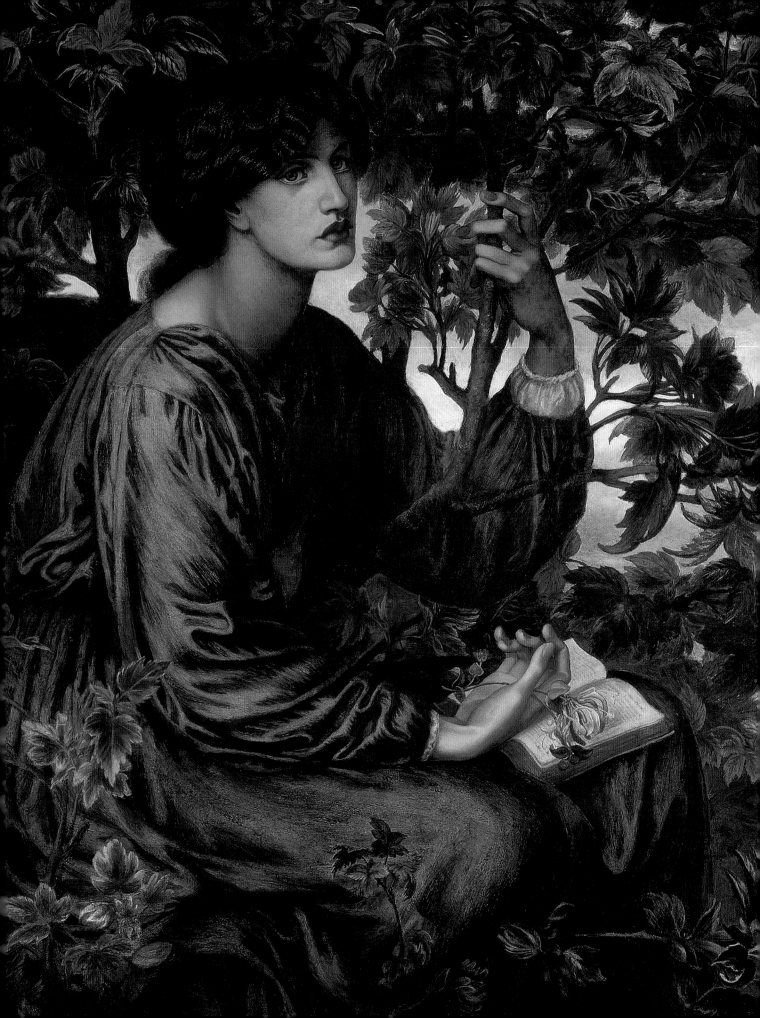

Introduction

The Victoria and Albert Museum and the Pre-Raphaelites

In 1862, South Kensington hosted an International Exhibition, bringing together fine and decorative arts, industry and empire in a spectacular fashion. Among the stands were two displays advertising the wares of Morris, Marshall, Faulkner and Company, one devoted to stained glass, the other to furniture and textiles. This group of young painters and designers, who had set themselves up in April 1861 as 'the only really artistic firm'[1], were attempting to fill a gap in the market for domestic and church decoration, and their exhibits included designs by one of the original Pre-Raphaelite Brothers (PRB), Dante Gabriel Rossetti, and his younger colleagues, Edward Burne-Jones and William Morris. The exhibition was a success for the fledgling company; they were awarded two medals, and a healthy flow of commissions kept the designers busy. Most importantly, they caught the eye of influential commentators and curators within the South Kensington Museum, who tried to acquire one of their painted cabinets for the Museum's collections. Unfortunately, the piece they wanted to buy, *King René's Honeymoon cabinet* (see plate 130), had been made for the office of the architect John Pollard Seddon, and he would not part with it. The Museum had to wait until 1927 to add it to the growing collections of work by Pre-Raphaelite artists. In the meantime, however, the firm was given a substantial commission to decorate one of the refreshment rooms in the new Museum buildings. Stained-glass and painted panels designed by Burne-Jones were installed in the Green Dining Room from 1866, and are still striking 150 years later.

The Green Dining Room remains the most visible testimony to the close relationship between the Pre-Raphaelite movement and the South Kensington Museum (now the V&A). From its foundation, the Museum was dedicated to educating design students and the public by bringing together the very best examples of fine and decorative art. The young artists who formed Morris and Co., inspired by Pre-Raphaelite ideals, were among the first to make use of these eclectic displays, and continued to visit the Museum throughout their long careers. Unlike many of their contemporaries, the artists associated with the Pre-Raphaelite Brotherhood were just as interested in designing book illus-

trations, tiles, stained glass or textiles, as conventional easel painting. Often their favourite subjects were reworked in several different media during their lives, and many examples of their versatile use of materials can now be seen in the Museum. This interdependence of artists and Museum was recognized in a memo of 1919, which acknowledged that it 'seemed a special duty of this museum to secure as worthy and complete a representation as possible of work by artists such as Burne-Jones [and] Morris ...whose endeavour it was to link the arts and the crafts'.[2]

Burne-Jones' love of the Museum's collections was described by his wife Georgie: 'after a day in the studio, he would go for a change to the South Kensington Museum in the evening, either to draw or to look at books'[3], and the results can often be traced in his sketches, many of which are now held in the Museum's Print Room. His devotion to the decorative arts was also recorded at the end of his life by his studio assistant, when Burne-Jones declared that 'there are two arts which others don't care for that Mr. Morris and I have found our greatest delight in – painted books and beautiful tapestry'.[4] They could indulge their enthusiasms for these subjects in the galleries of the Museum.

As a result of this long-standing co-operation with the artists, the V&A has an unrivalled collection of Pre-Raphaelite art, which includes some iconic easel paintings. Many of these were given to the Museum by the Ionides family, early patrons of Rossetti and Burne-Jones. More importantly, the Museum reflects the diversity of materials in which Pre-Raphaelite artists worked. Unlike most art galleries, it can show the full range of their output, from early sketches to vast tapestries. By focusing on the objects collected by the V&A, a new story of Pre-Raphaelite art begins to emerge.

In recent years there has been a flurry of interest in this group of artists. However, the majority of books and exhibitions, even those which claim to be most comprehensive[5], privilege the oil paintings and watercolours, and tend to ignore the ceramics, textiles, book illustrations and furniture design. This inevitably leads to a skewed account of the development of these artists' careers. We have to remember, for example, that most of Rossetti's oil paintings were enjoyed only by a handful of private collectors during his lifetime: the sensational impact of his work was generated by his book illustrations, which could be seen and shared by thousands. So this book will offer a fresh approach to the Pre-Raphaelite movement, one in which paintings and the decorative arts are given equal status.

What is 'Pre-Raphaelite art'?

Is it fair to yoke together artists as diverse as William Holman Hunt and Edward Burne-Jones with the same term: 'Pre-Raphaelite'? Visually they have little in common, but their works are linked by other factors. They were connected personally, through networks of friends, and culturally, through shared literary or historical sources. Perhaps most importantly, they were both described as 'Pre-Raphaelites' by their contemporaries.

This book will show how the Pre-Raphaelite ideal was transformed between the 1840s and the 1860s, as the original Pre-Raphaelite Brothers (1848–53) found that their personalities and aspirations pulled in different directions. Within a few years, these diverse approaches – particularly the tension between realism and the world of the imagination – were developed by a younger generation of artists. Images drawn from medieval poetry, minutely studied landscapes, and *femmes fatales*, could all be traced back to the Brotherhood of 1848, and were legitimately labelled 'Pre-Raphaelite'. We can also see how Pre-Raphaelite art evolved in the 1860s and 1870s into the equally controversial Aesthetic movement.

The growth of different strands of Pre-Raphaelitism may usefully be traced through the development of key pictorial subjects from the late 1840s. Certain texts, such as the Arthurian legends or the works of Chaucer, recur in the art of the Pre-Raphaelites and their associates. In a similar way, the faces of a few models, wives and mistresses can act as a guide, as their images metamorphose from portraits to icons during the second half of the nineteenth century. These subjects can provide a bridge between artists, helping us to link the original Pre-Raphaelite Brothers, especially William Holman Hunt, John Everett Millais and Dante Gabriel Rossetti, with others in the Pre-Raphaelite circle, including Edward Burne-Jones, Simeon Solomon, Frederick Sandys, George Price Boyce, Ford Madox Brown, and even photographers like Julia Margaret Cameron.

The Pre-Raphaelites and their associates were not working in a cultural vacuum. Indeed the changing nature of Pre-Raphaelitism was partly a reflection of the wider artistic world of Victorian Britain. If we compare the art of a second generation Pre-Raphaelite, such as Burne-Jones, with the work of his non-Pre-Raphaelite contemporaries like James McNeill Whistler, also represented in the V&A's collections, we can reach a better definition of the distinctive character of Pre-Raphaelite art.

The Pre-Raphaelite Brotherhood

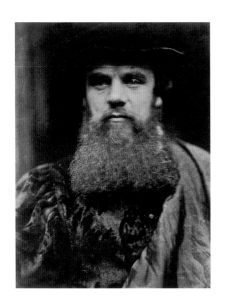
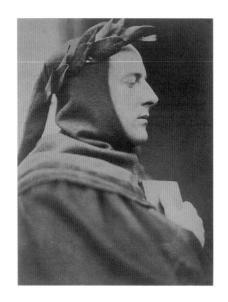
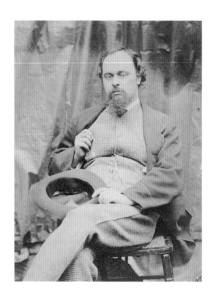

The early history of Pre-Raphaelitism has been a contentious subject since the death of Dante Gabriel Rossetti in 1882. Three of the original Brothers – Rossetti, Millais and Holman Hunt – became hugely successful artists, but followed very different paths from the mid-1850s; hence each was bound to portray the Pre-Raphaelite years (1848–53) in a way that would reinforce their later reputations. (The four other members of the PRB were F.G. Stephens and William Michael Rossetti, both later to become celebrated art critics, the sculptor Thomas Woolner, and the less successful painter James Collinson.) The three most prominent artists, with increasingly acrimonious interventions from their families and followers, squabbled over the right to be regarded as the leading light of Pre-Raphaelitism. Biographies and autobiographies published at the end of the nineteenth century made their opposing claims.

It is hard to unravel the true nature of the late-night discussions in Millais' studio in 1848 that led to the formation of the Pre-Raphaelite Brotherhood. However, the collections of the V&A do provide some useful clues as to the

artistic environment of these young Royal Academy students. We can look at designs by older artists who were already challenging the accepted wisdom of the Academic tradition, which encouraged aspiring artists to follow classical and Renaissance models. We can also see drawings and paintings made by the Pre-Raphaelite Brothers before they formed their secret society, dedicated to 'absolute independence as to art-dogma and convention'.[1] By focusing on these works from the 1840s and early 1850s, we can also begin to understand why the first Pre-Raphaelite paintings so disgusted the art critics.

LEFT TO RIGHT

1 David Wilkie Wynfield,
William Holman Hunt in fancy dress, albumen print, undated (1860s),
21.3 × 16.3 cm.
V&A: 132–1945.

2 David Wilkie Wynfield,
John Everett Millais dressed as Dante, albumen print, 1862,
21.1 × 16.2 cm.
V&A: 125–1945.

3 C.L. Dodgson,
Dante Gabriel Rossetti,
photograph, October 1863.
V&A: 814–1928.

4 Frederick Hollyer,
F.G. Stephens, photograph, 1880s
V&A: 7607–1938.

5 C.L. Dodgson,
Thomas Woolner,
photograph, 1860s,
16 × 12.5 cm
V&A: 1686 (C)–1956.

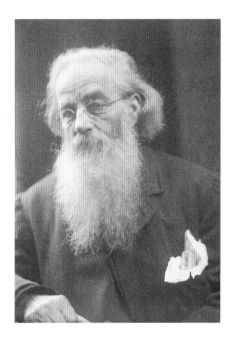 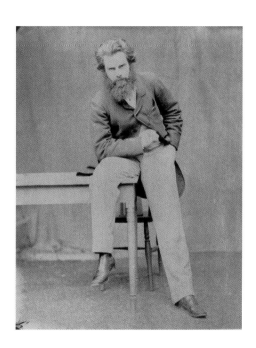

Precursors to the PRB

In most accounts of the foundation of the PRB, the names of several older artists crop up, with William Dyce (1806–64) and Ford Madox Brown (1821–93) at the head of the list. These two painters paved the way for the Pre-Raphaelites as they had already rejected the conventional manner of composing a painting, based on High Renaissance formulae. As one early champion of the PRB explained, since the sixteenth century, 'painters have for the most part held up Raphael between themselves and Nature'[2], but both Dyce and Brown found alternative sources of inspiration in the art of the fourteenth and fifteenth centuries.

Ford Madox Brown's role in the history of Pre-Raphaelitism stems from his relationship with Rossetti. When Rossetti became disillusioned with the teaching at the Royal Academy schools, he spent a short time, from March 1848, working in Brown's studio. In August 1848, Rossetti moved to share a studio with

Holman Hunt, but Brown remained in regular contact with the younger artists as they developed their revolutionary artistic theories. In particular, Brown was able to provide first-hand knowledge of the work of the German artists, the Nazarenes, whom he had met in Rome in 1845–6. The Nazarenes in some ways provided a model for the PRB. This group of Roman Catholic converts, including Peter Cornelius and J.F. Overbeck, had settled in Rome around 1810. They lived as a community, dedicated to serious-minded historical and religious subjects, and painted in a hard-edged style, with clear colours, reminiscent of early Renaissance works. Their paintings were admired by Prince Albert, who was also a pioneering collector of early Italian art.

6 William Dyce,
Study for a mural for All Saints, Margaret Street, London,
oil on canvas, 1849,
130.1 × 87 cm.
V&A: 164–1894.

The influence of the Nazarenes and the Early Renaissance was also visible in William Dyce's work. Although he was less personally involved with the Pre-Raphaelite Brothers, he was held up as a role-model both by the artists themselves, and by their critics. Hunt recognized that Dyce had shown how modern artists could draw on the art of the past in a constructive way: 'although he saw Nature mainly through the eyes of the Quattrocentists, he was not…a mere plagiarist'.[3] Dyce, an established artist whose work was collected by the royal family, registered his support of the controversial paintings by the young Pre-Raphaelites by sending a note to Hunt 'asking me to call upon him' to congratulate him on his 1850 Royal Academy exhibit, *A converted British family sheltering a Christian missionary from the persecution of the Druids* (Ashmolean Museum, University of Oxford).[4]

A design for one of Dyce's own major works, a *Mural for All Saints, Margaret Street, London* (plate 6), gives us an insight into the relationship between his art and Pre-Raphaelitism. Like many early works by the Pre-Raphaelite Brotherhood, including Hunt's *Christians and Druids*, it is bound up with the intense mid-Victorian debates about ritual in the Anglican Church. All Saints, Margaret Street, was one of the centres of High Church worship, and Dyce's design for the decorated reredos at the east end of the church reflected the sympathies of the clergy and congregation in several ways. Firstly, the colour scheme, with clear blues, pinks and greens, and prominent gold haloes, referred back to altarpieces by early Renaissance artists such as Fra Angelico (c.1400–55) and Fra Filippo Lippi (c.1406–69). These colours would have stood out in striking contrast to the shadowy umbers and russets of conventional 'Old Master' religious subjects. We know that Angelico's *Coronation of the Virgin* (plate

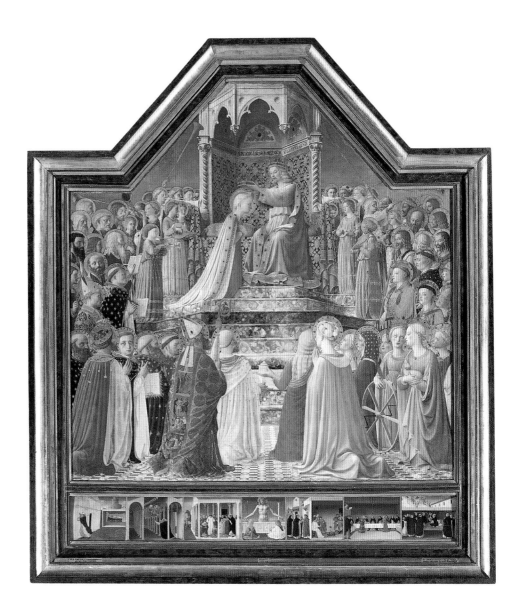

7 Fra Angelico,
Coronation of the Virgin,
tempera on panel, 1450–53,
Louvre, Paris.

7) made a particularly strong impression on Hunt and Rossetti when they visited Paris in the autumn of 1849; Hunt was delighted by its 'peerless grace and sweetness'.[5] It was not only Angelico's colour and technique that had an impact on the development of the Pre-Raphaelite approach. As with Dyce's design, the centrality of the Virgin Mary in Fra Angelico's image was significant.

Roman Catholic veneration of the Virgin was treated with extreme suspicion by the majority of Anglicans in Victorian Britain. In the aftermath of John Henry Newman's shocking conversion to Rome in 1845, debates about Mariolatry and the worship of the saints divided families and friends. For the young Pre-Raphaelites, there was a frisson of rebellion in the depiction of Marian subjects, and images such as Rossetti's *Ecce Ancilla Domine* (Tate Gallery, 1849–50), an Annunciation scene, caused a stir among the critics. In the meantime, Dyce was exploring new ways of depicting the Virgin and saints within the context of the Anglican Church. His deliberate rejection of the traditional Old Master style, which smacked of the Baroque and the Catholic

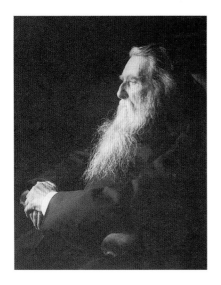

8 Frederick Hollyer,
Portrait of John Ruskin, at Brantwood,
platinotype, c.1894.
V&A: Ph.7603–1938.

Counter-Reformation, in favour of a purer, pre-Reformation style, was one useful approach, which the Pre-Raphaelites also followed.

The influence of John Ruskin

The Pre-Raphaelite Brotherhood had another reason to feel indebted to Dyce. It was through his actions that they gained their most outspoken champion, the art critic John Ruskin. At the 1850 Royal Academy exhibition, Dyce made sure that Ruskin could not miss Millais' controversial painting, *Christ in the House of his Parents (The Carpenter's Shop)* (plate 9). As Ruskin explained in a letter, Dyce 'dragged me literally up to the Millais picture…which I passed disdainfully, and forced me to look for its merits'. [6]

Although Ruskin had ignored the Pre-Raphaelite Brothers until this point, they had been well aware of him, and Hunt in particular admired his writings. Hunt had heard about this young writer from a fellow student at the Royal Academy, and plunged into the first volume of Ruskin's *Modern Painters* (1843): 'of all its readers, none could have felt more strongly than myself that it was written expressly for him'. [7] Looking back, Millais was rather more circumspect about the influence of Ruskin. His son claims that 'when asked to read the

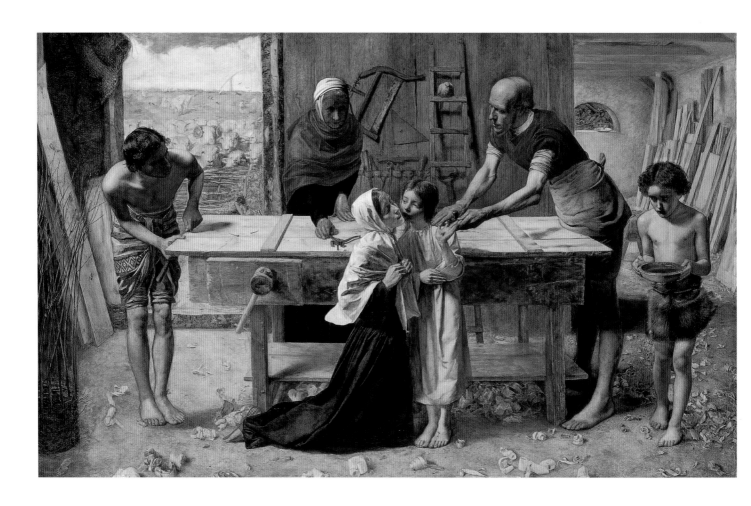

10 John Ruskin,
Mountain scene, Lansleberg,
Savoie, France,
pencil and watercolour, 1848,
24.9 × 37.9 cm.
V&A: E.651–1937.

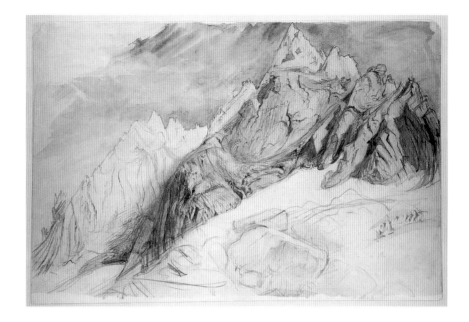

work, [Millais] resolutely refused to do so, saying he had his own ideas, and convinced of their absolute soundness, he should carry them out regardless of what any man might say'.[8] Millais' reluctance to acknowledge Ruskin's influence is perfectly understandable given their later difficulties: during a painting holiday in Scotland in 1853, Millais fell in love with Ruskin's wife, Effie. The Ruskin marriage was a disaster, and had never been consummated, but for Effie to seek an annulment was a bold step. Eventually she was able to marry Millais in July 1855. These romantic entanglements were bound to colour Millais' memory of the early influence of Ruskin. However, it is clear that Ruskin's theories on the role of the modern artist had a profound impact on the Brotherhood and their younger associates.

Ruskin challenged the mid-Victorian art establishment in three ways, and the PRB were eager to rise to these challenges. Firstly, he demanded a moral and whole-hearted approach to painting. Secondly, he held up the natural world as the only true model for artists, and thirdly, he encouraged artists to look to the Middle Ages, which he believed was the only time when art enjoyed its rightful role in society. His early writings were relentless in their insistence that art should avoid all decadence. Instead, the British school should create works of art that would be a direct reflection of God's hand in creation. This was why it was imperative that artists should work directly from nature, as the natural world alone 'declares the perfectness and eternal beauty of the work of God; and tests all work of man by concurrence with, or subjection to that'.[9]

Ruskin's own drawings, and the illustrations in his books, show his theories put into practice. In 1848, he made a watercolour of a *Mountain scene* (plate 10) during one of his regular visits to the Alps. There he found inspiration in the grandeur of the landscape. In his autobiography, he described his first view of

LEFT
9 John Everett Millais,
Christ in the House of his Parents
(The Carpenter's Shop),
oil on canvas,
Tate Gallery, 1850.

11 John Ruskin,
Coronet of leaves and acorns,
pencil and watercolour, 1856, 3.3 × 7.6 cm. V&A: E.380–1977.

12 John Ruskin,
Linear and Surface Gothic decoration: The Stones of Venice, Vol. II, book
illustration, 1853, 27 cm tall. V&A: 34.b.121, page 224.

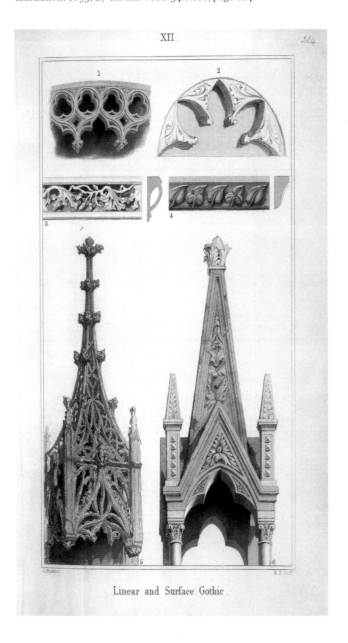

Linear and Surface Gothic.

the Alps as a young man as 'infinitely beyond all that we had ever thought or dreamed – the seen walls of lost Eden could not have been more beautiful'.[10] As ever, his vision of the natural world was intimately connected with his spiritual experience. He was equally delighted to turn his attention to the most delicate works of God's creation, and could study the tiniest details of plants and animals with as much intensity as he mapped the geology of mountains. His faintly coloured *Coronet of leaves and acorns* (plate 11) seems to be both a concentrated observation of natural forms, and also a meditation on lines from Tennyson's poem, 'The talking oak': 'And when my marriage morn may fall, / She, Dryad-like, shall wear / Alternate leaf and acorn-ball / In wreath about her hair.'[11]

Ruskin's focus on nature was reinforced by his enthusiasm for the art of the Middle Ages. One of his most celebrated chapters, 'On the Nature of Gothic', declared that 'to the Gothic workman the living foliage became a subject of intense affection'.[12] Many of his engraved book illustrations demonstrate how leaves and flowers were translated by medieval workmen into the traceries and capitals of Gothic buildings (plate 12). If medieval workmen were taking the infinite variety of the natural world as their model, they were also demonstrating their independence. This argument was spelt out forcefully in 'On the Nature of Gothic'. In Greek and Roman art, where forms were conventionalized and repetitive, artists were effectively slaves; however, 'if, as in Gothic work, there is perpetual change, both in design and execution, the workman must have been altogether set free'.[13]

Ruskin believed that this independent spirit, which allowed artists to turn to nature directly, was an essentially northern European characteristic. He contrasted 'that general tendency to set the individual reason against authority…in the Northern tribes' with 'the languid submission, in the Southern, of thought to tradition'.[14] This refusal to submit to convention, and the desire instead to look at the world with fresh eyes, was also at the root of the Pre-Raphaelite revolt against Academic training. Encouraged by Ruskin, and also by Dyce and Madox Brown, they focused their attention on the details of the natural world, and sought out examples

13 Hill and Adamson,
Master Grierson,
calotype photograph, 1845,
V&A: 67.379.

13 Hill and Adamson,
Master Grierson,
calotype photograph, 1845,
V&A: 67.379.

of painting created before the long shadow of Raphael fell across European art.

There was of course an added incentive to the PRB's attempts to find a new visual language. The painter's art was being threatened by the new technology of photography. In 1839 the cumulative efforts of Niepce and Daguerre in France, and William Henry Fox Talbot in England, to fix a fleeting image burst upon the Victorian public. In January 1839, Talbot demonstrated his negative/positive process to the Royal Society, a process he called 'Photogenic Drawing'. Leaves, faces, entire landscapes could now be captured and preserved on prepared paper without the intervention of the artist's hand. Viewers were forced to acknowledge the extreme accuracy of these images, and began to delight in the new visual worlds that were opened up by photography: the microscopic investigation of a tangle of hedgerow, or the unexpected awkwardness of the human body (plate 13).

In the late 1840s, while photographers were revealing these remarkable advances in ways of looking, the young Pre-Raphaelites were struggling with their conventional artistic training. Is it any wonder that they should react to the challenge of photography in their attempts to conjure up a fresh visual

experience? The 'innocent eye' of the camera, Ruskin's injunction to 'go to nature…rejecting nothing, selecting nothing'[15], and the so-called primitivism of Early Renaissance painters like Jan van Eyck or Fra Angelico were all pointing in the same direction. As Prettejohn has shown, there was no inevitable conflict between the naturalistic and archaistic tendencies in Pre-Raphaelite art. Instead, despite later differences, at the outset all the Brothers were pursuing a coherent ideal – the desire to 'start from scratch'.[16]

Early works

All the painters in the Brotherhood were the product of traditional Academic training, which concentrated on the study of the ideal human form, initially by drawing from casts of antique sculpture, and then from the life model. Without this professional training, it was hard to establish a successful career as a painter.

In the mid-1840s, the Royal Academy schools were still teaching the same principles of 'Ideal Beauty' set out by the first President of the RA, Sir Joshua Reynolds. His *Discourses* encouraged artists to 'make out an abstract idea of … forms, more perfect than any one original'.[17] However, the Pre-Raphaelite Brothers did not want to create some composite perfection. Instead they hoped to represent the beauty of individuals, from single stems of grass to the bodies of working class models. As Hunt expressed it: 'it is simply fuller Nature we want. Revivalism, whether it be of classicism or medievalism, is a seeking after dry bones'.[18] When we study some of the Brothers' earliest works, we can see how far they had to travel to achieve their desire for a new vision.

The early career of John Everett Millais gave little hint of his potential as an artistic rebel. He was recognized as an artistic prodigy in his childhood, and began his training at nine years old. However, having easily achieved proficiency in the eyes of the Establishment, by his late teens he wanted a new challenge, and a fresh technique.

Rossetti came into the Pre-Raphaelite Brotherhood by another route. He had started as a probationer in the Royal Academy schools in the summer of 1844, but was disillusioned by the strict system of drawing from antique sculptures, and began looking about for alternative inspiration. Rather than tackling large-scale oil paintings which taxed his patience, he was more interested in drawing and illustration. He devoured the obscure works of Blake, Keats and Edgar Allan Poe, and was intimate with Dante and other early Renaissance poets through the influence of his father, an Italian exile and scholar. His imagination was fired by the supernatural and the uncanny, as we can see in his drawing from Poe's 'The Raven' (plate 14). This carefully worked image, given to his friend William Allingham, was one of three versions inspired by this poem. It was drawn only four years after the poem was first published in the *New York Mirror*. Rossetti's own annotated copy of the 1846 edition of the *Poems*, now in Princeton University, is testimony to the painter's early and intense study of these extraordinary writings.

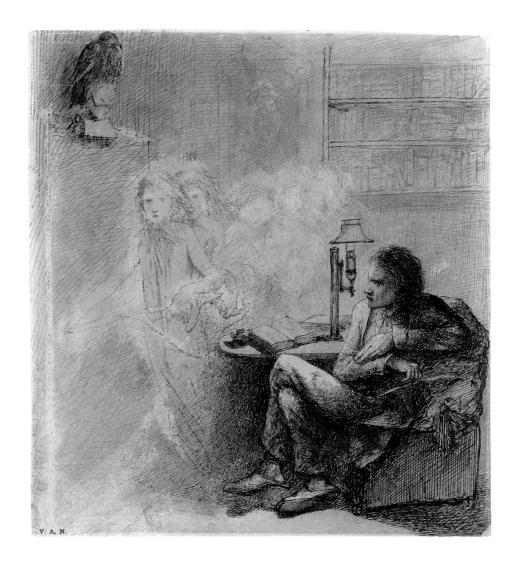

14 Dante Gabriel Rossetti,
The Raven,
pen and ink with brown wash,
c.1848,
23.2 × 21.6 cm.
V&A: E.3415–1922.

Rossetti's handling of the pen reflects the strange conjunction of the real and the supernatural in Poe's work. Dense hatching reinforces the uneasiness of the man's posture, with his body twisted in the armchair, his legs uncomfortably crossed. This is contrasted by the lightness of touch employed in the ghostly figures who fill the room with incense. They emerge out of the air, gradually becoming more defined, and drifting across the room. The angularity of the figures, underlined by the jagged electric strokes of the angels' hair, became a common feature in the drawings of all the PRB around this time. Only one of the spirits seems aware of the man's presence as they pass beneath the raven. This 'grim, ungainly, ghastly, gaunt, and ominous bird' has perched upon the bust of Pallas Athena. The poet had hoped to find consolation for the loss of his love, Lenore, whose picture hangs next to the bookcase, but his hopes are blighted by the appearance of the bird and its repeated croak, 'Nevermore'.[19]

The concerns addressed by this drawing were repeated in many of Rossetti's later works. Both he and Burne-Jones were fascinated by encounters between the natural and the spiritual worlds – epiphanies, annunciations, metamorphoses. The theme of the division of lovers by death was also a central Pre-Raphaelite

motif, taken up by Rossetti in his poem 'The Blessed Damozel' (first published in the magazine *The Germ* in 1850), and often reworked by later artists.

Like Rossetti, Hunt was also turning his attention to untapped literary sources for his subjects, although his aim was to work up his ideas into oil paintings for the Royal Academy exhibitions. In 1848 he showed *The Eve of St Agnes* (Guildhall Art Gallery, Corporation of London), and the RA catalogue included a substantial quotation from Keats to explain the story of the lovers' escape. As Hunt later explained, 'no-one had ever before painted any subject from this little known poet'[20], so this painting attracted the interest of Rossetti, who was already a devoted fan of Keats. Until this point, Hunt and Rossetti had barely known each other, but for the next few years they worked closely together, developing the subjects and techniques that they hoped would reinvigorate British painting.

'Disgusting incidents of unwashed bodies'

In September 1848, a handful of students assembled in Millais' family home to thrash out their ideas about art. Millais and Holman Hunt had been working side by side in the spring, trying to finish their Academy exhibits, and were already becoming known for their antagonism towards conventional teaching. (Looking back on these late-night conversations, Millais said that he and Hunt pledged that they were not prepared to follow blindly in the footsteps of Raphael, but would 'go back to earlier times for examples of sound and satisfactory work…and take Nature as their only guide'.[21]) Now Rossetti was sharing a studio with Hunt, and with four artistic friends they decided to pool their ideas for a new approach to painting. In youthful high spirits, they formed a secret society: 'Pre-Raphaelite', because they wanted to recapture 'what is direct and serious and heartfelt in previous art, to the exclusion of what is conventional and self-parading and learnt by rote'[22]; and 'Brotherhood', to reflect the conspiratorial nature of the group. Rossetti was particularly keen on the idea of a 'Brotherhood', possibly because it suggested links with the 'Early Christian' style of the Nazarenes, which he had discovered in Madox Brown's studio.

However, their first-hand knowledge of fourteenth and fifteenth-century art was extremely limited. The National Gallery had only just started to collect Early Renaissance work[23], so the young students had to make do with engraved reproductions. They were enthralled by the illustrations of the frescoes by Gozzoli and Orcagna in the Campo Santo in Pisa, which Millais had managed to borrow. Hunt remembered their delight in 'the naïve traits of frank expression and unaffected grace'[24] which had made Italian art of the time so vigorous, but he was always concerned that, in their enthusiasm for the art of the past, they might forget their determination to attempt a 'childlike submission to Nature'.[25] As the Brothers' encounter with early art was largely through these black and white line engravings, their own work tended to reflect the sharp

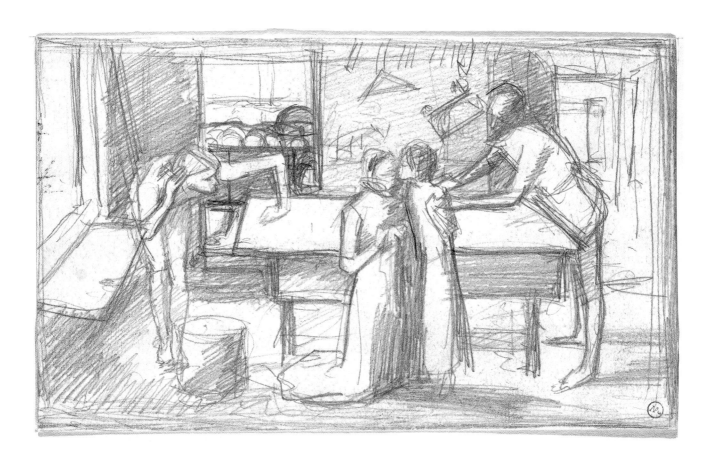

15 John Everett Millais,
*Compositional sketch for Christ in
the House of his Parents*, pencil,
1849–50, 11.4 × 19 cm.
V&A: D.1444–1903.

outlines and abrupt style of the printed reproduction. The engravings made a
refreshing change from the plump, reposed figures and classical backdrops of
High Renaissance paintings.

The ideals of the PRB were brought into the open at the London exhibitions
of 1849 and 1850. Their paintings caused an outcry among the art critics, who
condemned the new style in unprecedented terms. The painting that bore the
brunt of the abuse was Millais' *Christ in the House of his Parents (The Carpenter's
Shop)* (see plate 9), and an early compositional sketch (plate 15) shows that the
elements which were most heavily criticized in the finished work were in place
at the outset. The angular poses of the figures, and some of the symbolic details
such as the set-square representing the Holy Trinity above the head of the
Christ-child, can already be seen. In fact, the awkward position of the bending
figure on the left, whose arm is twisted as he leans forward, was toned down in
the final composition. Even so, the painting horrified the critics, who took
offence at the very qualities the Pre-Raphaelites had set out to foster. As Barry
Bullen has shown in his study of *The Pre-Raphaelite Body*, journalists and pub-
lic alike were repelled by the way this picture seemed to be retrogressive, hark-
ing back to the infancy of art. They also felt that the intense realism, the
detailed painting of wood-shavings and the gnarled working-man's hands of St
Joseph, 'distracted from or debased the larger narrative'.[26]

Millais had chosen to work from models that were deliberately individualized,

rather than sticking to the convention that 'the most beautiful soul must have the most beautiful body'.[27] However, his choice of models and their twisted poses were considered by some as the equivalent of 'pictorial blasphemy'.[28] The figures of the Virgin and of Christ caused particular offence. To begin with, they were depicted as red-heads. At the time, red hair was considered unlucky, or at the very least vulgar, so this colouring was inappropriate for the Holy family. In addition, their poses were hideously out of proportion and akin to the worst excesses of medieval art. Charles Dickens, in the fiercest of all attacks on the picture, was horrified by 'the wry-necked, blubbering, red-headed boy' and the woman who was 'horrible in her ugliness…with that dislocated throat…a Monster'.[29] Other critics blamed the contortions of the two central figures on the bad example of pre-Reformation art. They believed that Victorian artists should not celebrate the mortification of the flesh of a priest-ridden age. They could not understand why a well-trained and technically proficient artist like Millais should turn his back on rounded and pleasing bodies, based on Classical and High Renaissance examples, in favour of wasted, tortured images of medieval saints. And, as the critic in the *Athenaeum* pointed out, Millais was mistaken if he imagined that he had truly 'reverted to *any* early period of art…the disgusting incidents of unwashed bodies were not presented in loathsome reality' in any previous school.[30]

Ruskin came to their rescue. In a letter to *The Times* in May 1851, he suggested that, rather than drawing inspiration from a dubious Roman Catholic past, the Pre-Raphaelites were turning to nature as their primary source. He praised the 'admirable though strange pictures of Mr. Millais and Mr. Holman Hunt' as evidence of progress, rather than regression. It was up to the critics to open their eyes to the ground-breaking endeavours to paint 'what they see in Nature, without reference to conventional or established rules'.[31] He acknowledged that they had indeed spent many months painting the backgrounds to their works directly from nature, often sitting out in all weathers. And they had worked in bright colours directly onto prepared white canvases to capture the effects of brilliant sunshine on leaves and costume; most painters would work over a brown undercoat, which re-created the muted colours and deep shadows of Old Master paintings.

The Pre-Raphaelite images were shockingly bold in their scale, colouring and subject matter, and the art world found it hard to accept these audacious works. They were mocked by fellow artists like Henry Nelson O'Neil. In 1857 he exhibited a pair of paintings entitled *The Two Extremes: the Prae-Raphaelite and the Post-Raphaelite*. His parody of a PRB picture, sadly now lost, teased their solemn manner and awkward style. The *Illustrated London News* described the result: an artist is 'painting with infinite labour…he has two red-haired models'. He paints 'in the most formal, hard manner possible, giving them the sourest of expressions…the subject is "Love and Duty". The artist sits on his stool as if doing penance, with his long hair combed down with ascetic straightness.' [32]

However, with Ruskin on their side, the prospects for the PRB were not uniformly bleak.

Reaching a wider public

Although the oil paintings exhibited by the PRB remained controversial throughout the 1850s, they were only seen for a short period each summer at the annual exhibitions. However, there was an alternative way to reach the growing audiences for art in mid-Victorian Britain. From the 1850s, the boom-

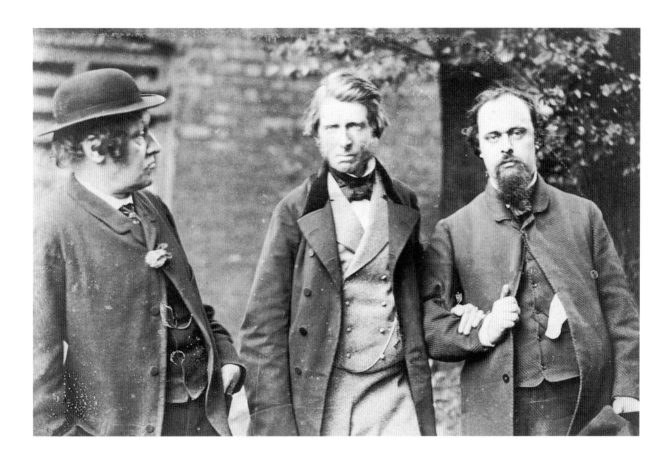

16 Anonymous photographer, *William Bell Scott, John Ruskin and Dante Gabriel Rossetti*, photograph, *c.* 1865, 8.8 × 13.5 cm. V&A: 800–1928.

ing publishing industry allowed the middle and upper classes to see the work of young artists in their own homes through a revival in the art of book illustration. Wood engravings, cut on tiny blocks of box or fruit wood, rarely more than six inches square, decorated the pages of novels and collections of poetry. Certainly Millais, Rossetti and Hunt, along with many of their friends and colleagues, benefited from this appetite for illustration. It was a convenient way to try out design ideas, working on a small scale, and it kept money coming in, even if the larger oil paintings were not selling.

The discipline and detail of the Pre-Raphaelite approach was ideally suited to wood engraving. As Rossetti exclaimed, when he was sent a block that was

17 Dante Gabriel Rossetti,
The Maids of Elfenmere,
wood engraving, engraved by the Dalziel
Brothers for *The Music Master*, 1855,
12.7 × 7.6 cm.
V&A: E.2923–1904.

one-sixteenth of an inch too narrow, 'Good God, I could get a whole city in there!'[33] The blocks were cut across the grain, so that very fine lines could be created. (In this relief printing, the high part of the block carries the ink, so the cuts into the wood are white in the finished print.) A number of firms were established in the mid-nineteenth century to cater for the growing market, with the Dalziel family becoming the most prominent. The eight sons and four daughters set up a substantial workshop, transferring artists' drawings onto the block by hand, or, from the 1860s, by photography. The engravers would cut through the artist's drawing, or the photographic reproduction, and could then make copies of the block by taking plaster casts and electroforming a duplicate block in metal. This was especially useful if the book or magazine had a large print run, as it preserved the original block from wear.

The wood engravings designed by the Pre-Raphaelite Brothers during the 1850s had an impact that belied their small scale. One of Rossetti's illustrations for William Allingham's *The Music Master* (1855) became an iconic image for the generation of artists who came after the PRB. *The Maids of Elfenmere* (plate

17) was only 5 x 3 inches, but it caught the attention of a young man who was determined to become an artist, though hardly knew where to start. Edward Burne-Jones wrote about his encounter with this print in *The Oxford and Cambridge Magazine* in 1856: 'It is, I think, the most beautiful drawing for an illustration that I have ever seen; the weirdness of the Maids of Elfen-mere, the musical timed movement of their arms together as they sing, the face of the man, above all, are such as only a great artist could conceive.'[34] The combination of imaginative detail, a medieval setting and the mysterious power of the fairy women conspired to enthral the young Burne-Jones.

The Maids of Elfenmere is one of the finest of Rossetti's creations, bringing together many elements found in works throughout his career. The scene is claustrophobic as figures seem boxed into a corner, between the sloping walls. The moonlight emphasizes the white robes and pale faces of the women, creating ambiguity – are they real or do they only exist in the man's imagination? The repetitive swinging of the spun thread across the picture is almost hypnotic, and the women themselves seem entranced, like sleepwalkers in their shifts. The 'heady mixture of sensuality and disquiet'[35] created here by Rossetti was repeated in his images of women for the next thirty years.

However Rossetti did not enjoy the design process. Initially he forgot that his drawing would be reversed in the engraving, and discovered too late that his spinners would appear left-handed; he had to trace and redraw it on another block. Having passed this to the Dalziels, he fretted about the cutting and was furious when he saw the result: the engraver 'does not always follow my lines, but a rather stupid preconceived notion of his own about the intended "severity" in the design, which has resulted in an engraving as hard as nails, and yet flabby and vapid to the last degree'.[36] The Dalziels later complained that the design supplied by Rossetti, a mixture of wash, pencil, coloured chalk and pen and ink, could not easily be translated into black and white, and so would never satisfy him. Only after recutting, to get rid of the 'oyster and goldfish cast of features'[37], would Rossetti allow the image to be printed, and even then he tore the illustration out of his own copy of Allingham's poems.

By the mid-1850s, the original Brotherhood was beginning to unravel, as each artist started to establish his individual mature style. Still, joint projects such as *The Music Master*, and Moxon's edition of the poems of *Tennyson* (1857), provided new outlets for the Pre-Raphaelite Brothers. These books helped to advertise their corporate identity among a wider audience, and also reflected the intimate connection between the visual imagination and literary sources, which was such a prominent feature of Pre-Raphaelite art. And they helped to convince a couple of Oxford undergraduates, William Morris and Edward Burne-Jones, that they should give up their preparations for the priesthood and instead devote their lives to art.

'The Child' Millais

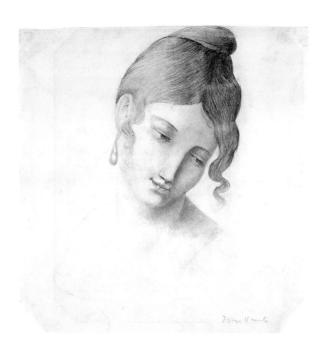

Millais' precocious talent for drawing was encouraged by his family. When he was just nine years old, they left Jersey for London so that he could train at Sass's Academy in Bloomsbury. There he was prepared for entry into the Royal Academy schools, and in 1840, at the age of eleven, he became the youngest student ever to be accepted. Nicknamed 'the Child', Millais was exceptionally successful, winning Royal Academy medals from thirteen years old and taking the prestigious gold medal for oil painting when he was seventeen. The artist George du Maurier remembered Millais as a young man overflowing with 'liveliness and vitality, such a spoilt child of nature and society and everything – and much of it owing no doubt to his astonishing beauty and naif impudence'.[1]

PLATE 18 John Everett Millais, *A head of a woman*, pencil, 1836, 22.9 × 16.2 cm. V&A: E.1046–1948. This drawing, made when he was just seven, demonstrates Millais' extraordinary abilities. He can already handle the material with confidence, and has begun to tackle shading techniques and emotional expression. Four years later he submitted his work for the Royal Academy exams.

PLATE 19 John Everett Millais, *Arms and armour*, pencil, pen and watercolour, 1840s, 26 × 33 cm. V&A: E.1789–1948. Millais' early sketchbooks show how carefully he constructed his paintings, paying particular attention to historical details. He was building up a store of useful objects that could be inserted into the grand narrative paintings he was expected to create.

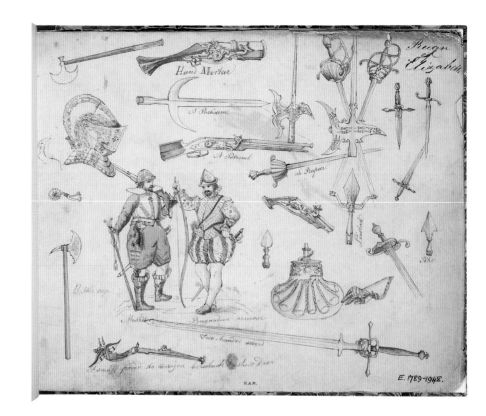

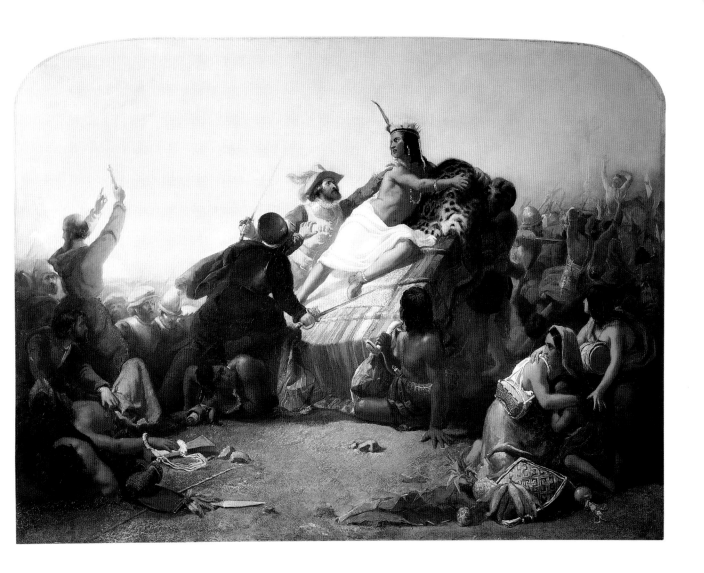

PLATE 20 John Everett Millais, *Pizarro seizing the Inca of Peru*, oil on canvas, 1846, 128 × 172 cm. V&A:
121–1897. By the age of sixteen, Millais had completely mastered the Academic process of creating a painting,
both in composition and detail. This first oil painting to be shown at the Royal Academy was an ambitious and
exotic subject. It shows the moment when the Spanish conquistador Francisco Pizarro captured the Inca
emperor Atahualpa in 1532. The setting sun illuminates the crucifix held aloft, as an ancient civilization and
religion is overwhelmed by European Christianity. The composition conforms to the conventions established in
the High Renaissance, with the central characters arranged in a pyramid, and subsidiary groups, notably the
mothers and children, adding an emotional subtext and framing the main action of the picture. Even the
lighting effects were carefully stage-managed, with the left corner in shadow and the central figures
conspicuously lit. This theatricality was influenced by Sheridan's play *Pizarro*, which Millais had seen at the
Princess's Theatre early in 1846. He even asked one of the main actors, James Wallack, to sit for him, and may
have borrowed props from the theatre. He also used 'an artistic selection of native ornaments & garments'[2] lent
by a friend who had recently visited South America, to add archaeological authenticity. Unfortunately it was
poorly hung, and barely noticed by the critics: the figures were 'drawn with accuracy…The composition is most
judiciously managed…The work is abundantly rich in colour.'[3] The painting was given to the V&A by Millais'
half-brother, Henry Hodgkinson.

CHAPTER 2

The Next Generation

One evening in January 1856, a shy Ned Burne-Jones attended a lecture at a London Working Men's College in the hope of seeing the artist who had created *The Maids of Elfenmere*. He explained, 'I had no dream of ever knowing Rossetti but I wanted to look at him...and so I saw him for the first time, his face satisfying all my worship.'[1] Rossetti's brand of Pre-Raphaelitism was moving away from the heightened naturalism of Hunt and Millais' sensitive historical subjects; he was also conspicuously attracting the attention of several younger artists. It is at this point that we can see unbridgeable divisions opening up between the leading artists of the Brotherhood, as each sought to define 'Pre-Raphaelite' in terms of their own art.

For Hunt, art was bound up with notions of morality. He believed that fidelity both to God and nature was expressed through serious subjects and an intense study of natural phenomena. This would create a 'tangible and worthy image of the national body and mind'[2], which should be the aim of their new British school. Millais agreed that the Brothers should record the details of the natural world, but he used these details as accessories in his exploration of emotion and narrative. His paintings had always focused on human sentiment, but gradually this element came to the fore, and the minute technique of his Pre-Raphaelite days was given up in favour of a bolder, more fluent touch. With this shift in emphasis, by the end of the 1850s he had become a hugely popular and influential artist.

Both painters were agitated by changes in Rossetti's style in the early 1850s. Millais described how he 'drifted away from us to follow his own peculiar fancies...They were highly imaginative and original, and not without elements of Beauty, but they were not Nature.'[3] However, these paintings were accepted as 'Pre-Raphaelite' by the public, and despite the protests of the other Brothers, the label stuck.

'The whole Round Table is dissolved'

The cracks in the PRB had begun to appear early on. Millais and Hunt had never entirely forgiven Rossetti for exhibiting his oil painting *Ecce Ancilla Domine* (Tate Gallery, 1849–50) at the National Institution, rather than waiting a week and showing at the Royal Academy exhibition alongside his Pre-

Raphaelite Brothers. In his memoirs, Hunt gleefully recounts the response of Millais' parents to this action: 'I don't like the look of him,' said Mrs Millais, 'he's a sly Italian, and his forestalling you by sending his first picture to an exhibition…was quite un-English and unpardonable.'[4]

In the summer of 1850, James Collinson converted to Roman Catholicism and decided that he could no longer remain a member of the secret Pre-Raphaelite Brotherhood. He broke off his engagement to Rossetti's sister, Christina, resigned from the PRB and began to train for the priesthood. Then, in 1852, Thomas Woolner, the only sculptor among the original Brothers, became frustrated at the lack of commissions. He determined to try his luck in the gold-fields of Australia instead. The youthful enthusiasm of 1848 was being worn down by the realities of making a living.

The fatal blow to the Brotherhood came in 1853, when Millais was elected an Associate of the Royal Academy. After all the talk about breaking away from the art establishment, Millais was now willing to go back into the Academic fold. His acceptance of this token of respectability was deplored by Rossetti, who complained to his sister that 'now the whole Round Table is dissolved'[5], and Millais' decision to join the ranks of the Academicians has been held against him by Pre-Raphaelite colleagues and art historians ever since. William Morris was particularly harsh. In the 1880s, he condemned Millais as 'a genius bought and sold and thrown away'.[6] Burne-Jones was equally critical, saying he could only look at Millais' later work 'with bewildered pain…the artist died in him and left only the splendid craftsman'.[7]

Perhaps we should consider the story from Millais' point of view. As a boy he had become accustomed to artistic success, and the violent abuse of his Pre-Raphaelite paintings was hard to bear. However, in the early 1850s he found a way to combine the visual intensity of Pre-Raphaelite details with more attractive subjects. He toned down the high-minded religiosity of paintings like *Christ in the House of his Parents* in favour of images with a stronger emotional appeal. By the summer of 1851 he was painting *Ophelia* (Tate Gallery) and *The Huguenot* [8] (Makins Collection), which maintained the 'truth to nature' that was essential to PRB ideals. However, the narratives of both paintings added a new element of pathos which immediately resonated with the public and critics alike. In October 1852, soon after these pictures were shown in the Royal Academy, Millais wrote to his friend and patron Thomas Combe, 'It is quite a "lark" now to see the amiable letters I have from Liverpool and Birmingham merchants, requesting me to paint them pictures, any size, subject and amount I like.'[9] Yet he was cautious about throwing himself wholeheartedly into these lucrative commissions; he did not want his work to be simply 'bought and sold', whatever Morris might say later.

Millais' changing style was described by his son as an 'emancipation from the excessive detail of Pre-Raphaelite expression'.[10] The bolder touch employed in his oil paintings from the late 1850s should be seen as the culmination of

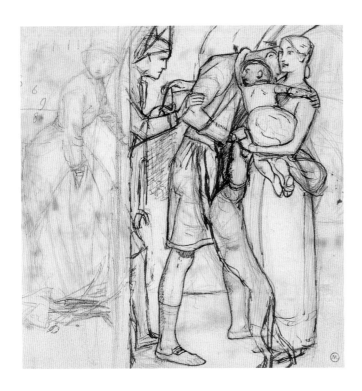

22. John Everett Millais,
*Study for The Order of Release, 1746, and
the Proscribed Royalist,*
pencil, pen and ink, 1852,
12.3 × 8.1 cm.
V&A: D.1445–1903.

RIGHT
21. John Everett Millais,
The Order of Release, 1746,
oil on canvas,
Tate Gallery, 1852–3.

years of technical training and acute observation. Now he had the confidence to broaden his handling of paint. He was also moving away from the influence of early Italian works, which had been so prominent among the PRB, and discovering the more fluid manner of eighteenth-century artists.

However, Millais' artistic credibility was undermined, in the eyes of Rossetti's followers, by his bluff personality. He was delighted to earn enough to enjoy the lifestyle of an English gentleman. (In his biography, the descriptions of his annual shooting and fishing holidays in Scotland sometimes overshadow the story of his artistic career.) Hunt also mentions that from an early age Millais 'dressed with exact conventionality so as to avoid in any degree courting attention as a genius'.[11] Millais himself acknowledged that his own openness of approach would not find favour with those who preferred Rossetti's brand of charm: 'if you affect a mysterious air…you stand a fair chance of being taken for a wiser man than you are', unlike those who 'talk frankly and freely' about themselves and their work.[12]

Millais' 'crowd of admirers'

With his 1853 Royal Academy exhibits, Millais got into his stride as a mature artist, showing paintings with historical subjects, including *The Order of Release, 1746* (plate 21). The V&A's collection contains several sheets of studies (plate 22) demonstrating the development of this subject. Millais imagines a scene from the aftermath of the Jacobite revolt, when the wife of a Highlander has negotiated the release of her husband from an English prison. The upright female figure supports both her husband and her child; her fortitude and her slight smile of triumph are the focus of Millais' attention. In this drawing he has begun to establish the figures. As he explained to Hunt, he was struggling to resolve their final relationships. He complained that the man, woman, child and dog 'are all mixed up together in the design…The child who is in the arms of the woman perfectly obliterates the man.'[13] The little girl in particular caused him dreadful difficulties, because she was so 'obstinate that she would not do anything I wanted, and when forced…squalled and foamed at the mouth'.[14] In the final version, Millais decided to depict the child asleep. This had the obvious advantage that he could work from a more biddable model, and also allowed the face of the exhausted Highlander to be seen.

The V&A's drawing is also a record of the changing title of this picture. It was originally called *The Ransomed*, and here the woman is clearly holding out a purse of money. However, at the last minute, this was replaced by a written order. These changes to the composition create a gentler narrative than that

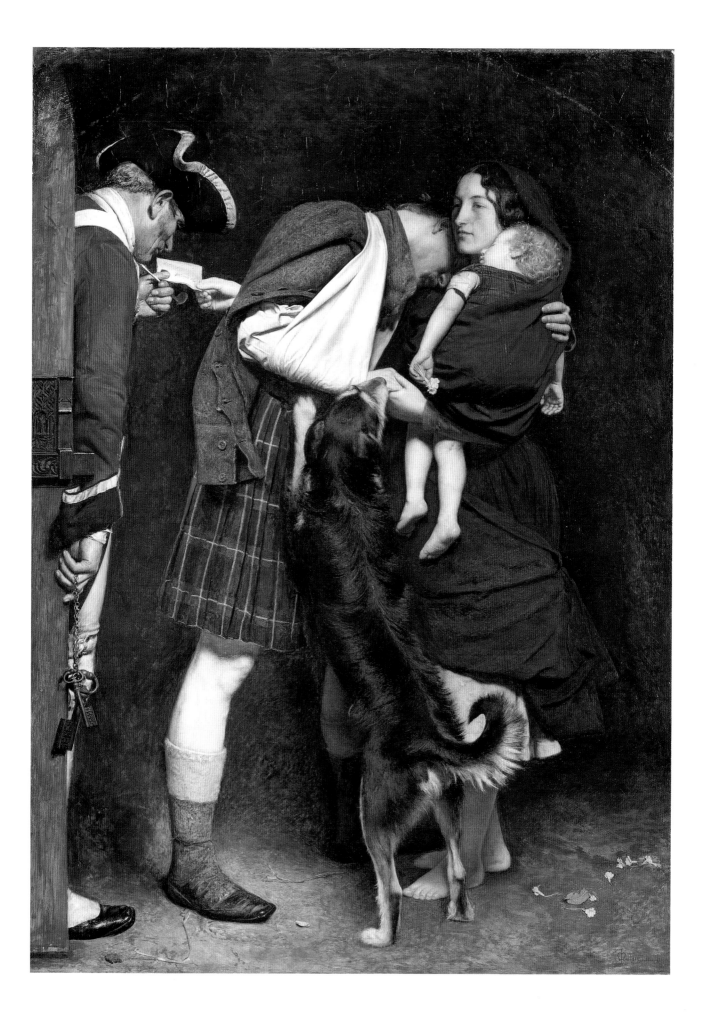

23 John Everett Millais,
My Second Sermon,
watercolour, 1870–86,
24.1 × 16.5 cm.
V&A: 399–1901.

indicated in the early drawings – this is no longer an exchange of man for money, but a legal reprieve, and the figures are more reposed. The drama is created by the intensity of expression on the woman's face, the clasped hands of the husband and wife, and the excitement of the dog who greets his master. The quiet strength of the woman and the detailed naturalism of the whole composition made this painting the hit of the 1853 Royal Academy show. The work was so popular that, according to his son, Millais' picture was the first Academy exhibit that 'required the services of a policeman to move on the crowd'.[15]

The face of the woman was drawn from Effie Ruskin, who was still imprisoned in her own miserable marriage. As a Scotswoman herself, she found the subject appealing. However, the woman's figure was drawn from a professional model, probably Anne Ryan. After all, Mrs Ruskin could not allow her bare legs to be displayed on the Academy walls.

As Millais became more commercially successful, he began to concentrate on three main areas of work: his engaging book illustrations, images of children, and grand portraiture. He became particularly well known for his sensitive designs for Trollope's serialized novels, and exerted a powerful influence over many illustrators of his generation. He was encouraged by his friend William Allingham to seize the opportunities afforded by the boom in magazine publishing: 'Surely one picture in a year, shown in London, and then shut up, is not result enough for such a mine of invention as you possess. This is the age of printing.'[16] So Millais launched himself into this market with typical vigour. Between 1854 and 1869 he produced over 270 book illustrations, and engraved reproductions of his oil paintings also helped to promote his work more widely.

Towards the end of the 1850s Millais became increasingly associated with images of childhood. Many of these were initially drawn from his own new family. Shortly after he married Effie Ruskin in 1855, he began a substantial oil painting, *Autumn Leaves* (Manchester City Art Galleries), which included portraits of her young sisters Alice and Sophie Gray quietly tending a bonfire at sunset. This painting set the tone for many of his subsequent images of children, which emphasized the thoughtfulness and transience of childhood. By 1863 he had five children of his own, and the portrait of his four-year-old, Effie, concentrating hard in church, was shown at the Royal Academy exhibition that year as *My First Sermon* (Guildhall Art Gallery, Corporation of London). Two years later, he returned to this highly popular subject with *My Second Sermon* (Guildhall Art Gallery, Corporation of London). The success of this picture, showing the little girl fast asleep in her pew, can be judged from the watercolour version now in the V&A's collections (plate 23).

Since 1858, Millais had been persuaded by the art dealer Gambart to create smaller replicas of his most acclaimed oil paintings in the cheaper medium of watercolour. He is said to have made up to eight replicas of *The Huguenot*. It is not easy to date these works, as they continued to be produced at intervals throughout his career, but the watercolour of *My Second Sermon* is known to

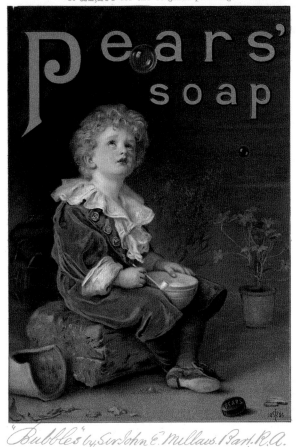

Put this in your Scrap book

It cost **£20,000** to produce the first editions, inclusive
of **£2,200** for the original painting.

"Bubbles" by Sir John E. Millais. Bart. R.A.

A perfect facsimile in miniature.
The original is in the possession of Messrs. Pears.

24 After John Everett Millais,
Bubbles, poster, 1886,
22.2 × 14.6 cm.
V&A: E.2335–1889.

RIGHT
25 John Everett Millais,
Lord Lytton, Viceroy of India,
oil on canvas, 1876,
114.2 × 74.3 cm.
V&A: F146.

have been exhibited at the Grosvenor Gallery exhibition in 1886. It was at this retrospective exhibition that stories began to circulate about Millais' dismay at the deterioration of his style since his Pre-Raphaelite days. Hunt describes Millais rushing out of the gallery with tears in his eyes, saying, 'You see me unmanned. Well, I'm not ashamed of avowing that in my looking at my earliest pictures, I have been overcome with chagrin that I so far failed to fulfil the forecast of my youth.'[17]

For many commentators on his work, the most typical image of his later years was the portrait of his grandson Willie James, known as *Bubbles* (plate 24). It has come to represent the high or low point of his career, depending on one's reading of his work. This oil painting of 1885 was originally intended as a meditation on the fleeting nature of childhood – bubbles are traditional symbols of the fragility of human life. However the picture was hijacked by the proprietor of Pears soap: Mr Barrett bought both the painting and the copyright from the first owners, the *Illustrated London News*. Millais had been glad when the painting was reproduced in the *News* as a very successful colour supplement, but he was upset about its subsequent use as an advertisement for soap. However, there was nothing he could do about it – Messrs Pears held the copyright for reproduction. Millais did manage to oversee the quality of the posters that were produced, but the episode lowered him even further in the eyes of the 'long-haired and velvet-coated tribe'[18] of Aesthetes who desired that art should be separate from squalid commercial transactions.

From the late 1860s, Millais was also in demand as a portrait painter. He was known for the dexterity with which he captured a personality, and was often able to complete the faces and hands of his subjects within three sittings. His likenesses of both Gladstone and Disraeli were highly acclaimed, and he was also admired for his sensitive portraits of women. The V&A holds one of his successful images of statesmen, a portrait of *Lord Lytton, Viceroy of India* (plate 25). This was commissioned by John Forster, Dickens' biographer. Forster wanted a portrait to remind him of his friend Edward Robert Bulwer-Lytton (1831–91), who was about to sail for India to take up his appointment as Viceroy. Sadly, Forster never lived to see the work finished. When it was exhibited in the Royal Academy in 1876 it was considered by the *Art Journal* to be

26 William Holman Hunt,
The Desolation of Egypt,
etching, published by the Art Union of
London, 1857,
4.8 × 11.4 cm.
V&A: E.466–1903.

one of the 'notable portraits of the year'.[19] Millais draws attention to the character of the sitter by focusing on the intensity of Lytton's gaze out of the canvas, and by creating deep contrasts between the brightly lit face and hand, and the sombre background and coat.

The popularity of Millais' paintings, and his changing style, contributed to the break-up of the Brotherhood. But Millais was not the only member of the PRB who wanted to follow his own artistic path. Hunt was preparing for a pilgrimage to the Holy Land, and in January 1854 he set off for Egypt. He did not see England again for two years.

Hunt: 'A missionary in disguise'[20]

Hunt had recently completed *The Light of the World* (Keble College, Oxford, 1853), his visionary picture of Christ knocking at the door of a human soul. He was now determined to continue his mission to elevate British art, by creating religious images that would challenge his complacent contemporaries. In order to remain true to his principles, he would need to see the Holy Land with his own eyes, to study Jewish practices and Eastern landscapes.

His first stop was Egypt, where he met up with Thomas Seddon, a painter who had been introduced to the Pre-Raphaelite circle by Rossetti. Together they visited Gizeh and camped near the Sphinx for several weeks in April and May 1854. As Hunt was still waiting for his canvases to arrive from England, he began sketching the dreary landscape. His etching, *The Desolation of Egypt* (plate 26), was conceived during this time in the desert. It is both an archaeological record and an allegory of Hunt's reaction to this ancient place: his choice of title is resonant of the biblical story of Joseph and the great famine in Egypt.[21]

His letters to Millais make it clear that he was depressed by the experience: 'the pyramids in themselves are extremely ugly blocks, arranged with imposing but unpicturesque taste'.[22] He and Seddon had to battle against dust-storms which threatened to carry off their tent, and made watercolour painting impossible. They eventually retreated to Cairo, and then Hunt made his way to Jerusalem, where he began work on two important canvases, *The Finding of the*

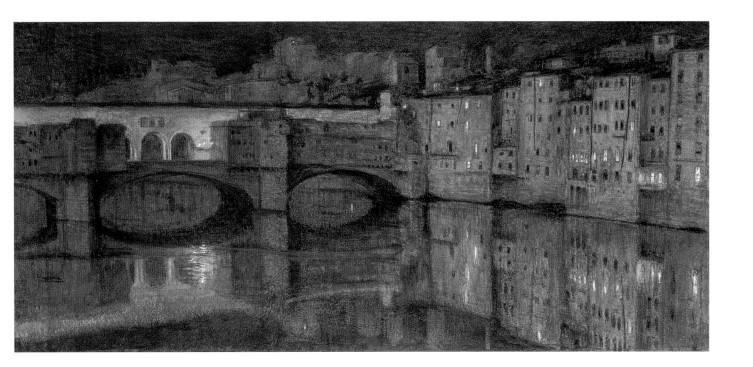

27 William Holman Hunt,
The Ponte Vecchio,
watercolour, c.1867,
26.7 × 52.3 cm.
V&A: 196–1894.

Saviour in the Temple (Birmingham Museum and Art Gallery, 1854–60) and *The Scapegoat* (Manchester City Art Galleries, 1854–8). Just like these major paintings, his tiny etching was worked and reworked. However, the nature of the medium created a more spontaneous effect than Hunt could ever achieve in his hypnotically detailed oil paintings. The darkness seems almost to envelop the small group of figures huddled around a camp fire, and Hunt's composition has balanced the solid mass of the Sphinx against the flimsy tent. The image recaptures the sense of isolation recorded by Hunt in his letters home.

Despite the impression created by this etching, Hunt's time in the Holy Land was ultimately successful. He returned to England with several canvases, which were then worked up in the studio, and which created a stir when they were exhibited. In 1866, he decided to return to the East to continue his researches, this time with his new wife Fanny Waugh. The couple got no further than Florence. The city was under tight quarantine restrictions because of an outbreak of fever, and they were forced to remain there. In October 1866, Fanny gave birth to a son, Cyril. Shortly afterwards she became ill, and died on 20 December, just days before their first wedding anniversary.

Hunt remained in Italy until the following September, painting a number of watercolours, including *The Ponte Vecchio* (plate 27). Although many of the landscapes of this time, made in and around Florence, retain the brilliant sunlight effects for which he was renowned, this picture seems a more sombre record of his bereavement. The night scene is unexpectedly subtle and mysterious; his usual style, with its extreme elaboration of detail and intensity of colour has given way to a vision of a ghostly city. The bridge and river are unpeopled, and the glowing lights at the windows are mirrored in the unruffled water. Hunt has created a sense of calm unreality, with the doubled image of the city, the

golden lights, and the limited colour palette of the deep blue-green uniting the sky and water.

During his travels, Hunt had maintained a close correspondence with Millais. However his early intimacy with Rossetti had given way to disdain for what he considered to be his increasingly amoral style. He was appalled by Rossetti's oil painting of 1859, *Bocca Baciata* ('The Kissed Mouth', oil on panel, Museum of Fine Arts, Boston), which he described as 'remarkable for gross sensuality of a revolting kind'.[23] However, despite Hunt's best efforts to transform British art with his brand of earnest naturalism, it was Rossetti who was the mentor for the next generation of artists.

Rossetti and his circle

Even Hunt had to admit that Rossetti could have immense personal charm.[24] He may have exhibited few oil paintings, but his watercolours, drawings and prints circulated among an eager group of patrons and artistic admirers. Even relatively well-established artists like Frederick Sandys fell under his spell. Many of Sandys' superb book illustrations and portrait drawings clearly show how Rossetti's distinctive vision of beautiful women began to pervade other men's work.

For an aspiring painter like Edward Burne-Jones, the impact of Rossetti's art and personality were life-changing. Having been introduced in 1856, Burne-Jones began to visit his studio regularly. There was always an element of danger about Rossetti, but his eccentricities could be enormously appealing. Even as an old man, Burne-Jones clearly remembered the excitement of those early years: 'My first summer with Rossetti I worked with him entirely, and he would paint away the whole day without stopping to eat anything at all but… a huge dish of strawberries.'[25] Burne-Jones shared his enthusiasm for an artistic career with his college friend, William Morris, who had just begun to train as an architect. Their letters help us to recapture the sense of a new world opening up in the spring and summer of 1856. Morris wrote to a college friend that 'I have seen Rossetti twice since I last saw you…[Holman] Hunt came in while we were there, a tallish, slim man with a beautiful red beard…Rossetti says I ought to paint, he says I shall be able; …I *must* try.'[26] Together with Rossetti, they would develop a new phase of Pre-Raphaelitism, derived from a love of the medieval and a passionate imagination.

Although Rossetti had tried to subscribe to the naturalism of PRB principles in his early oil paintings, his drawings and watercolours betrayed his true interests – the world of Dante's Florence, and a fascination with images of women. As an accomplished poet, as well as a painter (Burne-Jones declared, 'No man ever did two arts at once so perfectly before *ever*'[27]), his visual imagery was tightly bound up with literary sources. This imaginative relationship with literature was very appealing to Morris and Burne-Jones. In 1856, they were both involved with a short-lived publication, *The Oxford and Cambridge Magazine*,

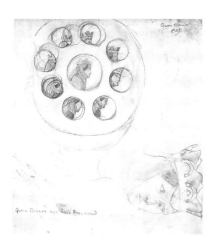

28 Edward Burne-Jones,
*Study of mirror and head of
Queen Eleanor, for Fair
Rosamond,*
pencil, 1862,
24.5 × 22 cm.
V&A: E.2857–1927.

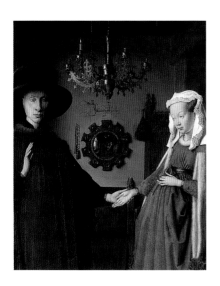

29 Van Eyck, *Arnolfini
Marriage* (detail), oil on panel,
1434, The National Gallery,
London.

which was a descendant of the PRB's experiment with their own magazine, *The
Germ*, in 1850. *The Oxford and Cambridge Magazine* reprinted a number of
Rossetti's poems, including 'The Blessed Damozel', as well as new poems by
Morris, who already had a reputation among his friends for the ease with which
he wrote his startlingly vivid verse. In both Morris's poems and Burne-Jones'
paintings there is the sensation that the young men were inhabiting the world of
their imagination, and reproducing their impressions with an unprecedented
intensity. The audience often feels as if their works allow us to glimpse a land in
which the artists were able to wander at will.

The world which they conjured up was drawn from a number of sources,
mostly medieval, to which they returned throughout their careers. At the very
end of his life, Burne-Jones described some of the revelations of their time at
Oxford: 'Two luminaries burst upon us at that time. One was Chaucer, and the
other was Albert Durer'[28], and Georgiana, his wife, also mentions how they
'went often to look at the painted books in the Bodleian'[29], establishing a life-
long love of illuminated manuscripts. Among the greatest treasures they discov-
ered was Malory's *Morte d'Arthur*. Together they studied the stories of the quest
for the Holy Grail for the first time. They held this work in such high esteem
that 'even among their intimates there was some shyness over it, till a year later
they heard Rossetti speak of it and the Bible as the two greatest books in the
world, and their tongues were loosened by this sanction of authority'.[30]

The intensity of their relationship with the medieval world is embodied in
the famous account of Burne-Jones' walk along the river from Oxford to
Godstow Priory. Every term he made a pilgrimage to the ruins, where Fair
Rosamond was said to be buried. Rosamond was the mistress of Henry II, who
would visit her bower at the heart of a maze; she was murdered by his Queen,
Eleanor. Burne-Jones described walking home 'in a delirium of joy…in my
mind pictures of the old days, the abbey, and long processions of the faithful,
banners of the cross, copes and crosiers, gay knights and ladies by the river
bank…I get frightened of indulging now in dreams, so vivid that they seem rec-
ollections rather than imaginations.'[31] We are struck by the impression that he
has experienced this medieval world at first hand, and is remembering rather
than creating the vision.

The romantic tale of Fair Rosamond haunted Burne-Jones for many years.
Drawings in the V&A relate to one version of the subject (plate 28), shown at
the Old Watercolour Society in 1864. The multiple convex mirror behind
Queen Eleanor's head reinforces the tension of the scene, as her murderous fea-
tures are repeated, not once, but nine times. The distinctive shape of the mirror
makes a direct reference to Van Eyck's *Arnolfini Marriage* (plate 29), bought by
the National Gallery in 1842. We know that Burne-Jones admired Van Eyck's
works, and longed to emulate their clarity. He admitted that 'as a young man I
have stood before that picture of the man and his wife, and made up my mind
to try and do something as deep and rich in colour and as beautifully finished

30 William Morris,
A Book of Verse, ink, watercolour
and gilding on paper, completed 26
August 1870,
leaf 27.9 × 21.6 cm.
V&A: L.131–1953.

in painting, and I have gone away and never done it, and now the time has gone by'.[32] These sentiments of nostalgia for a vanished age, and a subdued melancholy about his own creative power, were distinctive traits in Burne-Jones' character throughout his life.

William Morris, on the other hand, was an ebullient figure, blessed with overwhelming energy and determination. He believed that by resurrecting the most positive elements of the past he could build a more beautiful future. He was particularly influenced by Ruskin's description of the role of the medieval craftsman, outlined in 'On The Nature of Gothic', which he described as 'One of the very few necessary and inevitable utterances of the century.'[33] When he came to build his own home, soon after his marriage to Jane Burden in April 1859, he was excited at the prospect of being able to put Ruskin's ideal of the designer-maker into practice. He would work with his friends to break down the Renaissance hierarchies which privileged easel paintings over all other artistic production. Beginning with the decoration of his own house, they would master the skills required to transform the decorative arts in Britain, as the original PRB had transformed the art of painting.

We can see the lengths to which Morris was prepared to go to achieve this mastery when we look at one of the illuminated manuscripts he created. The National Art Library at the V&A houses *A Book of Verse* (plate 30), which he wrote out in a flattened italic hand. This collection of his own poems was decorated with miniatures by his colleagues Burne-Jones and Charles Fairfax Murray, and ornaments by George Wardle. Morris gave the manuscript to Georgie, Burne-Jones' wife. It was an acknowledgement of their close supportive friendship, which flourished during difficult times in both their marriages.

Morris's experiments with calligraphy began in the late 1860s when he

became fascinated not only with refining the shape of his letters, but also with discovering the best ink and paper. These investigations were to prove very useful in the 1890s when he established the Kelmscott Press. In his manuscripts like this *Book of Verse*, as in the later printed books, he was addressing the relationship between margin and text in the page layouts, and attempting to marry flat pattern decoration with figurative illustrations. His delight in turning natural forms into ornament is also clearly felt in the delicate weaving and sprinkling of decoration around the lines of verse. As in all Morris's designs, the flowers and plants remain clearly identifiable.

Although he studied Italian Renaissance writing books while perfecting his manuscript hand, his work was not cramped by the influence of the past. Instead he took the best examples of historical techniques and styles and applied them to the new circumstances of the nineteenth century. By investigating and reinvigorating medieval crafts like staining glass and weaving tapestry, Morris was able to provide the ideal outlet for the romantic visions of his friends, Rossetti and Burne-Jones. In 1856 he had declared, 'My work is the embodiment of dreams.'[34] With the formation of 'the firm', Morris, Marshall, Faulkner and Company, Morris began to fulfil this vocation.

The firm

So the second phase of Pre-Raphaelitism grew out of the collaboration between Rossetti, Madox Brown and a group of younger artists and designers, to set up a firm of interior decorators and church furnishers. They made their first splash at the 1862 International Exhibition, and soon won a prestigious commission to decorate one of the refreshment rooms attached to the new galleries at the South Kensington Museum. There they were able to demonstrate their skills in stained glass, panel painting and pattern design. This project also allowed Burne-Jones to develop his style, as the need for narrative was less important in this decorative context. His devotion to medieval details was giving way to more ambiguous settings for his works, which introduced classical elements. In the Green Dining Room his designs for wall panels and stained glass present a world of the imagination that is always coherent, but is often hard to place precisely. The impression of timelessness is particularly strong in the *Garland Weaver* windows. Burne-Jones seems to be meditating on the beautiful combinations of subjects – women moving with a slow grace, tulips, irises, roses, falling water and music.

Here we can begin to see the direction Pre-Raphaelitism was to take. Instead of the moral messages of the early PRB, Rossetti and his circle were concentrating on what Holman Hunt dismissed as mere 'gratification of the eye'.[35] This focus on the aesthetic qualities of a work – its visual pleasures – gave rise to a controversial tendency in British art, which became known to its admirers, and its many detractors, as Aestheticism.

31 Unknown photographer,
William Morris in hat and working smock,
albumen print, c.1876,
13.3 × 9.3 cm.
V&A: Ph.1808–1939.

The Green Dining Room

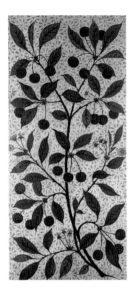

Work on the Green Dining Room began in 1866. Philip Webb oversaw the decoration, which was carried out by Morris & Co.'s own staff, and by sub-contractors S. & S. Dunn. Webb also designed the frieze of running dogs and hares, and the olive branch plasterwork for the walls.

PLATE 32 Morris, Marshall, Faulkner and Co., *Cherry dado panel*, Green Dining Room, V&A, 1866–7, painted and gilded wood panel. Branches of fruit are silhouetted against gold backgrounds: figs, cherries, oranges, gourds, peaches, pomegranates and lilac flowers appear in glowing profusion around the walls. These panels are interspersed with figures representing the signs of the zodiac, the sun and the moon.

PLATE 33 Morris, Marshall, Faulkner and Co., Green Dining Room, V&A, 1866–7, general view. The soft greens, buffs and muted deep blues set this decorative scheme apart from mainstream interiors. Some critics thought the results were rather muddy: Gilbert and Sullivan famously mocked the passion for 'greenery-yallery' colour schemes in their operetta *Patience*. However, the overall effect is far from dull. The quiet tones of the panelling are relieved by gilded highlights in the frieze and dado.

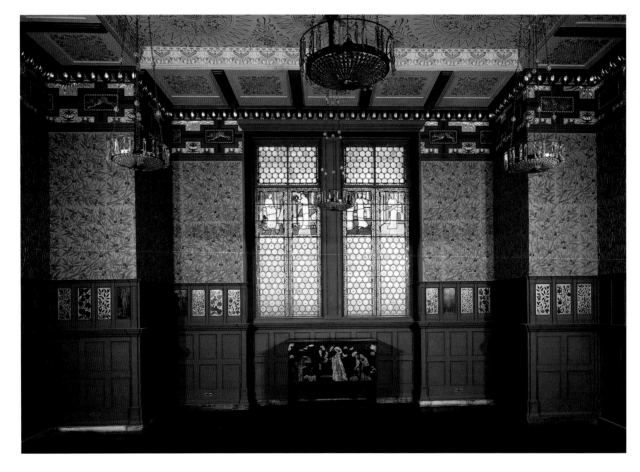

PLATE 34 Edward Burne-Jones and Charles Fairfax Murray, *Aries zodiac dado panel*, Green Dining Room, V&A, 1866–7. In his original designs for these figures, Burne-Jones created a complex symbolic code for each sign of the zodiac, incorporating birds as well as flowers. His notes for this sequence are in the V&A's collection (E. 2905–1927). So the sign for November, Sagittarius, was to hold a tiny image of an archer, with an 'oak tree, leaves falling', a 'new ploughed furrow' and crows in the background. However, Morris felt this was too complicated, and distracted from the overall unity of the scheme. The figures were repainted in a simplified manner by Fairfax Murray. The inspiration for the zodiac figures is clearly drawn from the classical astrological tradition, but seen through the eyes of the Middle Ages.

PLATE 35 Frederick Hollyer, *Mary Frances, Mrs Walter Crane*, platinotype, 1886, 15 × 10.3 cm. V&A: 7811–1938. In the 1860s, Burne-Jones' female figures wear simple robes that anticipate the fashion in advanced circles for 'Rational Dress' – high-waisted, uncorseted costumes – which became prominent in the 1870s, often made from modish Liberty fabrics.

PLATE 36 Edward Burne-Jones, *Garland Weavers*[1], made by Morris, Marshall, Faulkner and Co., stained glass, 1866–7. Each figure in these windows is different – several have their hair bound with ribbons or a white head-dress – but they all inhabit the same imaginary space: a walled town or large villa with paved and tiled courtyards, beds of spring flowers and standard roses. Their poses set up a rhythm through the sequence of the windows. We glimpse them from the front or the back, moving gently but purposefully through the courtyards and climbing the stairs, each figure swaying to left or right. Their movements are restrained, echoing the enclosed environment, which has a dreamlike ambiguity – it could be a medieval convent, or an Italian villa. The expressionless faces of the women also deny us an explanation for their actions.

CHAPTER 3

Towards Aestheticism

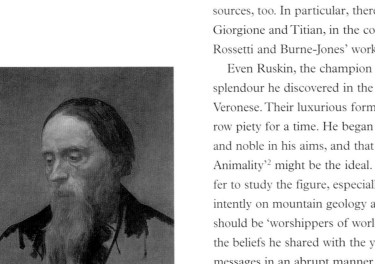

37 Alphonse Legros,
Portrait of Edward Burne-Jones,
oil on canvas, 1879, presented by the
artist,
50.2 × 36.8 cm.
V&A: 370–1880.

In 1866, the *Times* art critic described one of Burne-Jones' watercolours as 'the result of a passionate study of Dante and the Morte d'Arthur, early glass painting and medieval missal work, all grafted on Giorgione'.[1] This critic had identified a shift in the work of Rossetti and his associates. Now that their first love, the medieval world, was no longer the exclusive focus, they were beginning to look for examples of formal beauty in classical and Renaissance sources, too. In particular, there was a distinctively Venetian feel, an affinity with Giorgione and Titian, in the colours and in the broader handling of paint in Rossetti and Burne-Jones' work of the 1860s.

Even Ruskin, the champion of the Gothic, was succumbing to the visual splendour he discovered in the work of sixteenth-century Venetian artists like Veronese. Their luxurious forms and rich palette lured him away from his narrow piety for a time. He began to accept that an artist could be both sensual and noble in his aims, and that 'a good, stout, self-commanding, magnificent Animality'[2] might be the ideal. He even acknowledged that a painter might prefer to study the figure, especially the female figure, rather than focusing too intently on mountain geology and botanical detail. In accepting that artists should be 'worshippers of worldly visible truth'[3], Ruskin was moving away from the beliefs he shared with the young PRB – that paintings should convey moral messages in an abrupt manner. Now the sensory pleasures derived from looking at art could be explored more overtly.

A 'fleshly school'

For some artists and critics, this approach grew into a fully-fledged Aestheticism; they suggested that art should be enjoyed for its own sake, rather than for its social message. The journey towards Aestheticism can be traced in works by Rossetti like *The Borgia Family* (plate 38). Rossetti himself became one of the iconic figures of this Aesthetic movement, partly because his paintings had a certain occult quality: they were rarely exhibited in public, but instead were known only to the initiated. This feature of his art was admired by the critic of *Fraser's Magazine*: 'one occasionally encounters a rare piece of delicate work in which the intensity of the colour is equalled by the intensity of the expression'.[4] *The Borgia Family* would have appealed to such devotees of

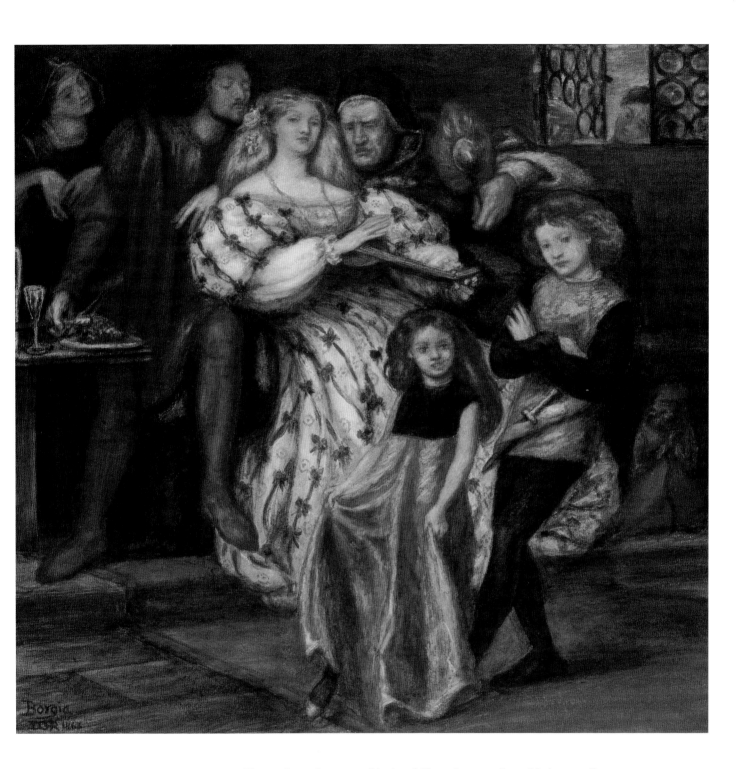

38 Dante Gabriel Rossetti,
The Borgia Family,
watercolour, 1863,
36.2 × 37.5 cm.
V&A: 72–1902.

Rossetti's art because of its jewel-like colours and troubled sensuality.
The development of this picture shows how Rossetti moved from medieval to
Renaissance sources during the later 1850s and 1860s. He first tackled this sub-
ject in a pen and ink drawing of 1850, related to a line from Shakespeare's
Richard III (Act I, sc.i.): 'To caper nimbly in a lady's chamber to the lascivious
sound of a lute' (Birmingham City Museum and Art Gallery). In the original
drawing, three men cluster around a central female figure to watch two children
dancing. Then, in 1851, Rossetti made a watercolour version, which he began to

alter a few years later (Carlisle Museum and Art Gallery). At Christmas 1857 he decided to revise the work completely, so he took it back from the owner, his friend and fellow artist George Price Boyce. Boyce recorded in his diary that 'he wants to convert it into a Borgia subject'.[5] When it was returned a year later, the work had been transformed. The V&A's enlarged watercolour version was made in 1863, probably with the help of Rossetti's pupil and studio assistant, W.J. Knewstub. Both watercolours demonstrate Rossetti's new interest in a Venetian manner, notably in the rich reds and golds of the costumes. The V&A's picture in particular shows a change in the handling of flesh and hair: Lucrezia Borgia's features are less refined than the women in his medieval images, her throat and shoulders are expansive, and her thick gold hair gleams in the light as it ripples over her skin. She catches our eye with a knowing look as she beats time for the dancers.

Her father, Pope Alexander VI, and her brother, Cesare Borgia, vie for her attention, pressing against her. Cesare smells the rose in her hair, while the Pope peers lecherously at her bosom. Their reputation for indulging in illicit sexual relations was clearly appreciated by Rossetti, who creates tension between the figures with his claustrophobic composition. The dancing children also contribute to the sensuality of the scene. One traditional reading of musical subjects associates music with courtship and heightened emotion. The implications of luxury and decadence are typical of Rossetti's images at this point. He was increasingly concentrating on the display of women's bodies, and his female characters were not afraid to meet the male gaze. Some critics admired this approach and praised Rossetti's 'mystical worship of Beauty'[6], but other audiences were repelled by the physicality of his images.

Rossetti's work, and especially his poems, were viciously attacked by the critic Robert Buchanan in his article 'The Fleshly School of Poetry', unleashed in 1871.[7] Rossetti was severely disturbed by the description of his art as a 'morbid deviation from healthy forms of life', displaying 'weary, wasting, yet exquisite sensuality'.[8] Rossetti's mental health began to suffer. Although he continued to paint, he became increasingly paranoid and refused to exhibit in public. He became addicted to the opiate chloral, originally taken to relieve insomnia, but Burne-Jones described the results: 'in the end he would take at one gulp what would have been enough to kill him at the beginning… For the last ten years of his life, he was entirely without power of will…I don't say he was ever entirely out of his mind, but he grew very violent at times, and was always difficult to manage. It was lamentable to see the downfall.'[9]

Both Rossetti and Burne-Jones were accused of 'unhealthiness' in their depiction of the body. This was a code for effeteness. Their men were not sufficiently virile, and their women were too overtly sexualized. They seemed to subvert the established order of nature. These charges continued to haunt them to the very end of their careers, and beyond. The *Edinburgh Review* in 1899 suggested that Burne-Jones' women were 'tainted at the fountainhead with the

moral and physical unhealth of instincts prematurely developed'.[10] Such criticisms were partly related to his close association with the poet Swinburne, whose *Poems and Ballads* of 1866 were dedicated to Burne-Jones. The first edition was withdrawn by the publisher for obscenity. As Barry Bullen has pointed out, throughout these poems 'the women are powerful, alluring, dangerous and sterile; the men are supine, submissive and largely emasculated'.[11] Burne-Jones' connection with verses that dwelt on Sapphic passion and 'Our Lady of Pain' contributed to accusations that his works were the result of 'abnormal and perverted talent'.[12] The increasingly androgynous appearance of his figures, and the languorous poses they adopted seemed to support Establishment fears about the amorality of the whole Aesthetic approach.

In 1873, the reality of these fears appeared to be confirmed when the painter Simeon Solomon was sentenced to eighteen months in prison; he had been arrested for committing homosexual acts in a public lavatory. Solomon, one of a family of successful artists, was a personal friend of Burne-Jones and Rossetti, and particularly close to Swinburne. After his disgrace most of his circle disowned him. Even Swinburne, who had encouraged his licentious behaviour, turned against him as 'a thing unmentionable alike by men and women, as equally abhorrent to either'.[13] Only Georgie and Edward Burne-Jones remained loyal. Georgie acknowledged their friendship in the *Memorials* of her husband, recognizing Solomon's artistic gifts as 'a rising genius' and writing of 'the tragedy of his broken career…before which I am dumb'.[14] His early exhibited work had been widely accepted: even the critic in the *Globe*, who suggested that recent works by Swinburne and Solomon had 'accustomed us to strange things'[15], admired his art. But there were far stranger images circulating privately.

The drawing *The Bride, Bridegroom and Sad Love* (plate 39) is one of the more explicit works enjoyed by the clandestine homosexual circles in which Solomon moved. It addresses the social obligations of marriage, at a time when homosexuality was unspoken and illegal. The bride draws the bridegroom towards her, but he is still entangled in a passionate encounter with a younger male figure, 'Amor Tristis'. The faces of all three reflect the melancholy of this situation, and their androgynous features reinforce the theme of confused sexuality. With these nude figures, Solomon is also alluding to the traditions of classical sculpture. For Victorian homosexuals, ancient Greece was admired as a time when passionate relationships between men could be openly expressed, and the epitome of this culture could be found in statues of nude athletic youths.

A fascination with Greek sculpture was not necessarily bound up with illicit sexuality, but was part of the wider movement towards Aestheticism. Heterosexual artists like Burne-Jones, who had initially concentrated on medieval and then Renaissance sources, began to look more closely at classical sculpture. The early Pre-Raphaelites had rebelled against the laborious study of

39 Simeon Solomon,
The Bride, Bridegroom and Sad Love, pencil on paper, 1865,
24.8 × 17.1 cm.
V&A: E.1367–1910.

40 Edward Burne-Jones,
Head of girl with braided hair, possibly a
study for The Mill,
pencil, early 1870s,
19.1 × 13.3 cm.
V&A: E.1850–1919.

these idealized forms in the Royal Academy schools, but their followers were considering them with fresh eyes. Burne-Jones, like many of his contemporaries, was particularly interested in the sculptures housed in the British Museum. He had missed out on a conventional artistic education and worked from these figures to improve his drawing and compositional techniques. One of his sketchbooks, which he used from 1859, was inscribed 'Studies from Antique'. It contains delicate transcriptions of sculptures, like the fragment from the *Chariot Frieze* in the British Museum (plate 41). Burne-Jones was concerned with the movement of limbs beneath light drapery, an effect that he tried to capture in his own designs, like the stained-glass panels in the Green Dining Room. Drawings like these also demonstrate his delight in creating subtle effects in pencil, a skill which he refined throughout his life. His sketchbooks are a treasury of carefully worked ideas rather than hasty notes. He tends to focus on the details of a figure – the fall of a robe, the gesture of a hand, or a complex hairstyle – which can then be built into the landscape of his imagination (plate 40).

Pater and pleasure

By bringing together medieval, Renaissance and classical sources, Burne-Jones was at the forefront of the new Aesthetic approach to art. The ideas he shared with Rossetti were given a theoretical framework by the Oxford academic Walter Pater, whose *Studies in the History of the Renaissance* often tell us more about the changing role of art in the 1860s and 1870s than they do about their ostensible subjects. Pater's essays wove together beautiful works of art from many disparate sources: late medieval French *chansons*, the paintings of Giorgione, or ancient Greek sculpture seen through the eyes of the eighteenth-century scholar Winckelmann. His message was that art should not be studied for its historical context, its narratives and morals. Instead, the critic should ask, 'What effect does it have on me? Does it give me pleasure?'[16] The sensation of beauty was paramount.

Pater's concluding essay explored the idea that all life was swiftly passing away, and that we should spend these fleeting moments in experiencing the very finest emotions, inspired by art. He suggested that 'while all melts under our feet, we may well grasp at any exquisite passion, …or any stirring of the senses, strange dyes, strange colours, and curious odours'.[17]

This awareness of transience, heightening the pleasure of sensory experi-

41 Edward Burne-Jones, *Female figure from the Chariot Frieze in the British Museum*, pencil on paper, V&A: E.5–1955, p.41.

42 James Abbott McNeill Whistler, *Self-portrait with straw hat*, etching, 1859, 22.5 × 15.1 cm. V&A: 19799.

ence, permeated the art of many of Pater's contemporaries. It was particularly noted in Burne-Jones' work. One sympathetic critic suggested that 'the very essence of beauty' in his work 'is in its fugitiveness'.[18]

Aesthetic alternatives: Whistler

This theme of ephemerality was also found in the work of a number of artists who are not normally associated with the later Pre-Raphaelitism of Rossetti and Burne-Jones, but who moved in the same artistic environment. James McNeill Whistler, for example, is often presented as antagonistic to the Pre-Raphaelite tradition, but the differences between their approaches to art have been exaggerated. Whistler's legal wrangling with Ruskin, who objected to the 'unfinished' appearance of his paintings, is of course significant, as Ruskin continued to be seen as the prophet of Pre-Raphaelitism throughout the 1860s and 1870s. However, even his devoted admirer Burne-Jones began to distance himself from Ruskin's more despotic declarations at this stage.[19]

The painting which particularly offended Ruskin was Whistler's *Nocturne in Black and Gold: the Falling Rocket* (Detroit Institute of Arts, oil on wood, 1875), exhibited in London's Grosvenor Gallery in 1877. This image was trying to capture temporary sensations, in the image of the firework, which burns up while we wonder at its beauty. It is therefore tackling the same themes of evanescence and nostalgia which are seen in Burne-Jones' work, although the style is radically different. Whistler's impressionistic approach was described by Ruskin as 'flinging a pot of paint in the public's face'.[20] Whistler retaliated with a very public libel action, at which Burne-Jones was obliged to support Ruskin in the witness box. In later years, however, he acknowledged that Whistler's technique 'is so perfect, and through the whole of it there's not one bit of bad colouring…I had no animosity against him'.[21]

So perhaps we should not be too hasty to emphasize the divisions between Burne-Jones and Whistler. We could instead consider how both artists approached the Aesthetic idea of fugitive beauty through musical references. As the very essence of music is the continual movement from one note to the next, as music cannot be fossilized, as it has no physical presence, it is the ideal symbol of fleeting sensation. Whistler entitled his twilight landscapes 'Nocturnes' because he wanted audiences to concentrate on the momentary transformation of the workaday Thames. He painted the instant 'when the evening mist clothes the riverside with poetry as with a veil…and the tall chimneys become campanili…and Nature for once, has sung in tune'.[22] Whistler explained that using a musical title encouraged his viewers to forget the historical and geographical context of the image, and focus instead on the picture surface (plate 43).

Burne-Jones tackled this relationship between music and transience more overtly on a decorated piano, which was given to him and Georgie as a wedding present in 1860. His image of *The Ladies and Death* (plate 44) makes the connection quite explicit. His design was based on an early favourite source of

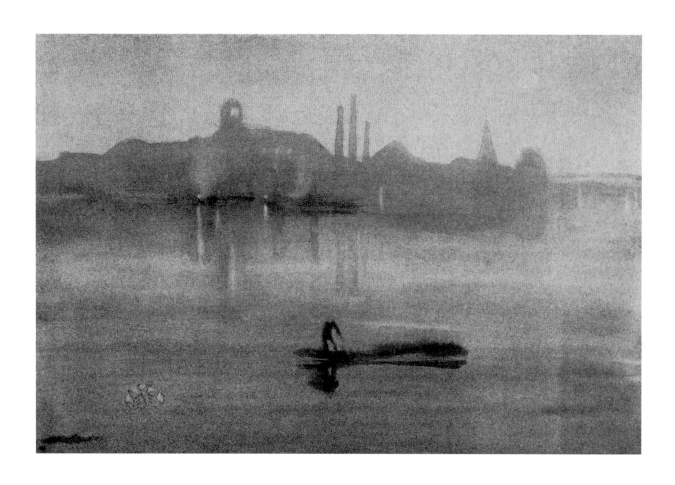

the PRB, the fourteenth-century frescoes in the Campo Santo at Pisa, which included a *Dance of Death*. Burne-Jones adapted the medieval composition, and introduced Venetian colours and a Renaissance fullness in the costumes. The image was described by Georgie: 'Death, veiled and crowned, standing outside the gate of a garden where a number of girls, unconscious of his approach, are resting and listening to music.'[23] Two of the girls are playing and singing softly, while the others seem overcome with melancholy. They droop, one sinks her head onto her knees, another leans on her companion's lap. As Death knocks on the door, they already appear to be drained of all liveliness and youthful vigour. The music has acted as a memento mori. Another version of the same subject (National Gallery of Victoria, Melbourne, pen and ink, 1860) is even more sinister: behind the figure of Death, the setting sun illuminates three shrouded corpses in a grave.

Burne-Jones' vision of young women and death was an extreme version of a subject which appealed to several artists at this point, including both Whistler and Millais. They explored the moment at which the innocence of girlhood is passing away, with the dawning of sexual awareness. The temporary nature of youth is mourned in images like Millais' *Summer Indolence* (plate 45). Alice Gray, the artist's sister-in-law, reclines on a lawn. The cut flowers and daisy chain, although appropriate accessories of girlhood, also remind us of withering and decay. Alice's frank gaze out of the picture suggests that she is aware of her fate. The blade of grass held between her lips also adds an erotic edge to her vulnerable recumbent pose. Like the girls in Burne-Jones' piano decoration, she will succumb to change and death.

This image started life as a detail from Millais' oil painting *Spring (Apple Blossoms)* (Lady Lever Art Gallery, National Museums and Galleries on Merseyside, 1856–9), a frieze-like composition of teenage girls in an orchard which includes an even more overt reference to decay and death, as a scythe looms over the scene, a symbol of the passing of seasons and, of course, the Grim Reaper. In the original version, only Alice makes a direct connection with the viewer; the other girls appear self-contained. So Millais' decision to rework her figure alone as an etching reinforces the suggestions of menace and lapsed innocence which were inherent in the oil painting.

Whistler also addressed the precarious state of girlhood in several of his oil paintings, most famously in his series of 'Symphonies in White'. In *The White Girl* (plate 46) and *The Little White Girl* (Tate Gallery, 1864), the face of his model, Joanna Hiffernan, is ambiguous. However, the bear-skin rug in the first picture implies a predatory sexuality. In the second, Jo's reflected image conveys an impression of regret, which was picked up by Swinburne in his poem,

45 John Everett Millais,
Summer Indolence, etching, 1861,
published in *Passages from Modern English Poets illustrated by the Etching Club*,
large paper edition, 1862,
17.8 × 25.4 cm.
V&A: E.1407–1904.

LEFT ABOVE
43 Printed by Thomas Way,
published by Boussod, Valadon
& Co., after James Whistler,
Nocturne: the River at Battersea,
lithograph, designed 1878,
printed 1887, 17.1 × 25.9 cm.
V&A: E.1517–1905.

LEFT BELOW
44 Edward Burne-Jones,
The Ladies and Death,
painted and gilded gesso on wood, shellac, on American walnut upright piano made by Priestly of Berners Street,
c.1860.
V&A: W.43–1926.

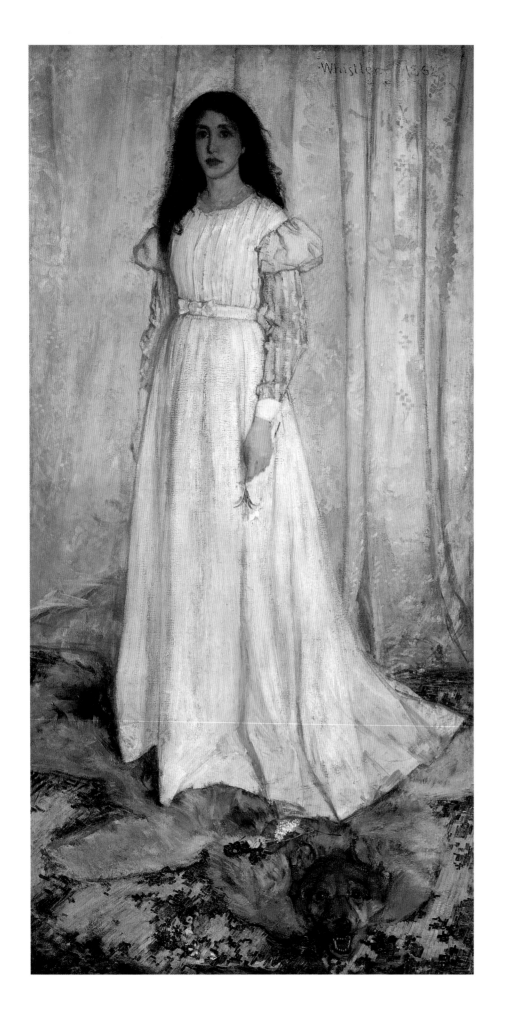

46 James Abbott McNeill Whistler,
*Symphony in White No. 1:
The White Girl,*
oil on canvas, 1862,
National Gallery of Art, Washington.

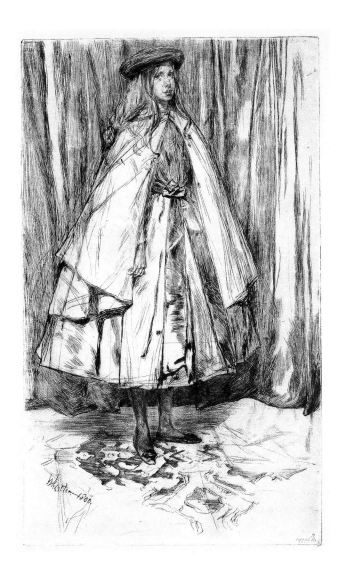

47 James Abbott McNeill
Whistler,
Annie Haden,
etching, 3rd state, 1860,
35.1 × 21.1 cm.
V&A: 19796.

pasted on the picture frame: 'Deep in the gleaming glass / She sees all past things pass, / And all sweet life that was lie down and die.'[24] Whistler had begun contemplating the subject of an isolated young girl a few years earlier, when he made an etching of his twelve-year-old niece, *Annie Haden* (plate 47). This image anticipates *The White Girl*, begun in the following year, in several key passages. In both, the heavy curtains cut off the background. Together with the treatment of perspective, which makes the floor appear to slope, they push the girl towards the viewer. The complex pattern of the carpet in the etching metamorphoses into the bear's head and flattened body in the painting. Annie's expression is quiet, almost resigned, as she carries her bulky clothing. The heavy pyramid of her cloak and skirt contrasts with the delicacy of her slender feet and ankles, her glimpsed hand holding back the folds of fabric and her loosened hair. As in many other images of young girls created at this time, her body is presented as vulnerable, and her gaze is grave and questioning, aware of impending transformation.

In addition to the shared preoccupation with transient states, Whistler overlapped with the late Pre-Raphaelite circle in other areas. As we have seen, Swinburne provides a personal link between Burne-Jones and Whistler. We know that Whistler and Rossetti met regularly – they lived near each other in Cheyne Walk in Chelsea. They also shared a passion for Oriental blue and white ceramics, and vied for the most sought-after pieces. As William Michael Rossetti explained, 'Mr. Whistler…first called my brother's attention to Japanese art: he possessed two or three woodcut books, some coloured prints, a screen or two.'[25] A number of pieces from both collections were acquired by the V&A in 1910 (plate 48). In Whistler's case, his fascination with the decorative arts encompassed the whole notion of interior design. Although their motivations were very different, Whistler, like William Morris, was determined to construct beautiful living environments. Whistler was particularly conscious of the manner in which his paintings were displayed, and would go to great lengths to create the ideal surroundings to complement his works.

The most famous example of this was his complete redecoration of the dining room at 49 Prince's Gate, London. In 1872, the industrialist Frederick Leyland had bought his oil painting *La Princesse du pays de la porcelaine* (Freer Gallery of Art, Washington DC, oil on canvas, 1863–4), which is full of Japoniste motifs, including the ubiquitous screens and fans. Whistler was

Ginger jar (V&A: C.836&a–1910) and *plate* (V&A: C.769–1910), porcelain decorated in underglaze cobalt blue from Whistler's collection; *vase* (V&A: C.935–1910), porcelain decorated in underglaze cobalt blue from D.G. Rossetti's collection, all Quing Dynasty 1683–1702, Jiangxi Province, China.

determined that this picture should have an appropriate setting, so in 1876, while Leyland was out of town, he painted over the expensive leather wall-hangings in the dining room where *La Princesse* was displayed. Richard Dorment describes the result as 'a giant lacquered box of swirling peacocks and showers of golden feathers, derived from… magnificent blue and white china'.[26] The whole room has now been transferred to the Freer Gallery of Art in Washington (plate 49).

However, it is often forgotten that the Peacock Room was the unexpected finale to an entirely different project. Whistler had originally been invited into 49 Prince's Gate to redecorate the hallway and staircase walls. Leyland had recently installed an astonishing marble staircase with an ormolu balustrade which he had bought from Northumberland House when it was demolished in 1874. (The staircase had been designed in 1818, and was regarded as a national treasure.) He intended to display his collection of Pre-Raphaelite paintings on the walls of the stairwell, and asked Whistler to create an appropriate colour scheme. Several panels from the dado of this staircase survive in the V&A's collections, and shed some light on the genesis of the subsequent Peacock Room, which led off from the hallway (plate 50).

The upper portions of the wall were painted a pale green, but the background colour of the dado panels has been described as 'shades of willow'.[27] The deep turquoise chosen by Whistler corresponds both with the later blue-green of the Peacock Room, and also with the predominant colour of the Green Dining Room in the V&A. Whistler created a shimmering effect by laying gold leaf under the green glaze of the panels, allowing it to oxidize, and then rubbing back through the painted surface to reveal gold highlights. The result was said to resemble Japanese lacquerware. Over this, he painted a trellis-work of stylized pink and white flowers, which are akin to his trademark butterfly signature. So both the colour scheme and the Japoniste detailing of the Peacock Room were an extension of this initial staircase decoration.

The fascination with Japan was a characteristic of British Aestheticism,

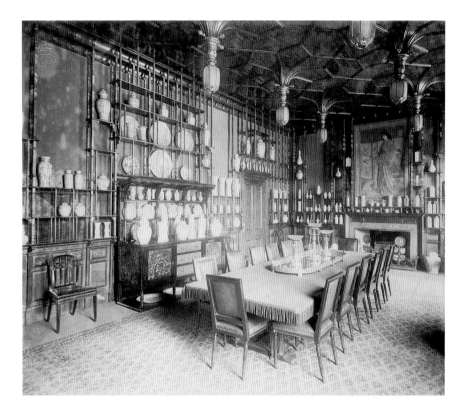

49 James Abbott McNeill Whistler, *The Peacock Room from 49 Prince's Gate*, painted and gilded wood and leather, 1876. Albumen print, 1892. V&A: 240–1926.

50 James Abbott McNeill Whistler, *Panel from staircase at 49 Prince's Gate*, wood, paint and gilding, 1876, 59 × 72 cm. V&A: W.35–1922.

shared with Rossetti, who featured a Japanese musical instrument and blossoms prominently in his sumptuous painting, *The Blue Bower* (see plate 164). It could be blended with references to medieval, Renaissance or outlandish sources to create a refined fantasy-land. Some artists managed to maintain a balance between the complete denial of narrative readings, the ultimate interiority of 'art for art's sake', and the archaeological detailing of conventional historical or exotic subjects painted by mid-Victorian artists. Burne-Jones manipulated these diverse sources particularly dexterously. He was able to retell myths or biblical stories, but, according to one critic, had 'discarded the outworn conventions of classic and medieval distinctions. His pathetic Virgins are of one race with his Psyche.'[28]

Although Burne-Jones developed a very different visual language from the original Pre-Raphaelites, he still explored many of the same themes in his paintings. So another way to assess the characteristics and developments within this movement is to consider the subject matter to which Pre-Raphaelites and their associates habitually returned. There are a number of key literary or historical references which pervade the work of the early PRB, and are carried forward into the 1860s and 1870s. This approach also reminds us that the Pre-Raphaelites were not exclusively easel painters. They were often skilled designers for the decorative arts, and their work in stained glass, furniture or textiles was central to their own perceptions of their careers. The V&A's collections are of course the ideal place to see how certain subjects were treated in a variety of media. So the remainder of this study will plot the development of these subjects in works by the original Pre-Raphaelite Brothers and their followers.

CHAPTER 4

The Natural World

When Ruskin came to the defence of the Pre-Raphaelite Brotherhood in 1851, he justified their boldness by saying that they were 'painting the truths around them as they appeared to each man's own mind, not as he had been taught to see them'.[1] Although the young artists had also clearly been looking at 'archaic art', it was their fresh approach to the natural world which became the focus of debate at this point. Both Millais and Hunt spent months painting in the open air to capture the effects of sunlight, or moonlight, on their landscape backgrounds. The vivid green of their canvases, the botanical details minutely reproduced, represented a distinctive vision of the natural world. Despite their critics, they exerted a powerful influence upon a number of their contemporaries who adopted the painstaking Pre-Raphaelite technique.

One of their closest associates was Charles Allston Collins (1828–73), the brother of novelist Wilkie Collins. In the summer of 1850, he and Millais worked on their paintings together 'en plein air' in Oxford. Millais even suggested that Collins should be admitted to the secret Pre-Raphaelite Brotherhood, but Woolner and William Michael Rossetti were less sure and he never became a full member of the group. Even so, his painting, *The Good Harvest of 1854*[2] (plate 51), is characteristic of the PRB approach. The carefully studied brick wall, smothered with ivy, reminds us of the background to Millais' hit painting *The Huguenot*, painted three years earlier, and the girl's pinafore dress seems to be the very one worn by Millais' *Woodman's Daughter* (Guildhall Art Gallery, oil on canvas, 1850–1). Millais had asked his Oxford patron Mrs Combe to look out for just such a dress: he wrote, 'if you should see a country-child with a bright lilac pinafore on, lay strong hands on the same…I do not wish it new, but clean, with some little pattern – pink spots, or anything of that kind'.[3] Apparently this useful item had been passed on to Collins.

On one level, this picture is a celebration of plenty after the hungry years of the 1840s. However, the little girl's solemn expression makes us hesitate. Her gaze reflects an awareness of the passing seasons and the symbolic resonance of harvest time. Collins' work pre-dates Millais' own exploration of these subjects in *Autumn Leaves* (1855–6) and *Spring (Apple Blossoms)* (1856–9). Collins is rather more subtle in his symbolism, unlike Millais' bonfire or scythe imagery. The girl's thoughtfulness suggests she recognizes that her own childhood is

RIGHT
51 Charles Allston Collins, *The Good Harvest of 1854*, oil on canvas, 1855, 43.8 × 34.9 cm. V&A: 1394–1869.

52 Richard Burchett,
View Across Sandown Bay, Isle of Wight,
oil on canvas, c.1855,
34.3 × 57.2 cm.
V&A: 9108–1863.

short-lived; the fact that she is clearly expected to work in the fields reinforces this. There is also an implied Christian interpretation of the sheaf of corn: it is both a symbol of the harvest of souls at the end of time, described in Revelations, and a reference to Christ's body, represented by the bread of the Eucharist. As a High Anglican, Collins would have been well versed in such multiple readings: he had already demonstrated this in his image of a young nun in an enclosed garden, *Convent Thoughts* (Ashmolean Museum, Oxford, oil on canvas, 1850–1). Although *The Good Harvest of 1854* was praised by Ruskin when it was shown at the 1855 Royal Academy, it was poorly hung and received no other critical notice. Collins gave up painting shortly after and became a writer instead.

Another early V&A acquisition shows how personal connections spread the Pre-Raphaelite approach to landscape painting. Richard Burchett's *View Across Sandown Bay, Isle of Wight* (plate 52) seems to have been bought directly from the artist, who taught at the Government School of Design in South Kensington. Like Collins, Burchett draws our attention to the fruitfulness of the earth, and makes a connection to the Christian readings of such subjects with the white bell tower of a church in the middle distance. However, his main interest is in the gold and blue of the landscape. Burchett captures a moment of

53 George Price Boyce,
The Old Tithe Barn, Bradford-on-Avon,
watercolour, 1877–8,
21.9 × 53 cm.
V&A: 175–1894.

rest when the reapers are out of sight, and the field is instead a leisured space – one young woman reads in the shade of the corn sheaves, another strolls up the hill towards us. The effect is more decorative than symbolic.

It seems that Burchett was influenced both in his choice of subject and in his technique by James Collinson, one of the original PRB. In 1855, the two artists were sharing a house, and Collinson painted a similar view of the Isle of Wight in the background of his *Mother and Child* (Yale Center for British Art, New Haven, USA, oil on canvas, c.1855). As William Dyce, Burchett's ex-teacher, also produced a watercolour of the same spot, there is a suggestion that the three artists visited the island together to look for subjects. However, Burchett never repeated this intense study of the natural world. He was better known for his publications on *Practical Geometry* (1855) and *Linear Perspective* (1856), and for his portraits of the Tudor royal family in the Palace of Westminster. Like many of his contemporaries, he seems to have discovered that the discipline of the Pre-Raphaelite technique was unsustainable.

Some artists within the Pre-Raphaelite circle maintained a lasting interest in landscape painting, but few were able to keep up with the large-scale, almost hyper-real naturalism of Hunt. For George Price Boyce, for example, the Pre-Raphaelite manner was more manageable in watercolour. Boyce is best known as a friend and patron of Rossetti, and his diaries are a revealing record of the artistic set in which he moved. He was also an accomplished painter, specializing in glowing images of the British countryside, which have a nostalgic flavour. *The Old Tithe Barn, Bradford-on-Avon* (plate 53) is typical of his work. His architectural training made him sensitive to the relationship between buildings and their environments. The soft afternoon light blends the foreground pasture and the ancient stone of the barn and farmhouse. A label on the back of the

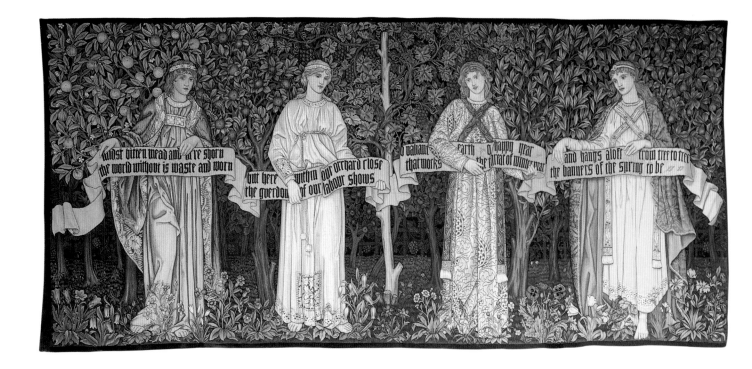

The banners on the tapestry read:

whilst bitter mead and are shorn / the world without is waste and worn

but here within our orchard close / the guerdon of our labour shows

o valiant earth o happy year / that works the fall of winter war

and hangs aloft from tree to tree / the banners of the spring to be

54 Morris and Company,
The Orchard (The Seasons) tapestry,
wool, silk and mohair on cotton warp,
1890,
221 × 472 cm.
V&A: 154–1898.

frame shows that the watercolour was painted on the spot in the autumn of
1877. This open air technique, combined with an underlying sympathy for the
medieval details of the gables, and the tiny touches of the brush, demonstrates
his Pre-Raphaelite affiliation. However, Boyce avoids the hardness or eccentric-
ity of some PRB landscapes.

For the later Pre-Raphaelites, a love of the Middle Ages and a delight in the
natural world produced very different results. William Morris was always care-
ful that his representations of plants and flowers should be clearly identifiable,
even though they had to be simplified for the purposes of ornament. We dis-
cover his ability to translate natural colour and form in his early writing, too.
Letters from France in 1855 demonstrate his clear eye for detail: he relishes 'the
hedgeless fields of grain and beautiful herbs…mingled with the flowers, purple
thistles, and blue cornflowers, and red poppies, growing together with the corn
round the roots of the fruit trees, in their shadows, and sweeping up to the
brows of the long low hills till they reached the sky'.[4] This vision of an
unchanging, fertile land was reproduced in many of his designs for the decora-
tive arts, and went hand in hand with his appreciation of medieval materials
and techniques.

Natural detail and traditional craftsmanship were perhaps most effectively
combined in Morris's tapestry production. They can be seen in the complex
tapestry of *The Orchard (The Seasons)*[5] (plate 54), which incorporated figures
from an earlier commission for the ceiling of Jesus College Chapel, Cambridge.
In the background we see fruit trees, each clearly defined – oranges, apples,

55 Edward Burne-Jones,
Study of a tree, pencil,
sketchbook from 1867,
18.7 × 22.8 cm.
V&A: E.10–1955, pp.84–5.

vines, plums and pears. The orchard floor is carpeted with flowers, which are not conventionalized 'mille-fleurs' but distinctive species, flattened but still individualized. These poppies, tulips, pansies and harebells resemble the botanical illustrations in Gerard's *Herball* (1597), a book which Morris had loved since boyhood, and which later 'supplied useful information about certain disused vegetable dyes'.[6] The whole composition seems a reminiscence of the glorious French countryside which had formed the backdrop to his decision to devote his life to art.

This decision was shared with Burne-Jones, and was the start of a life-long collaboration. However, their manner of depicting nature was markedly different. Burne-Jones was more interested in the landscape of the imagination. His studies of sunsets and poppies were one element in the creation of evocative twilight worlds, in which his characters moved with quiet deliberation. His sketchbooks were filled with drapery, medieval interiors, faces and hands, but he rarely went into the countryside to draw from nature directly. His *Study of a tree* (plate 55) shows how he focused on the expressive qualities of natural details. The twisting bare branches and gashed trunk are defined by pencil strokes, as if he were observing the muscles of a body. Although this was probably sketched from an old hawthorn tree, Burne-Jones transforms it into a potential symbol of pain and isolation. In his oil paintings, Burne-Jones' figures are placed in imaginary heaths and wide plains, or become entangled with thorns, but these environments are usually wildernesses, not the fertile meadows of Morris's medieval fantasy. Occasionally they find themselves at the edge of a dark wood, with gnarled trees stretching into the distance, but Burne-Jones most often depicts the urban landscapes of courtyards and narrow streets.

Burne-Jones' tendency to reduce nature to abstractions was a far cry from the acutely observed fields and hedgerows of the PRB. In the thirty years since the artistic revolution of 1848, beauty had replaced honesty as the Pre-Raphaelite ideal.

The Flower Book

In 1882, Burne-Jones began an intensely personal group of watercolours, each circular design only 6½ inches across, illustrating the names of flowers. Rather than drawing the flowers themselves, he used their names as the springboard for his imagination: 'I want the name and the picture to be one soul together…it is not enough to illustrate them: I want to add to them or wring their secret from them.'[1] His friends sent him lists of suggestions, seeking out the old-fashioned or poetic names for common plants. He preferred 'Ladder of Heaven' to the more usual lily of the valley, and 'Golden Cup' to marsh marigold. Georgie Burne-Jones described the drawings as 'a kind of magic mirror in which the vision appears'.[2] These designs only came to public attention in 1905 when she published a facsimile edition of his *Flower Book*. The original watercolours were given to the British Museum in 1909. However, a number of swift pencil sketches in the V&A give us an insight into the development of his ideas.

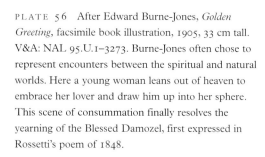

PLATE 56 After Edward Burne-Jones, *Golden Greeting*, facsimile book illustration, 1905, 33 cm tall. V&A: NAL 95.U.1–3273. Burne-Jones often chose to represent encounters between the spiritual and natural worlds. Here a young woman leans out of heaven to embrace her lover and draw him up into her sphere. This scene of consummation finally resolves the yearning of the Blessed Damozel, first expressed in Rossetti's poem of 1848.

PLATE 57 After Edward Burne-Jones, *Love in a Tangle*, facsimile book illustration, 1905, 33 cm tall. V&A: NAL 95.U.1–3270. Burne-Jones addresses a favourite subject, Fair Rosamond at the heart of her maze. He reduces the story to its essentials, so the rose trellis and the hedges of the labyrinth become geometric barriers separating Rosamond from the outer world, to which she is connected by a single thread.

PLATE 58 Edward Burne-Jones, *Studies for Meadow Sweet and Helen's Tears*, pencil, 1882–90. V&A: E.8–1955. Burne-Jones often returned to the theme of the sleep of King Arthur in Avalon. These sketches were made while he was also working on a vast canvas of the same story (now in the Museo de Arte de Ponce, Puerto Rico, plate 81). The larger of the sketches is more closely related to the oil version than to the final *Flower Book* idea. The smaller sketch shows that Burne-Jones considered placing Arthur's body in a small sailing boat, but this was rejected. It would have moved too far from the starting point of the flower name.

PLATE 59 After Edward Burne-Jones, *Meadow Sweet*, facsimile book illustration, 1905, 33 cm tall. V&A: NAL 95.U.1, 3291–1905. A large ship with three watching figures looms over the scene, and the four queens of the sketch are reduced to two. Arthur's pose has been changed. Initially he was laid out on his back, almost shrouded, but in the finished watercolour he has turned to rest his cheek on his hand, a position that better suggests sleep rather than death. These changes, and the addition of the ship and watchers, imply a narrative movement, which was not found in the original drawing.

CHAPTER 5

The Painter of Modern Life

Among the many different strands of Pre-Raphaelitism that emerged in the 1850s was an interest in contemporary social issues. William Holman Hunt's image of the fallen woman in *The Awakening Conscience* (Tate Gallery, 1853–4), and Ford Madox Brown's emigration scene, *The Last of England* (Birmingham Museum and Art Gallery, 1852–5) reminded audiences of the precarious nature of middle-class status. Respectability and prosperity could not be taken for granted.

The growth in magazine and book illustration allowed these themes to be explored more fully by a number of artists from the Pre-Raphaelite circle. By working on a small scale they could tackle subjects that would be difficult to sell as large oil paintings. Millais, for example, may have been wary of representing a London prostitute in a major Academy exhibit, but he did produce a sensitive response to the plight of such women in an etching. In 1858, he published an illustration to Thomas Hood's poem 'The Bridge of Sighs' (plate 60). The poem had caused a sensation in 1844 for its description of a young woman who drowns herself in the Thames: 'Mad from life's history, / Glad to death's mystery, / Swift to be hurled - / Anywhere, anywhere, / Out of the world.'[1] Millais chose the moment when the homeless girl contemplates suicide. Both Hood and Millais deliberately avoided the conventional image of the prostitute. She is not presented as one of the 'vicious and profligate sisterhood, flaunting it gaily'[2], nor is she 'hideous with disease and hunger'.[3] Instead, Millais has followed Hood in showing her as pale and beautiful but despairing. By placing her alone at night, by the edge of the river, Victorian viewers would automatically have inferred the rest of her story – seduction, leading to prostitution. No respectable woman would be in this position. Millais reinforces her isolation by shrouding her in a heavy cloak, which she draws tightly around her body. The dome of St Paul's Cathedral suggests the hope of Christian forgiveness, but it is too distant and shadowy to help her now.

Millais' sympathetic treatment of the fallen woman is consistent with other images by his Pre-Raphaelite colleagues. As well as Hunt's *Awakening Conscience*, Rossetti also tackled the subject both in his poem 'Jenny' (published 1857) and in his unfinished oil painting *Found* (Wilmington Society of Fine Arts, Delaware, oil on canvas, from 1854). They were all responding to an

60 John Everett Millais,
The Bridge of Sighs,
etching, 1858, for the Junior
Etching Club,
17.8 × 12.7 cm.
V&A: E.464–1903.

increase in visible prostitution on the streets of London, and vigorous public debate about a moral crisis. Their reaction was to create dramatic images of degradation, showing the moment of regret and shame. However, James Whistler's studies of the low life of the river took a very different approach. He refused to judge the figures he represented in his etchings of the Thames.

His detached observation in scenes like *Rotherhithe (Wapping)* (plate 61) derives from the theories of the French critic Baudelaire, that the painter of modern life should be 'a spectator…who everywhere rejoices in his incognito'.[4] Whistler's friend, George du Maurier, described him 'working hard and in secret down in Rotherhithe'.[5] Whistler wanted to translate the unpoetic corners of London, like this first-floor balcony in a shabby ale-house looking across the river to Wapping, into works of art. He imposes a structure on the scene through the strong verticals and horizontals of rigging, warehouse walls and

LEFT
61 James Abbott McNeill
Whistler,
Rotherhithe (Wapping),
etching, 1860, reprinted 1871,
3rd state,
27.7 × 20.3 cm.
V&A: 24767.5.

ABOVE
62 Frederick Sandys,
*The Waiting Time, or a
Lancashire Sermon*, wood
engraving, engraved by W.
Thomas, 1863,
17.8 × 11.4 cm.
V&A: E.1382–1910.

pulleys. The men in the foreground do not demand an emotional reaction from the viewer; their bodies are cut off by the edge of the image, as if they were snapped in a photograph. This device was also common in the Japanese prints which Whistler avidly collected. The etching is closely related to an oil painting, *Wapping* (National Gallery of Art, Washington, 1860–4), showing the two men with a 'jolly gal…with a superlatively whorish air'.[6] In both images, Whistler maintains a moral ambiguity. Unlike Millais, Hunt and Rossetti, there is no sense of outrage in his treatment of squalid subjects.

In 1863, another public outcry caught the attention of one of Rossetti's close associates, Frederick Sandys (1829–1904). This time, the issue was the hardship suffered by Lancashire weavers as a result of the 'cotton famine' caused by the American Civil War. As their supply of raw materials dried up, they began to starve. Sandys' wood engraving, *The Waiting Time, or a Lancashire Sermon* (plate 62), illustrated a poem about the economic distress among textile workers.[7] It is one of Sandys' finest images, and demonstrates his technical mastery of the medium. He was becoming well known for his taut, highly detailed prints, which often focused on the emotional plight of strong-limbed women. Sandys' technique contributed to the intensity of his pictures, as he made careful pencil studies for each element and then drew the final image with a very fine sable brush directly onto the woodblock. He builds up the drama through strong contrasts of light and shade, and the variety of textures he represents. The curling hair, the grain of the wooden stool and loom, the flounces of the skirt are finely rendered and make the image vibrant. A hank of yarn, knotted like a noose, hangs above the woman's head, reinforcing her sense of despair. The subject is even more poignant when we discover that Sandys' own family had been hand-loom weavers in Norfolk, whose skills were made redundant by industrialized production.

Illustration in the 1860s

During the mid-Victorian period, the effects of industrialization were felt in the publishing world, too. For the artist and novelist, however, this was a time of prosperity, as new magazines wanted to fill their pages with serialized stories and wood engravings. Sandys was among those who benefited from this new market. In May 1860, his first illustration was commissioned by Thackeray, novelist and editor of the *Cornhill* magazine, which had been established earlier

63 John Everett Millais,
Guilty (illustration for *Orley Farm*), wood
engraving, engraved by the Dalziel
brothers with pencil corrections by
J.E. Millais, 1862,
17.1 × 10.8 cm.
V&A: E.2880–1901.

in the year. The magazine claimed sales of 120,000 copies a month, and was able to pay Sandys handsomely – he received forty guineas for his design. Rival publications, *Once a Week* and *Good Words*, offered alternative outlets for the work of talented illustrators.

Millais was one of the most prolific designers for this trade. He was particularly associated with the novels of Anthony Trollope, after supplying illustrations for the serialized publication of *Orley Farm* in 1862. Trollope was delighted with Millais' treatment of his work. In his own album of the artist's proofs, he wrote, 'I have never known a set of illustrations so carefully true, as are these, to the conception of the writer.'[8] We can see the pains which Millais took with these designs in the pencil corrections to one proof in the V&A. His notes on *Guilty* (plate 63) include amendments to the line of Lady Mason's back, and comparisons with another proof 'admirably cut'. Millais' son described how 'unless perfectly satisfied with the finished production, he would tear it up at once, even if he had spent whole days upon it'.[9] Millais' great talent with these illustrations was that he used the voluminous skirts and shawls worn by the female characters to reinforce the emotion of a scene. He made a virtue of contemporary costume, and transformed the vast areas of fabric into compositional devices. In *Guilty*, for example, the crumpled, engulfing skirt emphasizes Lady Mason's dejection, and contrasts dramatically with the upright stance of the man.

Millais also provided illustrations for the serialization of Trollope's *The Small House at Allington* in the *Cornhill* magazine in 1862–4. Many of these images have a spontaneity and humour which is missing from the work of contemporaries like Sandys. The precarious position of the girl on a ladder in *'Bell, here's the inkstand'* (plate 64) is typical of his quirky response to Trollope's prose. The boldness of the girl's action is matched by the vivacious lines representing the fullness of the dress. Millais is particularly adept at highlighting the differences between male and female spheres. The brisk impatience of the standing gentlemen

ABOVE

64 John Everett Millais,
'Bell, here's the inkstand'
(illustration for *The Small House
at Allington*),
wood engraving, proof on India
paper, engraved by the Dalziel
Brothers, 1864,
15.9 × 10.5 cm.
V&A: 2368–1904.

ABOVE RIGHT

65 John Everett Millais,
'That might do' (illustration for
The Small House at Allington),
wood engraving, proof on India
paper, engraved by the Dalziel
Brothers, 1863,
15.9 × 10.5 cm.
V&A: E.2365–1904.

in 'That might do' (plate 65) is unheeded by the seated women. The expanses of their skirts anchor them in the design and suggest immobility.

A similar device is used by Arthur Boyd Houghton (1836–75) in his illustration for *The Love of Christ* (plate 66). Houghton was born in Madras, but came to England to study at the Royal Academy schools, even though he had lost the sight in his right eye through a childhood accident. In *The Love of Christ*, an illustration for a collection of poems, *Golden Thoughts from Golden Fountains* (published by F. Warne (London, 1867), p.187), the body of the woman is almost entirely hidden by the mass of her mourning dress. We recognize that she is kneeling from the swirling pleats of her skirt, but her costume is more expressive than her face, tucked under her hood and covered by her hand. The dashing strokes of rain falling across the image demonstrate Houghton's sympathy for the medium of wood engraving, as these contrasts of light against the dark dress are created by fine gouges into the woodblock.

Houghton's personal association with the Pre-Raphaelites was only slight, but his eye for detail, and the deliberate awkwardness of many of his compositions, shows their influence. His illustrations of children in particular create a

ABOVE

66 Arthur Boyd Houghton,
The Love of Christ,
wood engraving, engraved by
the Dalziel Brothers, 1867,
12.7 × 10.2 cm.
V&A: E.2543–1904.

ABOVE RIGHT

67 Arthur Boyd Houghton,
Noah's Ark,
wood engraving, proof on India
paper, engraved by the Dalziel
Brothers, 1865,
17.8 × 13.3 cm.
V&A: E.279B–1893.

sense of unease. *Noah's Ark* (plate 67) explores the private worlds of children and their unselfconscious bodies. The little boy with his head on the chair is not looking out at us, but inward, his foot hooked up on a rocking horse. The faces of his playmates are obscured as they concentrate on the row of Noah's animals. Houghton makes extraordinary demands on the viewer in this tiny image, with the wealth of observed detail. There is a similar visual intensity in his earlier illustration for *My Treasure* (plate 68). This print was first published in *Good Words* magazine in 1862 (p.504). Again there are toys strewn over the floor, and this clutter, together with the boldly patterned carpet and table-cloth, makes the scene claustrophobic. The sense of tension is increased by the oversized chair and the spreading skirt which cannot be contained within the picture. This apparently idyllic scene of mother and children is reimagined in a disturbing manner. The baby tugs at her hair, the toddler tries to attract her attention, and her weary expression suggests that she is almost overwhelmed by the demands of domesticity.

The disquiet represented in many of Houghton's images may not have been intended by the authors he was illustrating, but made his work compelling. As one critic wrote in 1896, he was 'a master of sympathetic attitude, whimsical and quaint at times', whose images contained a 'depth of tenderness and wise insight that convey charm not to be found in the stories themselves'.[10]

ABOVE
68 Arthur Boyd Houghton, *My Treasure*, wood engraving, proof on India paper, engraved by the Dalziel Brothers, 1862, 16.3 × 13.3 cm. V&A: E.2606–1904.

ABOVE RIGHT
69 Edward Burne-Jones, *Summer Snow*, wood engraving, proof on India paper, engraved by the Dalziel Brothers, 1863, 14.4 × 10.8 cm. V&A: E.2548–1904.

Houghton and Millais' accomplished manipulation of the potentially rigid medium of wood engraving is made clearer when we compare their illustrations with work by a less experienced artist like Burne-Jones. In later years, Burne-Jones became a masterful illustrator, collaborating with Morris on numerous books, but his early work, like *Summer Snow* (plate 69), shows how hard it could be to make costumes and poses flexible. Even with this contemporary subject, published in *Good Words* (1863, facing page 380), there is a medieval angularity to the woman's cramped body. By the mid-1860s, both he and Rossetti had given up modern life themes altogether. Burne-Jones was never able to sympathize with William Morris's vehement concern with social and political questions. Instead he tackled the great issues of love, loss and conflict through myth and poetry.

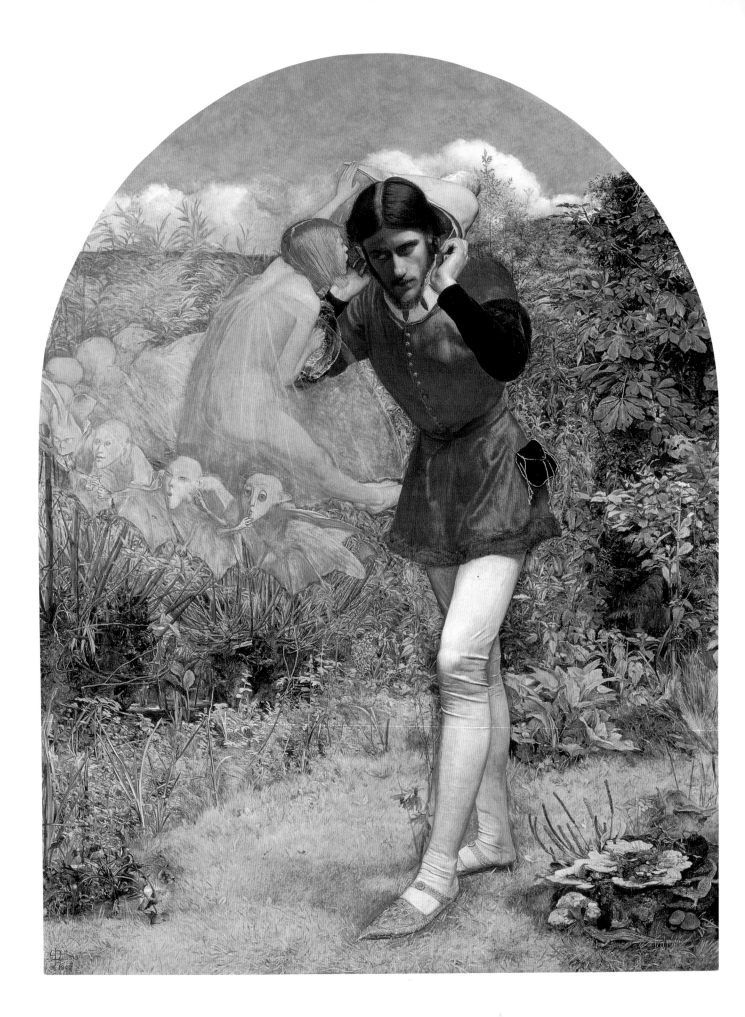

CHAPTER 6

Legends and Literature

LEFT

70 John Everett Millais,
Ferdinand lured by Ariel,
oil on panel, 1849–50.
Makins Collection / Bridgeman
Art Library.

BELOW

71 John Everett Millais,
Study for Ferdinand lured by
Ariel, pencil, 1849,
25.4 × 16.5 cm.
V&A: E.311–1952.

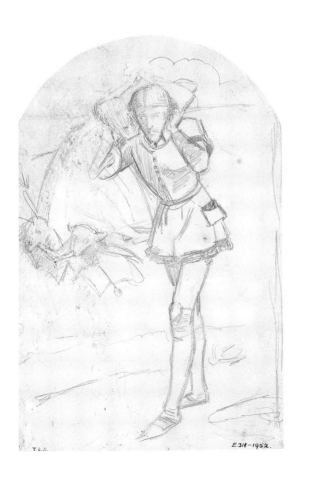

When Whistler complained that 'the vast majority of English folk cannot and will not consider a picture as a picture, apart from any story which it may be supposed to tell'[1], he was highlighting the intimate connection between word and image in Victorian Britain. Audiences expected paintings to refer to storylines beyond the picture's surface. Whistler wanted to undermine this convention by removing any external narrative from his works. They were to stand alone without a future or a past, to be enjoyed solely for their visual qualities.

Artists in the Pre-Raphaelite circle had a different strategy for negotiating the complex relationship between texts and pictures. They too were depressed by the simpering set-pieces drawn from popular novels shown at the Royal Academy each summer. But they did not reject literary sources; after all, both Rossetti and Morris were poets as well as artists. Instead they developed fresh ways to bring the sister arts together.

Their approach broke new ground in two ways. Firstly, they turned to writers who were unfamiliar to most nineteenth-century audiences, exploring authors like Keats, Dante and Malory, or illustrated poems composed by their friends. Secondly, once they had found these sources, they returned to them time and again. Reworking the same stories in different media, they produced multiple readings of these texts, which reveal how their preoccupations shifted during their careers.

Shakespeare

Of course they did not completely reject the traditional sources which inspired their contemporaries. Shakespeare still provided the young artists with many of their subjects, but their treatment was often unconventional. Take Millais' *Ferdinand lured by Ariel* (plate 70) from *The Tempest*, for example. A study in the museum (plate 71) demonstrates the Pre-Raphaelite angularity which overturned mid-Victorian ideals of beauty. Millais has interpreted Ariel's line 'On the bat's back do I fly' in a most literal manner, imagining nightmarish pixies with bat wings. These grotesque

creatures are not the only jarring note on Prospero's island. The figure of Ariel, normally shown as an alluring nude, was transformed into a mischievous imp. The dealer, William Wethered, was so disappointed that Ariel was not 'sylph-like' enough for his tastes, that he refused to buy it.[2] Millais' new reading of the text emphasized the disturbing elements in Shakespeare's descriptions, through the awkwardness of Ferdinand's pose and the bizarre creatures who lured him away from his companions. There is no hint of the romantic ending of Ferdinand's story in this work.

Mariana

After tackling *The Tempest*, in the following year Millais painted a subject from *Measure for Measure*. This time, Shakespeare's story was explored through the prism of Tennyson's poetry. When it was first exhibited at the Royal Academy, *Mariana* (plate 72) was accompanied by the verses:

She only said, 'My life is dreary,
He cometh not,' she said;
She said, 'I am aweary, aweary,
I would that I were dead.'

Mariana's five years of solitude in a moated grange became the focus of attention for Tennyson and the painters who followed him, as her plight enabled them to dwell on themes that had contemporary resonance, with the 'woman question' emerging in mid-Victorian debates. Here is a heroine who is confined within the domestic sphere; she is the victim of the marriage market; she yearns but cannot act upon her desires. All these elements are succinctly expressed in Millais' sketch (plate 73). Mariana is cut off from the world by a high wall which can be seen from her window. She has stabbed her needle into her embroidery in her frustration, but this tiny act of violence only emphasizes her impotency. A small purse hanging from her belt reminds us of the dowry that was lost in a shipwreck; it was this financial disaster that led to her exile. As she stretches her back, after hours of tedious needlework, we can admire the curves of her breast, waist and hips, the fall of her hair, her half-closed eyes. Although the girlish features of the drawing are transformed in the oil painting into the face of a more mature woman, in both versions Millais creates a 'strong sense of the physical and sensuous presence of the body'.[3] Millais sympathizes with her predicament, but also encourages us to enjoy looking at her constrained sexual energy.

In many respects, the clean lines of the drawing, unencumbered by the decorative details of the finished painting, have a more

RIGHT
72 John Everett Millais,
Mariana,
Tate Britain,
oil on panel, 1850–1.

BELOW
73 John Everett Millais,
Study for Mariana,
pen and wash, 1850,
21.4 × 14.5 cm.
V&A: E.354-1931.

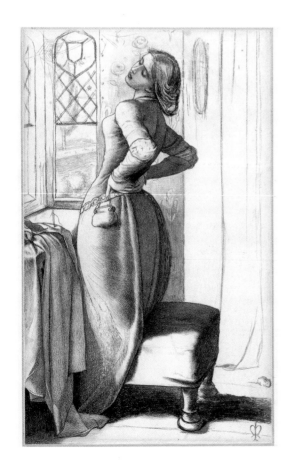

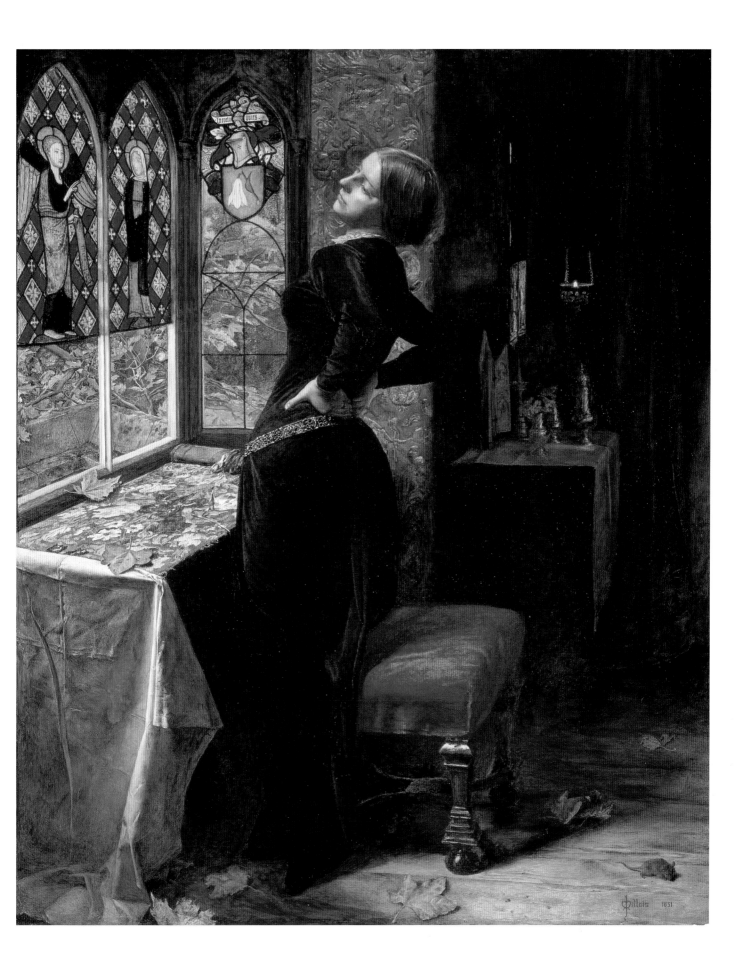

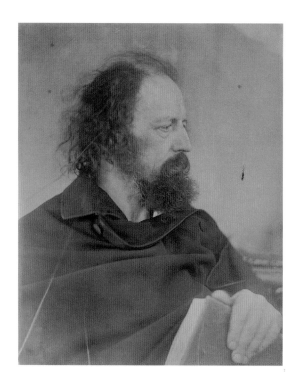

74 Julia Margaret Cameron,
Alfred Lord Tennyson, albumen print, 1865,
25.2 × 20.1 cm. V&A: PH.1143–1963.

75 John Everett Millais, *Mariana*,
wood engraving, proof on India paper, for *Poems by
Tennyson*, published by Moxon, 1857,
9.5 × 7.9 cm.
V&A: E.2347–1904.

direct emotional impact on the viewer. We are startled by the naturalism of Mariana's jutting elbows, silhouetted against the empty background. In the drawing, Millais makes us even more conscious of the uneasy angularity of her arms by splitting the sleeves of her dress, so that the underlying fabric pokes through. The effect is muted in the painting, as blue velvet sheaths her arms from shoulder to wrist and merges with the shadows behind her.

Millais returned to the subject of Mariana in 1857. His wood engraving (plate 75) again places Mariana by a window, but this time she is overcome by despair as dusk falls: 'I would that I were dead.' She is hemmed in by the criss-crossing lines of the panes, and by the sharp recession of the window seat and panelling. The carved faces above her head are oblivious to her grief. The contrast between the tautness of the earlier figure and this collapsed body is poignant. This engraving was just one of the illustrations to Tennyson's poems provided by the Pre-Raphaelite circle for an edition published by Moxon. Rossetti and Holman Hunt also submitted designs, and they too explored the theme of the confined woman, in *The Lady of Shalott*. Like Mariana, the Lady of Shalott is shut away from society, with only her needlework for company. She also desires a man beyond her reach, as she catches sight of Lancelot riding along the river.

The Lady of Shalott

The Lady's experience of the outside world is doubly distanced, as she sees only a reflection of the view from her window: 'I am half sick of shadows,' she says. However, rather than succumbing to her isolation like Mariana, she chooses to break out of her tower. She would rather suffer her curse than her confinement. She drifts down to Camelot in a small boat, singing 'Till her blood was frozen slowly' and her dead body becomes a spectacle for the townsfolk, and for Lancelot himself.

Both Rossetti and Hunt were keen to illustrate this poem. Rossetti was rather aggrieved that 'the best subjects had been taken by others' and wrote to Hunt, 'You for instance have appropriated the Lady of Shalott, which was the one I cared for most of all.'[4] They agreed to tackle different aspects of the story, and Hunt chose the act of transgression, when 'She left the web, she left the loom' to step across to the window and gaze out at Lancelot (plate 76). Tennyson was unnerved by the image. He apparently complained, 'My dear Hunt, I never said that the young woman's hair was flying all over the shop.' Hunt replied,

76 William Holman Hunt,
The Lady of Shalott,
wood engraving, proof on India paper, for
Poems by Tennyson,
published by Moxon, p.67, 1857,
9.2 × 7.9 cm.
V&A: E.30–1910.

'No, but you never said it wasn't'[5], and explained that he was trying to convey the Lady's own recognition of the catastrophe that she would suffer as a result of her rebellious act. Hunt manages to show that the moment when she grasps her freedom (signified by the whirling mass of loosened hair) is also the moment of doom. Her inevitable destruction is implied in the threads that spring from her weaving, unravelling her life's work. She is literally constrained by the materials of her feminine craft, as the yarn winds around her body. The circular low loom is completely impractical, as there would be no tension to weave on, but Hunt uses this shape to transform the 'web' described in Tennyson's verse into a spider's web, to trap the Lady. It is also a visual echo of the round mirror through which she saw the world.

The extraordinary energy of the moving threads and billowing hair; the magnificent figure of the Lady constrained by the borders of the image and yet fighting with bared arms to break free; these elements made a breathtaking image for admirers of Pre-Raphaelite art. They were excited by the sensuality of the Lady, who rebels against her enforced chastity, daring to gaze out at Lancelot. But they also saw in her an image of 'a Soul entrusted with an artistic gift'[6], struggling with the problem of representing the real world in art. Should the artist engage directly with life, or remain at one remove? This question was central to the emerging Aesthetic movement. By choosing to go out into the world, the Lady sacrificed her art, and became herself an object for the public gaze.

Rossetti's illustration shows her fate. His image of the Lady of Shalott in her

77 Dante Gabriel Rossetti,
The Lady of Shalott,
wood engraving, proof on India paper, for *The Poems of
Tennyson*, published by Moxon, 1857,
9.5 × 8.1 cm.
V&A: E.2922–1904.

78 Dante Gabriel Rossetti, *Detail of the Lady of Shalott*,
wood engraving, 1857,
3.5 × 3.5 cm.
V&A: E.3341–1910.

coffin-like boat (plate 77) fulfilled Edgar Allen Poe's belief that 'the death…of a beautiful woman is, unquestionably, the most poetical topic in the world'.[7] The 'knight and burger, lord and dame' press into the tiny picture space, crowding the wharf and holding up torches to see her more clearly. The importance of what Lancelot calls her 'lovely face' is demonstrated by the changes that Rossetti made to the proofs of this illustration. A detail in the Museum's collection (plate 78) shows that initially her head was completely in shadow, but Rossetti amended the design, casting light across part of her face. Like Lancelot, we are allowed to stare at her, now that her swan-song has died on her lips.

Rossetti's illustrations for Tennyson astonished his colleagues and had a far-reaching impact on a wider audience. Gleeson White suggests that the importance of his designs for this volume 'cannot be exaggerated' and are 'the golden milestone from where all later works need to be measured'.[8] The project as a whole helped to define the Pre-Raphaelite Brotherhood. This one volume presented radical interpretations of Tennyson's verse by the key figures in the group, creating the impression of a coherent movement at the very moment when the artists were going their separate ways. For younger men like Burne-Jones, the Moxon Tennyson was inspirational. He admired the delicacy of *St Agnes Eve* by Millais (plate 79): 'look at her little breath – the snow and everything', and told Rooke that '*The Lady of Shalott* is the very best of Holman Hunt.'[9] But it was Rossetti's images that came closest to his own vision. *The Death of Arthur* (plate 80) foreshadows Burne-Jones' own unfinished masterpiece, *The Sleep of Arthur in Avalon* (plate 81), on which he was still working forty years later. His watching queens are the granddaughters of Rossetti's keen-faced maidens. A study for the headdress of one of Burne-Jones' mourners (plate 82) is a reminiscence of the crowns and cascading hair in Rossetti's earlier illustration.

Le Morte d'Arthur

Burne-Jones did not discover the Arthurian legends through Tennyson's retelling. Long before the phenomenal success of *The Idylls of the King* (1859), and even before the Moxon edition, he had independently found the source of the legends. In 1855, Burne-Jones unearthed Malory's *Le Morte d'Arthur* in a Birmingham bookshop. Georgie described the impact of the fifteenth-century version of the story on her husband: 'it became literally a part of himself. It's strength and beauty, its mystical religion and noble chivalry of action, the world of lost history and romance in the names of people and places – it was his own birthright upon which he entered.'[10]

79 John Everett Millais,
St Agnes Eve,
wood engraving, proof on India paper,
for *The Poems of Tennyson*, published by
Moxon, 1857,
8.3 × 12.2 cm.
V&A: E.2346–1904.

80 Dante Gabriel Rossetti,
The Death of Arthur,
wood engraving, proof on India paper, for *The
Poems of Tennyson*, published by Moxon, 1857,
8.8 × 10 cm.
V&A: E.286.23–1893.

BELOW
81 Edward Burne-Jones, *The Sleep of Arthur in
Avalon*, Museo de Arte de Ponce, Puerto Rico,
oil on canvas, 1881–98, 282 × 645 cm.

82 Edward Burne-Jones,
Study for head of Queen from
The Sleep of Arthur in Avalon,
pencil, 1880s,
19 × 15.2 cm.
V&A: E.4044–1919.

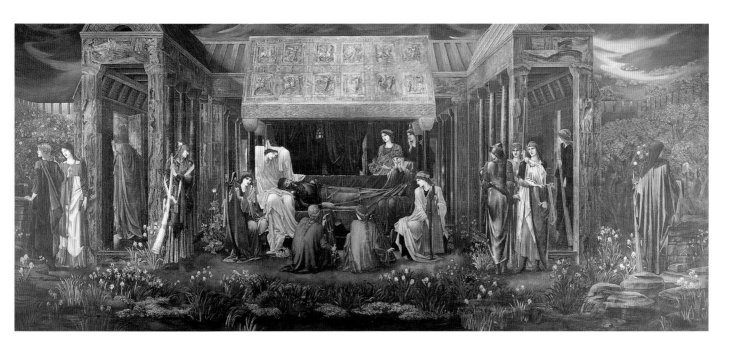

The Quest for the Holy Grail

Malory's central story of the quest for the Holy Grail allowed Burne-Jones yet again to imagine the overlapping of heavenly and earthly things, as Sir Galahad comes face to face with God in the form of the 'Sangreal'. This was the cup used by Christ at the Last Supper, which now holds the blood spilt at his Crucifixion. In 1885, Burne-Jones created a series of four stained-glass panels for his retreat at Rottingdean, showing the fate of the knights of the Round Table.

The stylized figures and limited colours demanded by the medium of stained glass are skilfully manipulated by Burne-Jones to enhance the drama of the tale. The red angel punctuates the series, offering tantalizing glimpses of the Grail. The quiet green backgrounds of the first panels contrast with the violent swirling blue sea and buckling bare earth endured by Lancelot. His white robe and prayerful pose demonstrate his sinless state, and he alone gazes wholeheartedly at the angel. These scenes are a visual echo of Malory's telling of the tales. The fifteenth-century text provides us with flashes of action and sudden apparitions, ideally translated into the vivid abstractions of Burne-Jones' stained-glass style. And the association of the medium both with the Middle Ages and with the Church is also appropriate, as the search for Christian virtue is at the heart of *Le Morte d'Arthur*.

how lancelot sought the sangreal and might not see it because his eyes were blinded by such love as dwelleth in kings' houses

how gawaine sought the sangreal and might not see it because his eyes were blinded by thoughts of the deeds of kings

PLATE 83 Edward Burne-Jones, *How Lancelot sought the Sangreal and might not see it because his eyes were blinded by such love as dwelleth in kings' houses*, stained-glass panel, made by Morris and Co., 46 × 33 cm, 1885–6. V&A: C.623–1920. The angel bearing the Holy Grail drifts out of Lancelot's sight as he is distracted by Queen Guenever. The sin of their adultery barred him from fulfilling his quest.

PLATE 84 Edward Burne-Jones, *How Gawaine sought the Sangreal and might not see it because his eyes were blinded by thoughts of the deeds of kings*, stained-glass panel, made by Morris and Co., 46 × 33cm, 1885–6. V&A: C.624–1920. The second scene echoes the composition of the first. It is Gawaine's pride, his soul 'eaten up by the world'[1], that prevents him from encountering God directly. He is lulled to sleep by a lady who sings to him of the deeds of great men.

PLATE 85 Edward Burne-Jones, *How Galahad sought the Sangreal and found it because his heart was single so he followed it to sarras the city of the spirit*, stained-glass panel, made by Morris and Co., 1885–6, 46 × 33 cm. V&A: C.625–1920. In the third panel, Galahad, Lancelot's son, is granted a vision of the Holy Grail and is led across the sea to its resting place. His ordeal in achieving the quest is symbolized by the stony wilderness and raging seas that he must cross, while the other knights languish among meadows and small streams. He is so close to his goal now that the rushing water in his panel spills over to the next, where the chapel of the Sangreal is ready to receive him.

PLATE 86 Edward Burne-Jones, *How the Sangreal abideth in a far country which is sarras the city of the spirit*, stained-glass panel, made by Morris and Co., 1885–6, 46 × 33 cm. V&A: C.626–1920. At the end of the quest, the cup containing Christ's blood is guarded by angels under a Romanesque canopy.

81

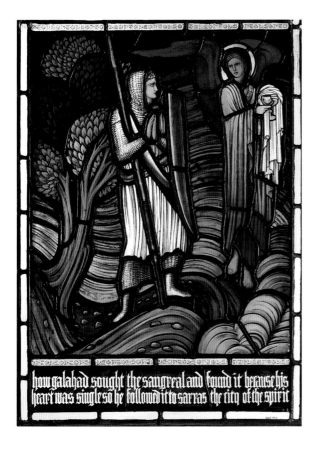

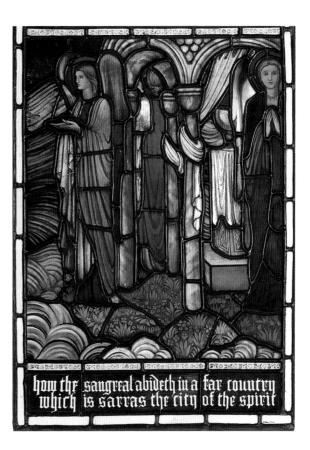

87 Julia Margaret Cameron,
Merlin and Vivien,
albumen print, 1875,
32.6 × 26.2 cm.
V&A: Ph.85–1970.

RIGHT
88 Edward Burne-Jones,
Merlin and Nimue,
watercolour and body-colour,
1861,
64.1 × 52.1 cm.
V&A: 275–1896.

Burne-Jones became so attached to the medieval form of the tales that he upbraided Tennyson for changing the character of Nimue in his *Idylls*, and persuaded the poet to call her Vivien instead.[11] This passion for the original texts was unusual among his artistic contemporaries. Julia Margaret Cameron, for example, preferred to illustrate Tennyson's version, photographing both the poet and the *Idylls* of his imagination. She told him that 'I know that it is immortality to me to be bound up with you.'[12]

We can see the difference between their approaches when we compare treatments of the same subject by the two artists. Julia Margaret Cameron's *Merlin and Vivien* (plate 87) presents a direct confrontation between the Lady of the Lake and the aged sorcerer, unrelieved by background details. There is no sense of Merlin's desire, only Vivien's vengeful power. Burne-Jones' pictures of the same subject are very different. He creates a melancholy meditation on the vulnerability of love, and demonstrates his tendency to internalize the written sources so that they become woven into his personal history. His intense relationship with Malory's text meant that he often produced alternative visions based on his favourite themes, and the story of Merlin and Nimue came high on the list. He could not resist the story of a beautiful but deadly woman who tricks the besotted magician into revealing the secrets of his power. She turns his magic against him, imprisoning him under the ground. Burne-Jones first attempted this subject in 1857 for the ill-fated murals in the Oxford Union debating chamber. In 1861 he tried again, creating a watercolour of *Merlin and Nimue* (plate 88). The connection with the written source is made explicit by a quotation from Book IV of *Le Morte d'Arthur* inscribed on the frame: 'so by her subtle craft and working she made Merlin to go under that stone'.

This version of *Merlin and Nimue* was later described as 'the most beautiful and the most characteristic of all [his] watercolours, and almost the finest piece of colour in the world'.[13] It is a sumptuous example of his 1860s Venetian style, with a ruddy palette and heavy drapery. The muted tones and soft details of the landscape contribute to the mystery. This is a wilderness of 'gloomy purple hills and evening shadows'.[14] In the foreground we see a heavy slab hovering over the entrance to a dungeon. Merlin is entranced by his desire, and moves towards his fate, heedless of his dog who tries to pull him away. Nimue, modelled by the sensuous Fanny Cornforth, has taken control of his book of magic. Merlin seems to dwindle before our eyes, as Nimue casts a sly glance at him, secure in the knowledge that she now has the upper hand. This image of the

89 Designed by Edward Burne-Jones,
Morgan le Fay,
worked by Georgiana Burne-Jones,
watercolour, velvet ground, embroidered
with wools and couched gold thread, 1863,
c.106 × 50 cm irregular.
V&A: T.119-1985.

enchanted magician came back to haunt Burne-Jones in the early 1870s when he was under the erotic thrall of Maria Zambaco, and he transformed the small-scale image of 1861 into a nearly life-size canvas. In *The Beguiling of Merlin* (Lady Lever Art Gallery, oil on canvas, 1873–4, 186 x 111 cm), Nimue is modelled on Maria, and the artist saw himself in the figure of Merlin: 'I was being turned into a hawthorn bush in the forest of Broceliande.'[15]

Arthurian stories of doomed passion were reworked by Burne-Jones to make them suitable for his domestic sphere. He designed large embroideries to hang around the walls of his first home, at 62 Great Russell Street, which were worked by his wife Georgie. He drew the figures of King Arthur, Morgan le Fay, Lancelot and Merlin (plate 89) directly onto the fabric. Unfortunately, Georgie was not such an accomplished needlewoman as her friend Jane Morris, and the scheme was never completed. However, it shows how Burne-Jones wanted to surround himself with these characters, and re-create them in the appropriately medieval medium of wall-hangings.

Chaucer

Malory had only one rival for Burne-Jones' affections, and that was Chaucer. Burne-Jones said of the magnificent illustrated *Kelmscott Chaucer*, 'When Morris and I were little chaps in Oxford, if such a book had come out then we should have just gone off our heads, but we have made at the end of our days the very thing we would have made then if we could.'[16] This collaboration with Morris, published in 1896, just months before his friend died, was the culmination of decades of reflection, and several years of regular work, when the couple met each Sunday to design the borders and illustrations. Burne-Jones always associated Morris with Chaucer; he felt they both had the same simplicity and directness of character, which contrasted with his own. In their discussions on the progress of the project, Burne Jones would say, 'I like a thing perfect and he says he likes a thing done'[17], but together they produced something equal to a pocket cathedral.[18]

The South Kensington Museum immediately recognized the value of this illustrated volume, and bought a copy directly from the Kelmscott Press for £16 3s (plate 90). The museum also purchased a number of designs from Sydney Cockerell, who was Secretary of the Press, including a proof of one of Burne-Jones' pictures, surrounded by Morris's hand-drawn border (plate 91). Such designs demonstrate the curious mixture of hand-work and modern technology that produced this book. Firstly, there is the pleasurable organic growth of Morris's flowers and leaves, which 'were stroked into place, as it were, with a sensation like that of smoothing a cat'[19] as he worked alternately with black and white inks. Then there is the use of photography to transfer Burne-Jones' drawings onto the woodblock. Robert Catterson-Smith explained how he tried to 'get rid of everything but the essential lines'[20], covering a photograph of the drawing with a light wash of white ink, and then going over it in pencil and

90 *The Works of Geoffrey Chaucer*,
title page, designed by William Morris,
illustrated by Edward Burne-Jones,
paper, Kelmscott Press, issued 26 June
1896,
42.5 × 29.2 cm leaf.
V&A: L.757–1896.

91 *The robing of Griselda: illustration for
the Tale of the Clerk of Oxenford*,
border by William Morris, Indian ink and
Chinese white, proof after Edward
Burne-Jones,
wood engraving, 1896,
22.2 × 27.7 cm.
V&A: D.1554–1907.

black ink. There are parallels here with the use of photography to assist the equally ancient crafts of stained-glass and tapestry production by the firm.

Although the finished volume was a harmonious interplay between the decorative borders and initials provided by Morris, and the images created by Burne-Jones, they did not always have the same attitude to Chaucer's text. Morris enjoyed the bawdiness of the *Canterbury Tales*, and urged Burne-Jones that he should 'by no means exclude these stories from [their] scheme of adornment'. According to Burne-Jones, 'he had hopes of my treatment of the Miller's Tale, but he ever had more robust and daring parts than I could assume'[21], and in the margin of one of his working drawings, now in the Fitzwilliam Museum, he clearly wrote 'no picture to Miller / no picture to Reeve / no picture to Cook's tale'. Instead, Burne-Jones preferred the tales of courtly love or female virtue, like the story of Griselda told by the Clerk of Oxenford. This tale had six illustrations, compared to three for the racy Wife of Bath's tale. As a result, there were some criticisms that 'he did not catch the lustiness of Chaucer – the infectious brightness'[22], but overall it was a resounding success, and the book rapidly sold out.

92 William Morris,
Helen (Flamma Troia),
pencil and watercolour, c.1860,
124.7 × 62.4 cm.
V&A: E.571–1940.

94 Edward Burne-Jones,
Chaucer Asleep,
manufactured by Morris, Marshall,
Faulkner and Co., stained glass, 1864,
46.2 × 47.2 cm.
V&A: 774–1864.

95 Edward Burne-Jones,
Amor and Alcestis,
manufactured by Morris, Marshall,
Faulkner and Co., stained glass, 1864,
46.2 × 49.5 cm.
V&A: 776–1864.

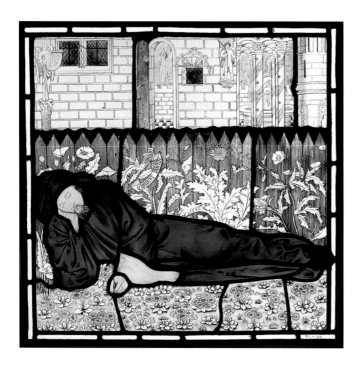

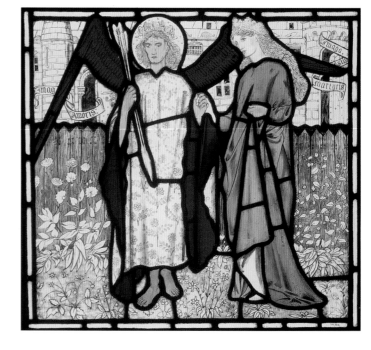

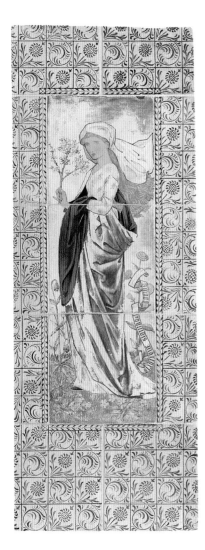

93 Figure by Edward Burne-Jones, scroll border by William Morris, *Imago Phyllidis Martyris, with Scroll border*, manufactured by Morris, Marshall, Faulkner & Co., panel of tiles, hand-painted in various colours on tin-glazed earthenware Dutch blanks, designed 1864 and (border) c.1870,
77.2 × 30.2 cm.
V&A: Circ.530–1962.

This project was a fitting end to a shared love of Chaucer that dated back to Morris and Burne-Jones' days at Oxford. As early as 1860, they had worked together on an embroidery scheme based on the *Legends of Goode Wimmen*. Morris's study of *Helen (Flamma Troia)* (plate 92) was one of the figures to be worked by Bessie Burden, Jane Morris's sister, as hangings for their Red House drawing room. They were conceived in the same spirit as the Arthurian embroideries designed by Burne-Jones, making use of the talents of young wives and friends, and as a way of exploring well-loved stories together. Here the focus is on great women from all periods of history, and their tales of love and loss. The artists took Chaucer's *Goode Wimmen* as a starting point, but then elaborated it, adding their own favourites, including Iseult, St Catherine and of course Guenever.

These figures then reappeared in various other projects. In 1863, there was a plan for the girls of Winnington Hall School to embroider another set of wall-hangings for John Ruskin – they were to be so beautiful that they would stop Ruskin from moving to Switzerland permanently. Then the *Goode Wimmen* were redesigned as decoration for tiles. Some were used for a fireplace surround at Sandroyd, a house built at Cobham, Surrey, by Philip Webb. These included *Philomela*, painted onto earthenware blanks imported from Holland (V&A: C.55–1931) and *Phyllis* (plate 93). By this stage, Burne-Jones perhaps felt that the designs were becoming a little jaded, as in his 1869 workbook he wrote, 'To touching up some Good Women and I would rather have been boiled ten times over £1.1.0.'[23]

After all, in 1864 the *Goode Wimmen* had also appeared as stained-glass windows to decorate Miles Birket Foster's house at Witley, Surrey. Pairs of heroines, Cleopatra and Dido, Thisbe and Philomela, Hypsipile and Medea, Ariadne and Lucretia, Phyllis and Hypermnestra, process across the panels. This version of the legend was so successful that three duplicate panels were acquired by the South Kensington Museum direct from the 'Exhibition of Stained Glass, Mosaic, etc.' held there in 1864. The first of these panels shows *Chaucer Asleep* (plate 94). In his dream, he sees the women pass by, telling their tales, led by the winged figure of Amor. Like the tile portrait of *Geoffrey Chaucer* (V&A: C.61–1979), made around the same time, Rossetti seems to have been the model for the poet.

In the second stained-glass panel (plate 95), the stern figure of Love presents Alcestis, as a symbol of faithfulness, to Chaucer. Burne-Jones creates the effect of a dream through his use of colour. The real world of an enclosed garden in a medieval town is painted in sepia, while Chaucer's dreamworld emerges in bold red, green and gold. This makes a reverie of the ancient past more vivid than the present. This does not mean that Burne-Jones ignores the medieval location of Chaucer's vision; far from it, as he lavishes attention on the intricate courtyards, turrets and statues of the town, and the meadow sprinkled with a variety of flowers. However, it does allow him to represent two different truths within

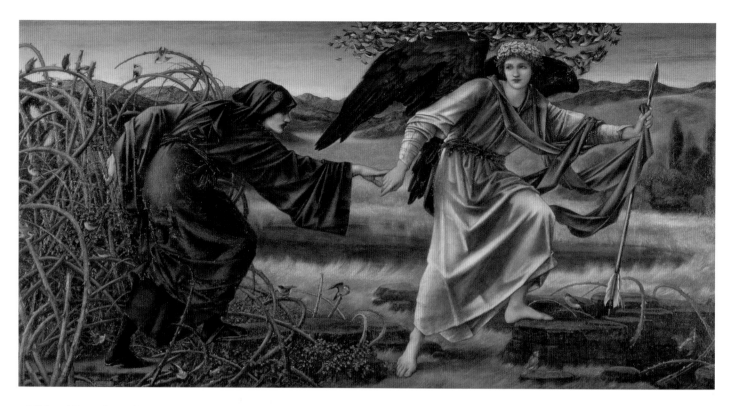

96 Edward Burne-Jones, *Love Leading the Pilgrim*, Tate Britain, oil on canvas, 1877–97, 157 × 304 cm.

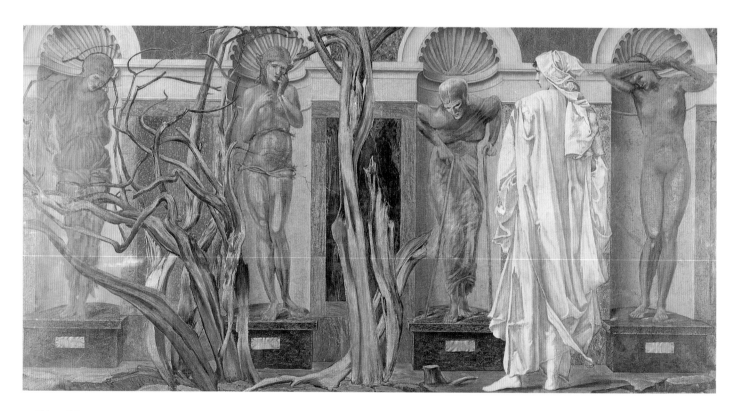

97 Edward Burne-Jones, *The Pilgrim Outside the Garden of Idleness*, unfinished, oil on canvas, c.1893–8, 155.9 × 306.7 cm. V&A: P.109–1920.

one image, both Chaucer's historical space (which is in itself Burne-Jones' own fantasy), and the procession of heroines emerging from the classical world into Chaucer's imagination.

The distinctive figure of Amor reappears in another of Chaucer's works which inspired Burne-Jones. *The Romaunt of the Rose*, like the Arthurian legends, describes a quest, but in this case the Pilgrim is seeking ideal love at the heart of the Rose. It also bears a striking resemblance to the story of *Sleeping Beauty*, which was another of Burne-Jones' favourites.[24] As with the Arthurian legends and the *Goode Wimmen*, Burne-Jones' first designs from this source were for embroidered wall-hangings. In 1874, Morris and Co. were commissioned to decorate the dining room of Rounton Grange, Northallerton, owned by the industrialist Lowthian Bell. Burne-Jones devised a frieze that was embroidered by Bell's wife Margaret and daughter Florence over the next eight years. (The embroideries are now in the William Morris Gallery, Walthamstow.) This project led on to a number of oil paintings, including *Love Leading the Pilgrim* (plate 96) and *The Pilgrim Outside the Garden of Idleness* (plate 97). The subjects occupied Burne-Jones from the mid-1870s until his death, and several of the canvases were left unfinished. Figure studies for *Love Leading the Pilgrim* show the intensity of his preparation for these works. His sketchbooks contain both nude and draped models (plates 98 and 99), as Burne-Jones explored the forward movement of the Pilgrim, and the cloak caught up in a tangle of thorns. As the composition is reduced to its essentials, with only the thornbush, Pilgrim and Love filling the canvas, the drapery takes on extra significance. Its heaviness, jagged folds and entanglement represent the struggle of the Pilgrim as he searches for the heart of the Rose.

The same distinctive drapery appears in the unfinished painting of *The Pilgrim Outside the Garden of Idleness*, suggesting that the two paintings were being worked on simultaneously. They are also linked by the bleached-out colours and the desolate environment depicted in both pictures, creating a melancholy mood. The disturbing presence of tangled thorns in one image, and twisted dead tree-trunks in the other, adds to this effect. The Pilgrim has stopped outside the walled Garden of Idleness, and is contemplating the allegories of Vices which he finds there. Of the ten figures shown in the Rounton Grange frieze, Burne-Jones has chosen only four for this painting: Avarice, Envye, Elde and Sorowe. He found it hard to interpret the poet's description of these figures, complaining, 'I wish Chaucer would once for all make up his

98 Edward Burne-Jones,
Nude study of the Pilgrim, brown chalk, after 1877,
26.2 × 29.2 cm.
V&A: E.1613–1926, pp.7v & 8r.

99 Edward Burne-Jones,
Draped study of the Pilgrim, red chalk, after 1877,
26.2 × 29.2 cm.
V&A: E.1613–1926, pp.9v & 10r.

The Legend of St George

William Morris, Edward Burne-Jones and Rossetti all tackled the story of St George at some point in their careers. Burne-Jones created a sequence of oil paintings, and Rossetti produced some jewel-like watercolours and stained glass, but it was Morris who decided to use the doors of a sideboard as the support for his images.

PLATE 100 *St George cabinet*, designed by Philip Webb, painted by William Morris, made by Morris, Marshall, Faulkner & Co., mahogany, oak and pine, painted and gilded, with copper handles, 1862, 95.9 × 177.7 × 43.2 cm. V&A: 341–1906. This sideboard was shown on the firm's stand at the 1862 International Exhibition. The story is told in five scenes of differing sizes, which gives the narrative a rather jerky feel. Contemporary critics complained about the apparently arbitrary relationship between the pictures and the structure of the cabinet. Morris seems to have been more concerned about the medieval detailing in the paintings than the overall effect of his decoration.

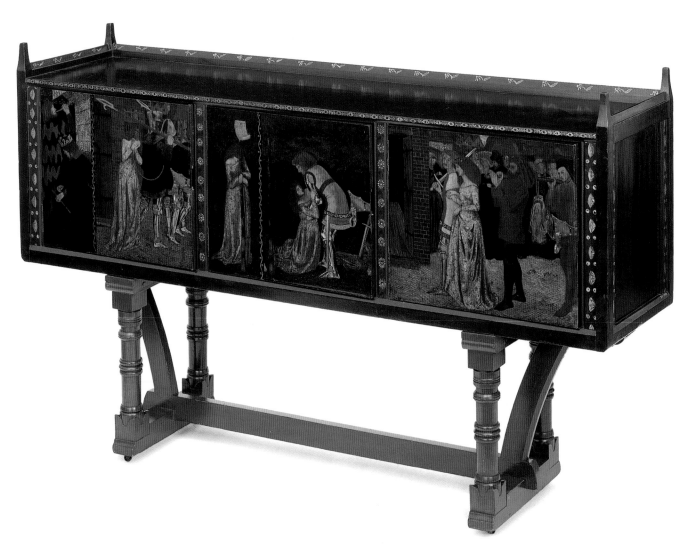

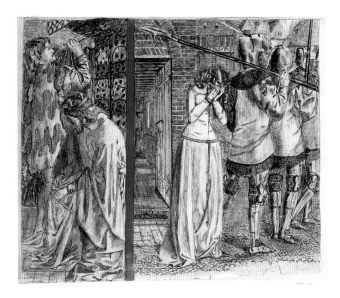

PLATE 101 William Morris, *The King's despair* and *The Princess Sabra led away*, pencil, pen and ink, and brush and ink on paper, 1861, 44.2 × 51 cm. V&A: E.2787–1927. Morris's sketch of the first two scenes shows that his attention was focused on the textile patterns, suits of armour and architectural setting, instead of the modelling of the figures or the interaction between the two compositions.

BELOW LEFT

PLATE 102 Dante Gabriel Rossetti, *How the good knight St George of England slew the dragon and set the Princess free*, stained and painted glass, manufactured by Morris, Marshall, Faulkner and Co., c.1862, 56.5 × 65.4 cm. V&A: C.319–1927. Rossetti's treatment of the battle is also more effective than Morris's. On the cabinet, we only see the aftermath, with an unconvincing dead dragon in the background, but Rossetti gives a sense of the struggle. St George is crushed by the dragon's tail as he delivers the death-blow. The semi-naked figure of the Princess also adds a frisson that cannot be matched by Morris's swooning model.

BELOW RIGHT

PLATE 103 Dante Gabriel Rossetti, *How word came to the king of Egypt touching a certain dragon*, stained and painted glass, manufactured by Morris, Marshall, Faulkner and Co., c.1862, 83 × 59 cm. V&A: C.316–1927. Rossetti's designs for a series of stained-glass windows have a drama and coherence that is lacking in Morris's version. The first scene manages to be both gruesome and humorous, with a basket of skulls in the foreground, and a monk pointing to an artist's impression of the dragon.

91

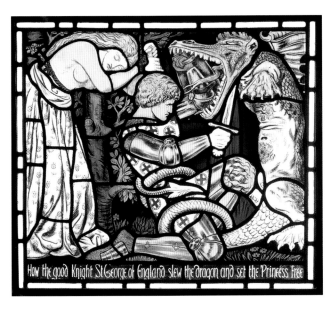

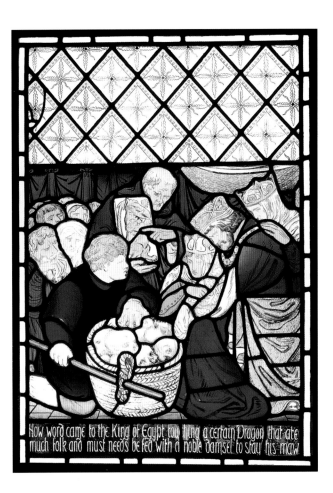

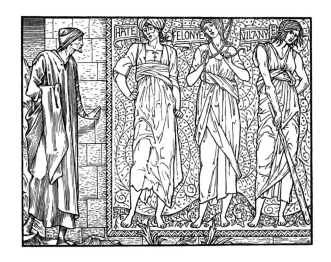

104 Edward Burne-Jones,
*Proof of illustration for Kelmscott
Chaucer – The Pilgrim outside
the Garden of Idleness,*
Kelmscott Press, 1896,
Sight 13.5 × 17.8 cm.
V&A: E.623–1923.

unrivalled and precious mind whether he is talking of a picture or a statue.'[25] In the *Kelmscott Chaucer* illustration (plate 104), he decided to represent them as murals or mosaics, while in the painting they are clearly statues in niches.

In his choice of subject, the artist seems to have focused deliberately on these disquieting allegories rather than the more upbeat elements of the original text: Chaucer describes the Pilgrim approaching the walled garden through 'a medewe softe, swote and grene'.[26] Perhaps this is part of Burne-Jones' attempt to depict the Pilgrim's dream-state, through muted colours and uneasy encounters.

Of course, one of the reasons that the image unnerves the viewer is that it was never finished. The verdigris on the statues and violent outline of the tree-trunks have not been softened by the top layers of paint. In fact, it is likely that Burne-Jones hardly worked on this canvas at all. Most of the painting was carried out by his studio assistants. Philip, Burne-Jones' son, was reported to have revealed that 'the preliminary painting of the canvas was done by assistants, and…much had been left awaiting his father's finishing touches'.[27] It seems that the only areas of paint applied by the named artist were 'the trees and part of the marble', 'the bolder touches on the bronze figures' and probably 'the face of the figure in white'. This assessment was confirmed by Thomas Rooke when he inspected the picture on 24 November 1921. He suggested that Matthew Webb had laid out the subject on the canvas and may have painted the Pilgrim himself. Looking at this painting causes us to reconsider the relationship between Burne-Jones and his works, especially when dealing with the large-scale pictures of his later years. All the biographies and contemporary criticism of this artist give the impression of otherworldliness; even, in Thomas Rooke's words, of a 'Demi-God or kind of Divine Creature'.[28] But this is not the whole story. Here is a successful artist, running a studio that can support a couple of experienced assistants, with a considerable commercial output of stained-glass designs. Although Burne-Jones complained that it was hard to find buyers for his more ambitious works, and looked on 'the big pictures as a sacrifice', he was certainly able to 'live by the little ones'.[29]

Perhaps we should not be surprised by this collaboration between Burne-Jones and his assistants. After all, it follows the historical precedent of Renaissance workshops, when a master painter had a number of apprentices who prepared materials, transferred designs and painted less important areas like backgrounds or drapery. And it was normal practice in his work with Morris & Co. for Burne-Jones to produce a pattern that would then be worked up by other craftsmen or women. So maybe this is yet another indication that Burne-Jones did not distinguish between his fine and decorative art production. Whether he was designing for tapestry, book illustration or oil painting, the key element was his initial imaginative input. He created the composition, having

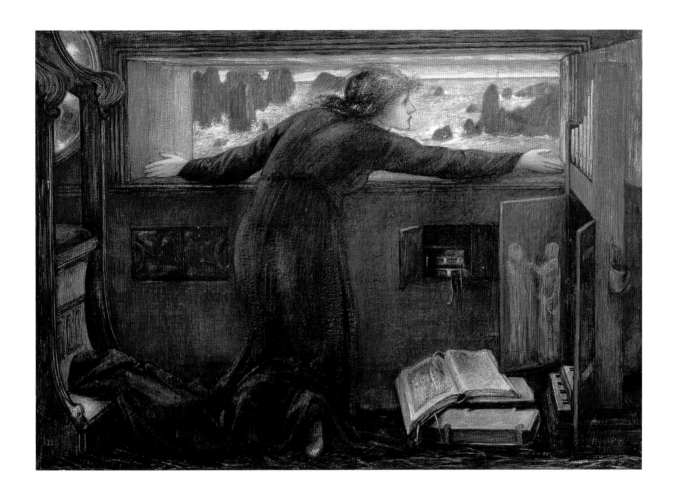

105 Edward Burne-Jones,
*Dorigen of Bretaigne longing for
the safe return of her husband*,
gouache, 1871,
26.7 × 37.4 cm.
V&A: CAI 10.

mulled over a subject, and studied the decorative details that made up his dis-
tinctive 'borderland between the world of work and the world of dreams'.[30]
Then he was often prepared to hand over his ideas for the next stage of the
project.

As a result, if we want to find the most personal readings of Burne-Jones'
favourite texts, without the intervention of other hands, we have to look at his
sketches and small watercolours. Some, like his picture of *The Prioress's Tale*
(Delaware Art Museum, Wilmington, c.1865–98), were subjects that he dwelt
on for many years, and which reappeared in several media. Others, like the
V&A's *Dorigen of Bretaigne longing for the safe return of her husband* (plate 105),
stand alone. Her story is told by the Franklin: 'she moorneth, waketh, wayleth,
fasteth, pleyneth'[31], fearing that her husband will be wrecked on the rocks at the
harbour's mouth. The reunion she desires is foreshadowed in the ghostly figures
that decorate her portative organ. The inclusion of this instrument has two
functions. On one level, it demonstrates that Dorigen is neglecting her domestic
skills, including music-making. However, it also underlines her loneliness. Like
the organ in Burne-Jones' *Le Chant d'Amour* (plate 200), this can only be
played when the bellows are pumped by someone else, so it is useless without a
companion to help and enjoy the music. The books and convex mirror seem to
refer to another part of the story, when Aurelius, the squire who is in love with

106 Dante Gabriel Rossetti,
The Rose Garden: frontispiece for Early Italian Poets,
etching, 1861,
14 × 10.5 cm.
V&A: E.434–1919.

RIGHT
107 Dante Gabriel Rossetti,
Regina Cordium,
Johannesburg Art Gallery,
oil on panel, 1860.

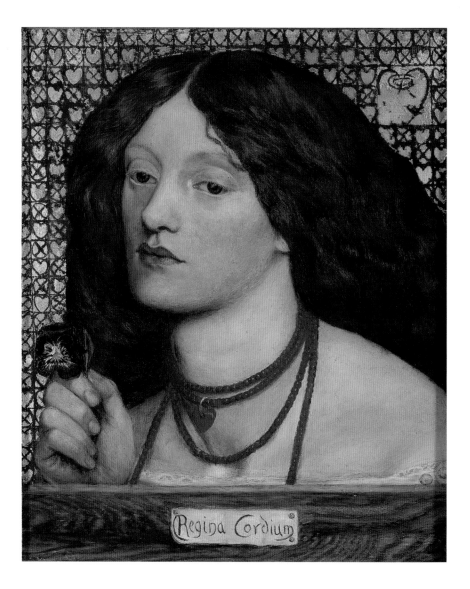

Dorigen, acquires magical powers in an attempt to hide the ominous rocks.

The subject of a yearning woman gazing out of a window has parallels with the earlier Pre-Raphaelite treatments of Mariana and the Lady of Shalott, but the style suggests a different comparison. The claustrophobic atmosphere of *Dorigen*, combined with the elaborate medieval detailing, the naïve handling of the figure and of course its medium, points to a resemblance with watercolours made by Rossetti in the 1850s. However, while Burne-Jones pondered Malory or Chaucer, Rossetti was captivated by Dante.

Dante

Rossetti identified personally with the poet, and Lizzie Siddal became his Beatrice. His passion for Dante was initially encouraged by his father, a renowned Italian scholar, but it became so central to his self-image that by late 1848 he transposed his Christian names, signing himself 'Dante Gabriel'. He set about translating the work of Dante and his contemporaries, and, in 1861, published these verses in *Early Italian Poets*. For Rossetti, his careers as artist

and poet were interwoven, so it was only natural that he should design a frontispiece for the volume. In the end it was never used, but a handful of copies of the print were preserved. *The Rose Garden* (plate 106) does not illustrate a particular poem, but the juxtaposition of chivalry and sensuality reflects the tone of many of the verses. Lizzie Siddal seems to have been the model, as an idealized bust-length portrait of her painted in 1860, *Regina Cordium* (plate 107), bears certain resemblances to this print. In both images, Rossetti concentrates on the fall of her hair around her face, and her drooping eyelids. He also uses the same pattern of hearts and crosses, or kisses, to create a lattice, abruptly cutting off the background. In the frontispiece, this device echoes the rose trellis which places the lovers in a garden, but there is no attempt at naturalism. The rows of tiny flowers beneath their feet are as purely decorative as the embroidery on their robes.

The historical moment at which Dante was working, on the threshold of the Renaissance, seems to have held a particular fascination for Rossetti and his friends, and they tried to recapture it in their work. This little etching, for example, combines both the medieval ideal of courtly love, represented by the kneeling knight, and a delight in the body, which was a feature of the Renaissance.

Rossetti's circle found a visual equivalent for Dante's poetry in the art of Botticelli. After all, Botticelli illustrated Dante's *Divine Comedy,* and we know that Burne-Jones was aware of the connection as he copied some of these illustrations into his own sketchbooks (plate 108). Rossetti demonstrated his affection for Botticelli's work by buying his portrait of *Smeralda Bandinelli* in 1867 (plate 109). The reverberations of this composition, which Rossetti kept until 1880, can be seen in many of his paintings, where beautiful women in tall, narrow spaces look out at us over a parapet.[32] His taste for Botticelli's art was as groundbreaking as his love of Dante's poetry; both were unfamiliar to mid-Victorian audiences. The first article in English on Botticelli, written by Walter

108 Edward Burne-Jones after Botticelli,
Tormented souls from Inferno,
pencil, after 1867,
11.4 × 18.7 cm.
V&A: E.10–1955, p.79.

109 Sandro Botticelli,
Smeralda Bandinelli,
tempera on panel, c.1471,
65.7 × 41 cm.
V&A: CAI 100.

Pater, was not published until 1870. When critics did refer to his work, they tended to be wary of his mannered style, which seemed to encourage the androgyny of late Pre-Raphaelitism.[33]

The interplay between Dante and Botticelli was still being explored by Burne-Jones when he designed an embroidery panel for Frances Horner, inspired by the last words of the *Divine Comedy*: '*L'Amor che muove il sole e l'altre stelle*' (The love that moves the sun and the other stars).[34] The cartoon for this embroidery, given to the V&A by Lady Horner's niece (plate 110), shows yet another figure of winged Love, attended by children who shelter under his feathers. Several aspects of this design seem to refer back to Botticelli's *Coronation of the Virgin (San Marco Altarpiece)* (plate 111) that Burne-Jones had studied. He copied some of the dancing angels into one of his sketchbooks (plate 112), and details of their expressions and the fall of their drapery appear to have resurfaced in this watercolour. Even the discrepancy in scale between the figure of Love and his attendants is reminiscent of Botticelli's composition. However, Burne-Jones never forgot that this was a needlework design rather than an easel painting. The wavy lines representing the sea, the stylized rose bushes, even the pleats in the drapery, are clearly intended to be reproduced by stitches. The bold colour contrast between the background and Love's wings is ornamental rather than naturalistic. By tackling this subject through the decorative arts, Burne-Jones wisely avoided attempting any literal interpretation of Dante's description of the Godhead.

Other painters, however, were keen to create more direct translations of Dante's world into images.

Following the publication of Rossetti's version of Dante's autobiographical *La Vita Nuova*, several of his associates were inspired to represent Dante's love affair with Beatrice. Henry Holiday (1839–1927), for example, travelled to Florence in order to research Dante's world. Holiday was a friend of Burne-Jones, frequently visiting his studio, and taking over his role as stained-glass designer for Powell and Sons. He certainly shared the Pre-Raphaelites' interest in Dante. One of his earliest paintings, made in 1860, showed the poet meeting Beatrice for the first time when they were children. Holiday's most famous work, *Dante and Beatrice* (Walker Art Gallery, Merseyside, oil on canvas, 1883),

TOP
111 Sandro Botticelli,
The Coronation of the Virgin (San Marco Altarpiece),
tempera on panel, c.1480
Galleria degli Uffizi / Bridgeman Art Library

CENTRE
112 Edward Burne-Jones,
Angels after Botticelli,
pencil, sketchbook, after 1863,
18.7 × 26.3 cm.
V&A E.4–1955, p.29.

LEFT
110 Edward Burne-Jones,
Love,
watercolour and body colour, c.1880,
211 × 107 cm.
V&A: E.838–1937.

113 Henry Holiday,
Study for Dante and Beatrice,
pencil and pen and ink, 1881,
22.8 × 26.5 cm.
V&A: E.1376–1927.

115 Edward Burne-Jones,
Study of Knight from Briar Rose,
pencil, 1874–90,
27.9 × 15.9 cm.
V&A: E.442–1943, p.19.

represents their later meeting, when Beatrice refused to greet Dante, having heard gossip about his flirtations with other women. A sketch in the V&A's collection demonstrates the development of this composition (plate 113). At this early stage, Beatrice has three companions. She gazes steadfastly ahead, while her friend Monna Vanna looks boldly at Dante. Holiday decided to remove one of the girls behind Beatrice for the finished painting. This concentrates the viewer's attention on the contrasting expressions of Beatrice and Monna Vanna. He also simplified the costume of the third girl, so that Beatrice's modest appearance, signified by her white dress, stands out more clearly against the coquettish red of Monna Vanna's robe, and the deep blue of the maidservant behind.

The most important differences between the sketch and the finished painting are in the background. Holiday seems to have completely changed the setting of this scene. Perhaps this explains the incomplete architectural details on the left of the sketch. He shifted the action along the River Arno to the Ponte Sta. Trinita, in order to include the Ponte Vecchio in the distance. We know that in 1881 he visited Florence in order to 'collect such fragments as remain of buildings of Dante's time'[35], and he must have decided at this point to transplant his figures, perhaps to present a more recognizably Florentine scene. Although the background of the sketch contains bell towers, a river embankment and houses with jutting balconies which might be associated with Florence, these elements are also found in the purely imaginary townscapes of Burne-Jones' work. They are reminiscent of the buildings in the background of Burne-Jones' *The Mill* (plate 199), for example. By changing the setting, Holiday broke away from the evocative fantasy of his friend's paintings, and placed his art into a real historical context.

Fairy tales

Burne-Jones, on the other hand, deliberately created ambiguity in his pictures, and often sought out subjects that allowed him to blur the boundaries between different times and places. This was why he found fairy tales so attractive: there is no correct way to tell these stories, they have no concrete historical setting. However, Burne-Jones' fascination with the tale of *Sleeping Beauty* suggests that his attraction to this particular legend was more complex. We know that he created designs for *Beauty and the Beast* (William Morris Gallery, Walthamstow) and *Cinderella* (National Museums and Galleries on Merseyside), but it was *Sleeping Beauty* which haunted him. All three tales were translated into tile panels designed as overmantels for Miles Birket Foster's house, but even here *Sleeping Beauty* dominated his imagination (plate 114). This panel contains nine vignettes, compared to six scenes each for the other two panels.

In this early version, Burne-Jones tells the whole story of *Sleeping Beauty,*

Of a certain Prince who delivered a King's Daughter from a sleep of a hundred years, wherein she & all hers had been cast by enchantment

114 *Sleeping Beauty with swan border*, designed by Edward Burne-Jones and William Morris, possibly painted by Lucy Faulkner for Morris, Marshall, Faulkner and Co., hand-painted on tin-glazed earthenware blanks, 1862–5, 76.2 × 120.6 cm. V&A: Circ.520–1953.

unrolling the scenes almost like a strip cartoon, from the birth of the princess to her reawakening and marriage. But when he revisited the story, he interrupted the narrative and refused to show the kiss that breaks the spell. In 1869–71 he worked on a group of paintings, known as *The Briar Rose* (Museo de Arte de Ponce, Puerto Rico), for his patron William Graham, but although these were conceived as a sequence of canvases, there is no movement from scene to scene. All three paintings show the effect of the enchantment on the princess and the palace. Even the standing knight who appears in the first canvas seems to pause before cutting through the rose bush, and it is unclear whether he will fulfil his quest. Perhaps he too will be overwhelmed by sleep. In one study in the V&A's collection (plate 115), the knight looks down at his comatose companions, as if contemplating his own failure.

When Burne-Jones returned to the subject again in the 1880s in a series of four canvases (plate 116), the spell remained unbroken. Contemporary critics were disturbed by this tangle of drooping figures. The *Edinburgh Review* described the effect of 'sleep grown as menacing as death' and 'of aspiration rather than fulfilment, of desire rather than fruition…Joy held forever in suspense'.[36] It seems that this reviewer discovered the secret of Burne-Jones' interest in the story, when he suggested that the artist had shown 'youth crystallised in the impregnable fortress of sleep'.[37] Burne-Jones did not want the princess to

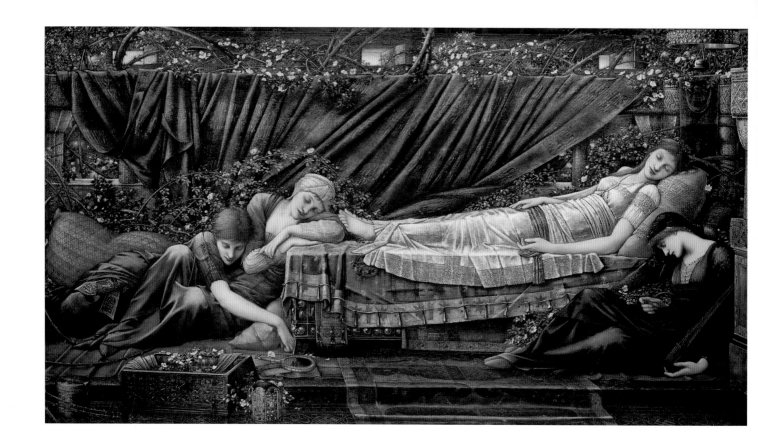

116 Edward Burne-Jones,
The Briar Rose: The Rose Bower,
oil on canvas, 1885–90.
The Faringdon Collection Trust, Buscot
Park, Oxon.

be woken by a man's kiss; he would rather she remained untouched forever. Burne-Jones' intense friendships with young girls are well recorded, and he became distressed when they grew up and were married. He was especially upset at the marriage of his own daughter, Margaret. He explained to his young friend Frances Horner that he had given Margaret 'a moonstone that she might never know love, and stay with me. It did no good but it was wonderful to look at.'[38] It seems that he associated the story of *Sleeping Beauty* with the idea of an unchanging state of innocence, and it became a talisman against his fear of losing Margaret. Certainly the sleeping girls (plate 117) resemble her, and Burne-Jones even gave Margaret a gouache version of the sleeping princess from the *Briar Rose* series as a wedding present.

The Eve of St Agnes

Burne-Jones was unusual in his refusal to explore the subject of sexual awakening. Many of his contemporaries found the idea irresistible. We have already seen how Millais presented images of teenage girls on the threshold of womanhood. One of his most enticing pictures on this theme was inspired by Keats's equally seductive poem 'The Eve of St Agnes'. He produced several oil paintings, as well as a watercolour, *The Eve of St Agnes: interior at Knole, near Sevenoaks* (plate 118), all illustrating the same passage from the poem, when Porphyro secretly watches Madeline undressing:

117 Edward Burne-Jones, *Head of sleeping attendant from Briar Rose*, oil on canvas, 1881–6, 42 × 42 cm.
V&A: E.328–1990.

118 John Everett Millais, *The Eve of St Agnes: interior at Knole, near Sevenoaks*, watercolour, 1863, 19.7 × 25.7 cm.
V&A: D.141–1906.

119 Frederick Sandys,
Harald Harfagr,
wood engraving, engraved by J. Swain,
proof on India paper, 1862,
18.6 × 10.8 cm.
V&A: E.2799–1901.

120 Edward Burne-Jones,
Caricature of William Morris reading to the artist,
pen and ink, 1861,
18 × 11.5 cm.
V&A: E.450–1976.

Of all its wreathèd pearls her hair she frees;
Unclasps her warmèd jewels one by one;
Loosens her fragrant bodice; by degrees
Her rich attire creeps rustling to her knees.

The curves of Madeline's bust and hips are emphasized by her corset and the fall of her dress. She is dominated by the vast bed; it grows in our imagination, as we are only shown one corner, but even that fills the entire left side of the picture. Millais worked hard to capture the appearance of the room by moonlight, placing Madeline in the centre of the soft light coming through the window. His wife Effie had to pose for three cold nights in the bedroom at Knole, so that the effect would be accurate. He was perhaps more successful in this watercolour than in the larger oil versions, as here the limited palette of blues and gentle browns seems ideally suited for the twilight scene.

The poem by Keats appealed to Millais not just for its sensuality but for several other reasons. Firstly, Keats was still relatively unknown to the public, so Millais had the advantage of presenting a fresh subject that would stand out among more hackneyed scenes. Secondly, it was set in the Middle Ages. Despite illustrating Trollope's contemporary novels, Millais shared with his Pre-Raphaelite colleagues an abiding affection for the medieval. Their favourite sources, from the Arthurian legends to Dante and Chaucer, were all linked by this medieval context. Each artist, of course, had a different response to the historical reality of the Middle Ages. Morris, for example, took the society of the fourteenth century as the starting point for his Socialism, while Burne-Jones was more interested in the decorative and chivalric aspects of medieval life. Yet it remained a constant thread that bound the careers of the Pre-Raphaelites together, and surfaced in their work in many different forms. We can see it in Morris's fascination with Icelandic sagas from the 1860s, which found a visual parallel in Frederick Sandys' work.

In August 1862, Sandys produced two illustrations for poems about Norsemen in the magazine *Once a Week*, *Harald Harfagr* (plate 119) and *The Death of King Warwolf* (V&A: E.8336–1905). *Harald Harfagr* was based on a poem by George Borrow: 'A discourse I heard / Betwixt a bright maiden / And a black raven bird.' The Valkyrie and the raven, both harbingers of death, are discussing the fate of the Norse king Harald Fairhair, who was slain in battle in 872.

This enthusiasm for Norse legends, like all the other examples of Pre-Raphaelite interest in the medieval world, was a manifestation of a far wider Victorian Gothic revival. But, although they were responding to a more general cultural movement, certain aspects of this revival were still peculiar to the Pre-Raphaelite circle. For some artists, their love of the medieval was so strong that it even coloured their images of the classical world. This was one of the reasons why Morris and Burne-Jones were excited by Chaucer's stories; they were able

121 *The Bath of Venus*,
designed by Edward Burne-
Jones,
engraved by William Morris,
wood engraving, 1866,
Sight 11.6 × 16.6 cm.
V&A: E.1838–1920.

122 Edward Burne-Jones,
*Details of classical dress and
hairstyles*, after *Costumes of the
Ancients* by Thomas Hope,
pen on tracing paper, c.1861,
25.4 × 19.1 cm.
V&A: E.1–1955, p.39.

to see the Greek and Roman myths through the eyes of a fourteenth-century poet. He retold the legends of Dido and Phyllis using the language of courtly love. When Morris came to write his own cycle of poems, *The Earthly Paradise* (published 1868–70), he chose the same approach. Half his stories were based on the legends of northern Europe, while the other half had classical origins, but they were presented within a medieval setting. Burne-Jones responded by illustrating a number of the tales, including 'Cupid and Psyche' and 'Pygmalion'.

The classical world

'Cupid and Psyche' was the first of the poems written by Morris in 1865. It was to have been published with accompanying illustrations by Burne-Jones, but although forty-five woodblocks were cut, the project was abandoned. *The Bath of Venus* (plate 121) shows the eclectic mix of classical, medieval and Renaissance styles that Burne-Jones developed for these illustrations. Venus herself is a quotation from a Botticelli painting, while some of her attendants hold ancient ointment phials, and others play medieval musical instruments. William Morris's engraving technique reproduces the overall appearance of a fifteenth-century print.

Burne-Jones was not unsympathetic towards classical art. Indeed, from the late 1860s, his own style increasingly assimilated elements from ancient sources, not only in the details of dress or architecture (plate 122), but also in the chalky palette he used, making flesh appear almost like marble.

This style was particularly appropriate for his paintings based on the Pygmalion legend, which shows the transformation of a sculpture into a living woman through the intervention of Venus. Burne-Jones again approached this classical legend through the intermediary of Morris's medievalizing poetry rather than Ovid's original tale in the *Metamorphoses*. The four oil paintings

RIGHT
123 Edward Burne-Jones,
Pygmalion: The Godhead Fires, oil on
canvas, 1875–8,
Birmingham Museums and Art Gallery.

BELOW LEFT
125 Edward Burne-Jones,
Study of Venus for The Godhead Fires,
pencil, 26.2 × 14.6 cm.
V&A: E.1613–1926, p.IV.

BELOW RIGHT
124 Edward Burne-Jones,
Study of Galatea for The Hand Refrains,
pencil, 1868–9, 25 × 18 cm.
V&A: Circ.81–1958.

were derived from proposed illustrations for *The Earthly Paradise*. Morris provided the titles for the paintings: *The Heart Desires, The Hand Refrains, The Godhead Fires, The Soul Attains*. Burne-Jones made two versions of this series, the first in 1868–70 for Maria Zambaco's mother, Euphrosyne Cassavetti (private collection), and the second in 1875–8 (plate 123), and the V&A has preparatory drawings for both sets which highlight the subtle changes he made in the interim. A sketch of *Galatea*, the beautiful sculpture (plate 124), relates to the earlier group of paintings, in which she is seen in profile, with one hand raised to her shoulder. There is also a study of *Venus* (plate 125) for the second series, in which Burne-Jones has modified the position of her left arm and made her drapery more diaphanous.

Two other works by Burne-Jones in the V&A's collection which at first sight appear to be purely classical in origin, can be traced back to medieval roots. *Cupid's hunting fields* (plate 126) and *The Car of Love* (plate 127) both derive from the image of *The Passing of Venus*. This subject surfaces as early as 1861 in

126 Edward Burne-Jones,
Cupid's hunting fields,
oil on canvas, 1880–2,
99 × 77.5 cm.
V&A: CAI 9.

an unused design for a tile panel. It then appears on a tapestry in the background of *Laus Veneris* (plate 128), a painting based on the medieval Tannhauser legend in which the Pagan and Christian worlds collide. *The Passing of Venus* shows lovers falling victim to the power of Love. They are either slain by Cupid's arrow, or crushed beneath the wheels of Love's chariot. Burne-Jones developed the two elements of this idea into independent subjects, but both demonstrate the impossibility of escaping from Love's power. *Cupid's hunting fields* reworks a favourite theme from Burne-Jones' overtly medieval images; Cupid is the winged figure of Amor, our constant companion in Burne-Jones' Chaucerian works, in a more spiteful mood, and wearing fewer clothes. The monochrome painting in the V&A was bought by Constantine Ionides after its exhibition at the Grosvenor Gallery in 1882, and in common with many of Burne-Jones' images, its subject was reworked in different media over the years. The same composition appears in a gesso low-relief of 1880, now in Delaware, and a watercolour with gold highlights (The Art Institute of Chicago, c.1885).

The Passing of Venus also inspired a massive canvas that occupied Burne-Jones until the very end of his life. He acknowledged that the subject of *The Car of Love*, also known as *Love's Wayfaring*, 'isn't a new subject…It's been done before, but not as I like.'[39] This time he turned Love's chariot around, so that it bears down upon the viewer. The dainty carriage shown in the background of *Laus Veneris* is transformed into a juggernaut that fills the narrow street. It is pulled by Love's victims, who have already been wounded by Cupid's arrows, and if any of them show signs of flagging, they will fall under the wheels. The nightmarish effect is made worse by the seemingly endless passageway along which they drag the chariot.

Burne-Jones never finished this picture, despite the assistance of Thomas Rooke, but Georgie believed that it should still be presented to the V&A Museum as a valuable tool for students who wanted to understand his technique. Rooke described how Burne-Jones transferred his small figure studies onto the canvas by referring to photographs, so evidently this practice was not confined to his designs for the decorative arts. He concentrated on the outlines of the figures before adding flesh tones, as he wanted the picture to look 'as much like sculpture as possible'.[40] The sculpture to which he referred was not necessarily classical, but rather Michelangelo's, which Burne-Jones came to love

127 Edward Burne-Jones,
The Car of Love,
unfinished, oil on canvas, 1870–98,
518 × 273 cm.
V&A: P.16–1909.

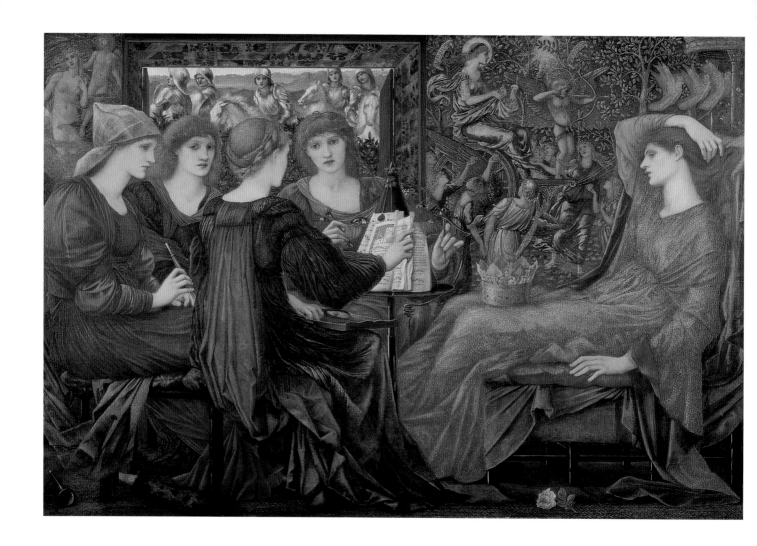

128 Edward Burne-Jones,
Laus Veneris,
Laing Art Gallery (Tyne and Wear
Museums),
oil on canvas, 1873–8.

despite Ruskin's fulminations against his style. He was even able to study
Michelangelo's figures without leaving London. The Cast Courts of the South
Kensington Museum contained replicas of the unfinished *Slaves* and *David*,
allowing Burne-Jones to revisit these works whenever he chose. So *The Car of
Love* was a hybrid, like so many of his later pictures, containing motifs from the
classical, medieval and Renaissance past, that he brought together in his distinc-
tive mix.

Although most of Burne-Jones' paintings do contain references to the Middle
Ages, there are a handful in which the classical world is dominant. His scheme
to illustrate the history of the Fall of Troy seems to fit into this category,
although we must remember that it was conceived as a triptych with a predella
below, so the form at least was based on a medieval altarpiece. This project was
unfinished at his death, but he also produced a number of independent can-
vases based on the story, including a large unfinished version of *The Feast of
Peleus* (plate 129).[41] This depicts the starting point for the events that led to the
siege of Troy, and was originally designed as the central predella image. It
shows the wedding celebrations of Peleus, King of Thessaly. He had invited all
the gods and goddesses apart from Discord, who caused uproar by arriving

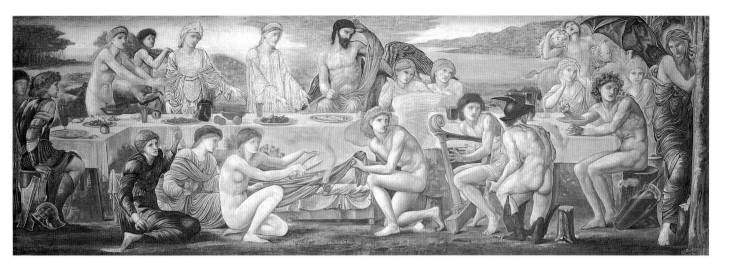

129 Edward Burne-Jones,
The Feast of Peleus, unfinished,
oil on canvas, 1881–98,
149.5 × 442.6 cm.
V&A: P.108–1920.

unexpectedly and handing over to Mercury an apple inscribed 'For the Fairest'. At the other end of the table, the three goddesses Venus, Minerva and Juno all expect to receive this prize. Classical subjects like this gave Burne-Jones a chance to paint the nude, and especially to demonstrate his fascination with Michelangelo, which developed in the 1870s. The central figure of Jove is effectively a quotation of the Christ from Michelangelo's *Last Judgement* in the Sistine Chapel.

The eclecticism of Burne-Jones' references, and the interplay between different versions of his images and their literary sources, can become baffling, but they demonstrate how he was constantly trying to refine his art, to present different readings of a well-loved tale. And Burne-Jones was not the only artist in his circle to approach painting in this way. Rossetti was equally concerned about integrating texts and images in his watercolours, oil paintings and book illustrations. By relying on intertextual references, these pioneers of Aestheticism were challenging Whistler's assertion that the visual arts should suppress narrative. For the late Pre-Raphaelites, the repetition of motifs from history or literature in different media was in fact the 'defining feature of the Aesthetic work of art'.[42]

King René's Honeymoon

The scheme to decorate a cabinet with scenes from King René's Honeymoon, a story told by Sir Walter Scott, provided another opportunity to combine painting and furniture in a collaborative project. The images were applied to separate panels, interspersed with inlaid decoration. There was no attempt at creating a narrative sequence; instead, artists represented the King as the patron of different arts, so each panel stood alone.

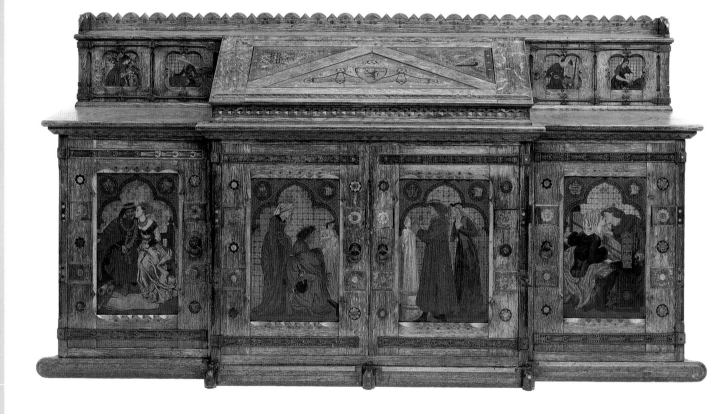

PLATE 130 *King René's Honeymoon cabinet*, designed by John Pollard Seddon, decorated by various artists, oak inlaid with various woods, painted metal, 1861, 133.3 × 279.5 × 94 cm. V&A: W.10-1927. Ford Madox Brown showed the King as an architect; Burne-Jones as a painter and sculptor. In Rossetti's scene he is enjoying music with his new wife. Gardening, embroidery, pottery, weaving, ironwork and glass blowing appear in smaller scenes at the top of the desk. Morris helped to create a coherent style by designing a decorative background for each panel, and the artists seem to have agreed on a consistent scale and colour palette.

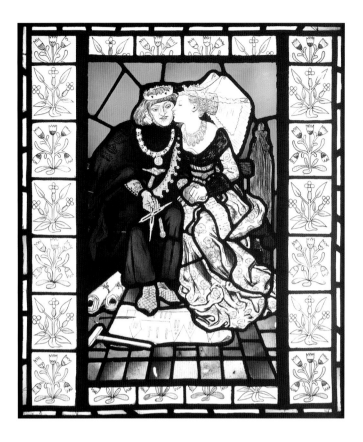

PLATE 131 Ford Madox Brown, *Architecture*, stained and painted glass, made by Morris, Marshall, Faulkner and Co., c.1863, 63.7 × 54.3 cm. V&A: Circ.519–1953. The cabinet was so well received at the Medieval Court of the 1862 Exhibition that four of the designs were adapted for stained glass, probably in the following year, as part of the decoration of Miles Birket Foster's house.

PLATE 132 Dante Gabriel Rossetti, *Music*, stained and painted glass, made by Morris, Marshall, Faulkner and Co., c.1863, 63.7 × 54.3 cm. V&A: Circ.519–1953. The companionable playing of a portative organ becomes a focus for desire.

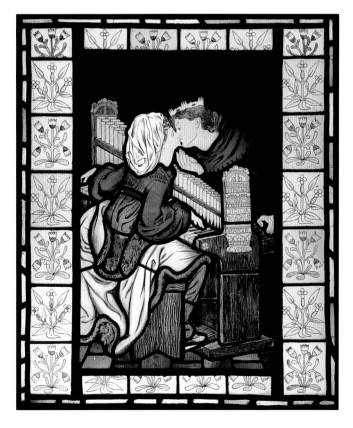

Women

133 Florence Claxton,
The Choice of Paris – an idyll,
watercolour, 1860,
45 × 60 cm.
V&A: E.1224–1989.

Pre-Raphaelite art has long been associated with a particular type of female beauty created by Rossetti and his acolytes; a 'union of strange and puissant physical loveliness with depth and remoteness of gaze'.[1] However, these distant, idealized images can overshadow a more complex relationship between male Pre-Raphaelite artists and their female models, muses and mistresses. At the outset, we should remember, the PRB were criticized for their refusal to

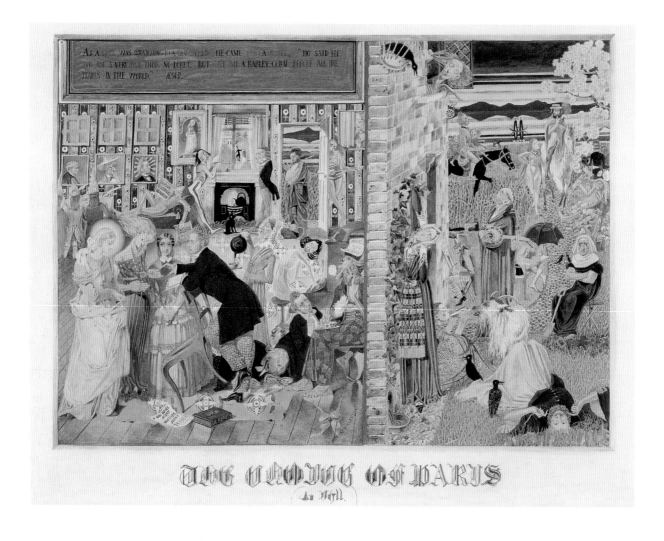

134 *Jane Burden standing,*
albumen print, by Herbert
Watkins, Regent Street, 1858,
8.5 × 8.5 cm.
V&A: Ph.1736–1939.

135 *Jane Burden leaning against*
the back of a chair,
albumen print, by unknown
photographer, c.1858,
9.3 × 5.9 cm. V&A:
Ph.1735–1939.

represent conventional beauty. We have already seen how Millais' painting *Christ in the Carpenter's Shop* was savaged for its depiction of the Virgin; her thin face and hands, red hair, furrowed brow and twisted neck were a far cry from the traditional Renaissance Madonna. Initially, Pre-Raphaelite images of women tended to be over-realistic, and so we need to consider how the stereo-typical beauty of the later movement emerged.

The tendency of the young Pre-Raphaelites to choose angular models for their heroines was parodied by a female artist, Florence Claxton. Her water-colour, *The Choice of Paris – an idyll* (plate 133), shows Millais in the left fore-ground, awarding the prize for beauty to a scrawny, contorted woman rather than a Raphaelesque saint or a simpering, crinolined Victorian girl.[2] Claxton criticizes the perceived ugliness of early Pre-Raphaelite paintings by exaggerat-ing details from many of their works, including *The Vale of Rest*, *Claudio and Isabella*, and, lying in the grass, Alice Gray from *Spring*. Her watercolour was so successful when shown at the Portland Gallery that it was reproduced in the *Illustrated London News*. Ten years after their paintings first caused a stir, the PRB were still the butts of satire.

Florence Claxton's picture reminds us that women were not passive in the production and reception of Pre-Raphaelite art. A substantial exhibition, *Pre-Raphaelite Women Artists*, shown around Britain in 1997–8, demonstrated the creativity and talent of the female painters and designers in this circle. Many of these works have remained in private hands, and therefore have attracted little recognition. The V&A, however, holds one of the finest collections of photo-graphs by Julia Margaret Cameron, and has works by a number of decorative artists, including Kate and Lucy Faulkner. Rossetti's collaboration with his pupil and wife Elizabeth Siddal also shows that he recognized and encouraged the potential of female artists, but at the same time, he was moulding his por-traits of Siddal to fit a fantasy image. It is this paradox which needs to be unravelled.

Jane Morris: original or copy?

The development of Rossetti's distinctive vision of the beautiful woman becomes clearer if we look at the way he depicted Jane Morris throughout his career. Her face emerges and is transformed in many photographs, drawings and paintings in the V&A's collections. Jane Burden, known as 'Janey', was the working-class daughter of an Oxford ostler, who married William Morris in April 1859; she had been spotted by Rossetti and Burne-Jones, who wanted to paint her. Her large features, heavy dark eyebrows and rippling hair did not fit the mid-Victorian ideal of beauty; a petite, rosy prettiness was more widely admired. Two photographs taken before her marriage (plates 134 and 135) show how she soon began to adapt to the expectations of the artists for whom she modelled. In the first, her appearance is unremarkable, even shy. In the sec-ond photograph, her attitude is self-conscious and already accentuates the

136 Dante Gabriel Rossetti,
Portrait of Jane Morris (study for The Seed of David),
pencil and ink, 1861,
34.6 × 28.9 cm.
V&A: 493–1883.

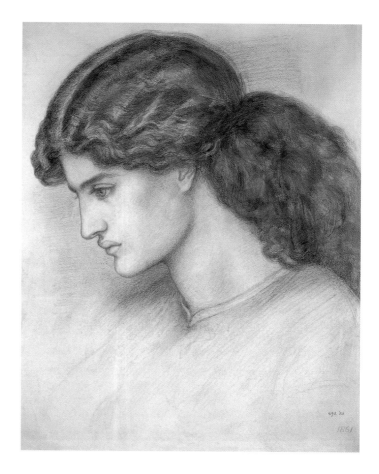

features for which she became famous – her long neck, heavy-lidded eyes and mobile hands.

Janey was not just important as a model, however. When Morris persisted in marrying her, in spite of their great disparity in background, he was marrying a highly skilled needlewoman. Her expertise proved invaluable in the early days of Morris, Marshall, Faulkner and Co. As one commentator acknowledged, 'Mrs. Morris was famous for her embroidery…[she] laid with her needle the foundations of the firm.'[3] She advised Morris on some of their earliest textile productions, notably the *Daisy* hangings (c.1860), which were shown at the Exhibition of 1862. After Morris's death, she described how 'the first stuff I got to embroider on was a piece of indigo dyed blue serge I found by chance in a London shop… I took it home and he was delighted with it, and set to work at once designing flowers – these we worked in bright colours in a simple rough way.'[4] These practical skills perhaps provide a key to the early relationship between Morris and Janey, which sadly faltered later in the marriage.

Rossetti, who had admired Janey since their meeting in 1857, began a romantic liaison with her in the late 1860s, which lasted until about 1875. Looking back, Burne-Jones described Rossetti's charm: 'He was *so* fascinating that he could bring over whatever man he chose and …I'm quite sure there's not a woman in the whole world he couldn't have won for himself. Nothing pleased him more though than to take his friend's mistress away from him.'[5]

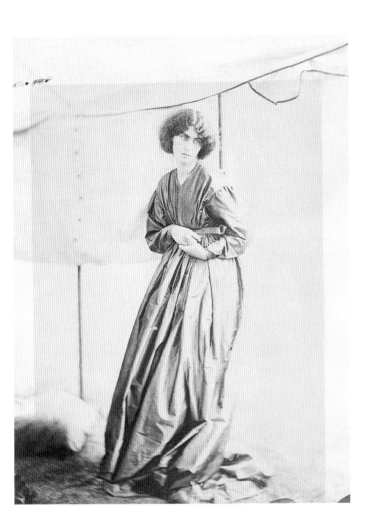

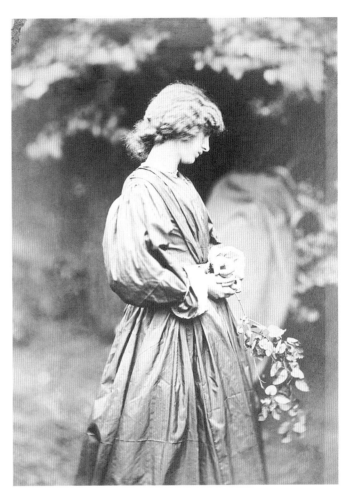

137 John R. Parsons and Dante
Gabriel Rossetti,
*Jane Morris in the garden of
Tudor House,*
original albumen print, 8 July
1865,
19.6 × 13 cm.
V&A: 1740–1939.

138 John R. Parsons and Dante
Gabriel Rossetti,
*Jane Morris in the garden of
Tudor House,*
later gelatin-silver print,
photographed 8 July 1865,
25.7 × 20.3 cm.
V&A: 1751–1939.

Even before their affair, Janey's image began to dominate his pictures, over-shadowing the delicate features of Lizzie Siddal. By 1861, he was drawing her as the Virgin Mary for his large altarpiece, *The Seed of David* (Llandaff Cathedral, oil on canvas). When we compare a study for this painting (plate 136) with the photograph taken three years before, we see how Rossetti has started to manipulate her features. The lines of her face have been softened, so that her nose is less prominent and her lips are more curved. Her hair is also tamed, with gentler curls across her brow. The effect is slight, but indicates the manner in which Rossetti was to treat her image in his art.

By 1865, their intimacy was growing, but this only seems to have increased Rossetti's tendency to transform her into an ideal, rather than to reflect her level-headed character. He asked her to model for a series of photographs taken in his garden in Chelsea. Rossetti arranged her poses, creating a sense of melancholy, as she leant against the backdrops or reclined on a sofa. One image (plate 137), showing Janey with her hands clasped, formed the basis for Rossetti's later composition, *Pandora* (Faringdon Collection, coloured chalks, 1869). Others, like the photograph of Janey with downcast eyes holding a leafy branch (plate 138), have no direct connection to his paintings, but they do demonstrate how Rossetti was moulding the living woman to fit his fantasies.

Sandys' Women
'She grows as a flower does'[1]

Frederick Sandys became acquainted with the Pre-Raphaelite circle in 1857 after he published a parody of one of Millais' paintings. By the 1860s, he was closely associated with Rossetti and his Chelsea friends; he sought refuge in Rossetti's house when he was declared bankrupt in 1866.

Sandys' pictures of women suppress the personality of the sitter, reducing her to one element in a decorative scheme: hair, jewellery, dress and floral accessories overwhelm any analysis of character. He was fascinated by the rhythm of lines across the picture surface, and kept colour to a minimum. He became renowned for his pastel portraits, often on tinted paper; originally he had made these as studies for oil paintings, but they were soon recognized as finished works.

116

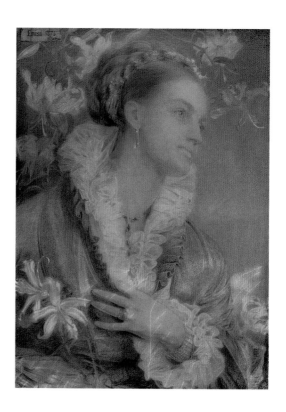

PLATE 139 Frederick Sandys, *Louisa Marks*, coloured chalks, 1873, 76.8 × 54.6 cm. V&A: P.41–1939. Sandys met Louisa's husband, Murray Marks, through Rossetti and Whistler: he was the antiques dealer who supplied the Chelsea set with their blue and white ceramics.

PLATE 140 Frederick Sandys, *Proud Maisie I*, black and red chalks on green-tinted paper, 1868, 39.4 × 28.7 cm. V&A: P.7–1933. Sandys' fascination with women's hair seems to derive from his relationship with the actress Mary Emma Jones, his mistress and model from 1867, and the mother of ten of his children. *Proud Maisie* is Sandys' most famous depiction of Mary Emma. The V&A has the original version of this image[2], which was replicated at least thirteen times during his career, and shows the young Mary Emma in a rage, viciously biting her hair. This drawing was exhibited at the Royal Academy in 1868, without the later title, which refers to Scott's poem, 'The Pride of Youth', from *The Heart of Midlothian* (1818). It attracted the notice of Swinburne, who admired the sensual representation of 'a woman of rich, ripe, angry beauty' who 'draws one warm lock of curling hair through her full and moulded lips, biting it with hard bright teeth, which add something of a tiger's charm to the sleepy and couching passion of her fair face'.[3]

ABOVE LEFT

PLATE 141 Frederick Sandys, *A young woman, probably Florence Emily, Lady Hesketh*, pencil and coloured chalks, c.1880, 76.2 × 63.5 cm. V&A: E.1391–1924. This portrait probably celebrates the marriage of Florence Emily Sharon, daughter of the senator of Nevada, to Sir Thomas Hesketh, in 1880.[4] Sandys presents the sitter as a beautiful specimen waiting to be plucked. The 'fetishistic elaboration'[5] of her hair demands our attention, as she tucks an azalea flower into the mass of curls, and takes on a more sinister aspect when we notice the snake bangle wound around her wrist.

ABOVE RIGHT

PLATE 142 Dante Gabriel Rossetti, *Keomi: study for the Beloved*, pencil, 1865, 36.8 × 33.6 cm. V&A: E.2914–1927. In the 1860s, Sandys discovered a young gipsy girl called Keomi. Her luxuriant dark features appealed to him, and also to Rossetti, who included her as a bridesmaid in his meditation on female beauty, *The Beloved* (Tate Britain, oil on canvas, 1865–6, plate 166). Her beaded necklaces and brooch reinforce the exoticism of her appearance, while her singing lips remind us of the legendary power of sirens.

LEFT

PLATE 143 Frederick Sandys, *Medusa*, black and red chalks on greenish paper, c.1875, 72.7 × 54.6 cm. V&A: P.18–1909. Sandys frequently made the connection between the dangerous sexuality of the *femme fatale* and her hair, which traps the unwary male, but never so overtly as in this image of the Gorgon. Her head may be disembodied, but her furious stare has lost none of its power, and the snakes and hair still writhe as if trying to escape the confines of the picture.

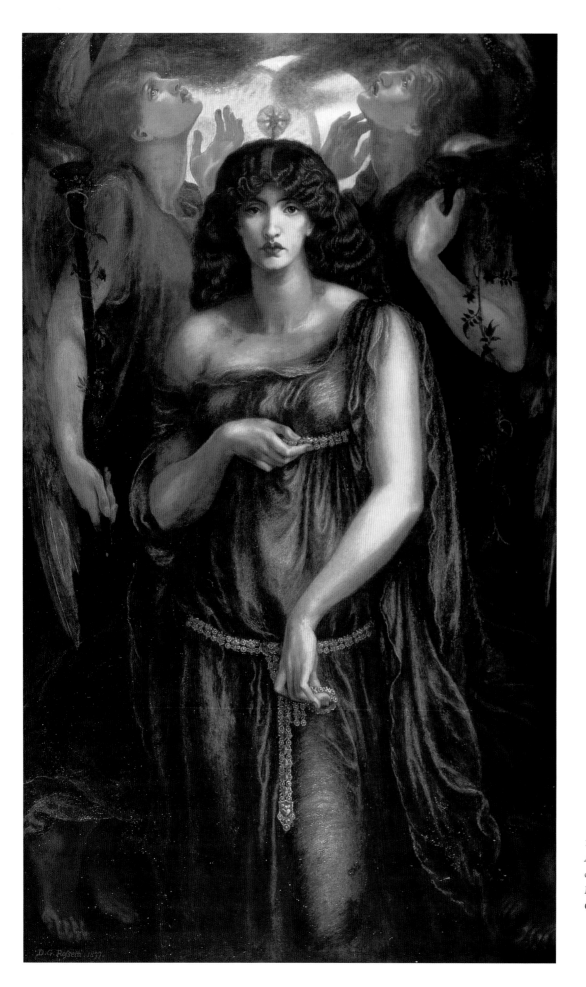

144 Dante Gabriel Rossetti,
Astarte Syriaca,
oil on canvas, 1875–7,
Manchester City Art
Galleries.

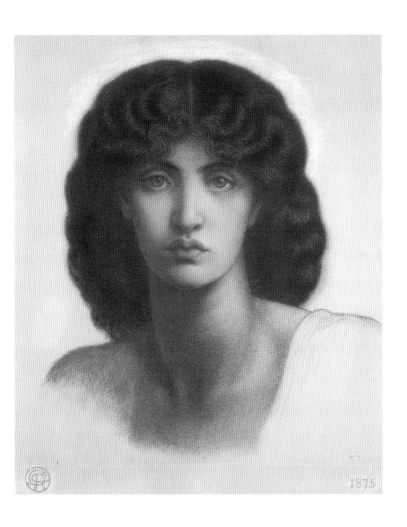

145 Dante Gabriel Rossetti,
Study for Astarte Syriaca,
coloured chalks, 1875,
54.6 × 44.7 cm.
V&A: 490–1883.

As she turns her gaze away, she seems elusive and preoccupied.

It is hard to say how far Janey colluded in this invention of her image. Certainly, she adopted 'artistic' dress: the lace collars and ruffled sleeves she wore before her marriage were soon given up. Henry James described her appearance in 1869: 'Imagine a tall lean woman in a long dress of some dead purple stuff, guiltless of hoops,…a long neck without any collar, and in lieu thereof, some dozen strings of outlandish beads.'[6] We can see the effect in the Cheyne Walk photographs as the simple bodice focuses attention on her face and hands, and the low-set sleeves emphasize her drooping, pensive pose.

During the 1870s, when their affair was at its height, Rossetti increasingly presented Janey in the role of unattainable goddess. He imagined her as the ancient deity *Astarte Syriaca* (plate 144). From c.1868, Rossetti worked increasingly in coloured chalks, a medium which suggests tactility and emphasizes the surfaces of a subject – the skin and hair especially. A study for this painting (plate 145) focuses on her forbidding gaze. As 'Astarte of the Syrians: Venus Queen / Ere Aphrodite was'[7], she demands desire, but is unapproachable by mortals. Both the picture, and the sonnet which Rossetti wrote to accompany it, place stress on her physical attributes, her eyes, lips, neck and bosom. However, there is no contemplation of her own desires. She is represented as unknowable. Her features have been exaggerated, especially the curve of the mouth and the columnar neck, and she has barely aged since the photographs ten years before. It seems as if Rossetti is no longer looking at her, but through her, to an idealized image he established long ago. In Griselda Pollock's reading of this picture, she suggests that it represents Rossetti's lack of sympathy for his subject, by depicting Woman as terrifying and Other.[8] Certainly this was one of the last pictures for which Janey sat, as she was finding Rossetti's erratic behaviour too hard to bear.

Yet Rossetti continued to treat Janey as his muse. Her features appear in many of his pictures of isolated mythical or allegorical figures until the end of his life. These include the oil painting *The Daydream* (plate 146), commissioned for 700 guineas by Constantine Ionides, who bequeathed his collection, containing several works by Pre-Raphaelite artists, to the South Kensington Museum.[9] This painting began life as a sketch made in 1872 at Kelmscott

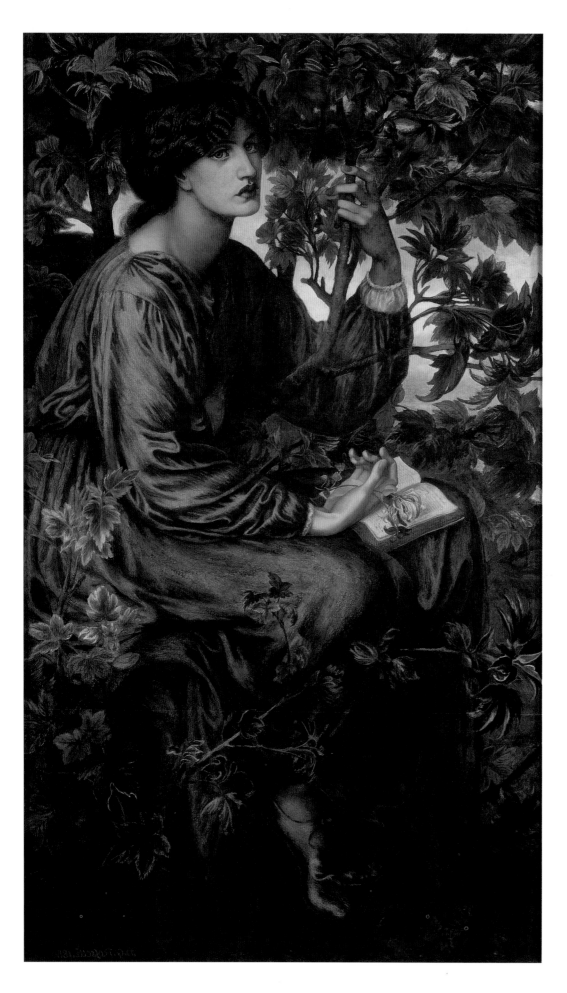

146 Dante Gabriel
Rossetti,
The Daydream,
oil on canvas, 1880,
158.7 × 92.7 cm.
V&A: CAI 3.

Manor in Oxfordshire, where Janey and Rossetti often spent time together.[10] The sketch hung over the fireplace in Rossetti's house in Chelsea, and attracted the attention of Ionides, who suggested that Rossetti should make a full-length oil painting based on the pose. Rossetti was delighted, as he claimed in a letter to Ionides that 'the drawing is my prime favourite among all those I have done from my noblest type'.[11] It is telling that Rossetti describes Janey as a 'type' rather than an individual: her painted face has taken on a life which overwhelms her own personality. Henry James recognized this confusion in his account of their meeting: 'when such an image puts on flesh and blood, it is an apparition of fearful and wonderful intensity. It's hard to say whether…she's an original or a copy.'[12]

Rossetti originally intended to present Janey as the figure of spring, and described the picture as *Vanna* or *Monna Primavera*. She is seated in the fork of a budding sycamore tree, and the vibrant green of her dress reflects the vitality of the foliage around her. However, as the picture developed, it became clear that Rossetti could not include a spray of snowdrops, as he had initially hoped – they would not be in flower when the sycamore was in bud. Instead, he opted for a honeysuckle bloom, which transforms the imagery of the picture. Snowdrops were traditionally associated with chaste yearning, as the emblem of St Agnes, but honeysuckle flowers were read in a much more sensual manner. Rossetti's own poem, 'The Honeysuckle', dwells on the image of plucking a bloom and resting in a bower, 'Where, nursed in mellow intercourse, / The honeysuckles sprang by scores.'[13] His painting, *Venus Verticordia* (The Russell-Cotes Art Gallery and Museum, Bournemouth, oil on canvas, 1864–8), shocked Ruskin with the profusion of the flowers. He found them 'wonderful…in their realism; awful – I can use no other word – in their coarseness: showing enormous power'.[14]

The new title, *The Daydream*, together with the single bloom of honeysuckle, and the open book of verse, suggests a less straightforward allegory. Rather than representing the season of spring, Janey now seems to embody desire. One of her expressive hands caresses a branch, the other holds the flower loosely, as her fingers search for a reciprocal touch. She looks out of the picture, but does not engage with the viewer. She is thinking of a lover, as the sap rises in the tree. The sonnet written by Rossetti for the frame of this picture encourages a sensual reading of this imagery: he concentrates on the leaves 'rosy-sheathed as those which drew / Their spiral tongues from spring-buds'. Although the 'heavy languid voluptuousness'[15] of this picture was not always appreciated by critics, it stands witness to the continuing spell which Janey Morris's face cast over Rossetti and his admirers. She is more an object of desire than a desiring woman, perched alone in a tree, out of reach.

Over the years, Janey seems to have adapted to this iconic status, rarely breaking the illusion by revealing her own personality. George Bernard Shaw said, 'she was the silentest woman I have ever met. She did not take much

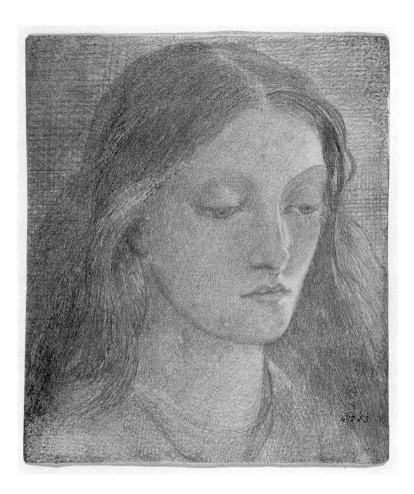

147 Dante Gabriel Rossetti,
Head of Elizabeth Siddal,
pencil, c.1860,
12.1 × 11.4 cm.
V&A: E.5642–1910.

notice of anybody, and none whatever of
Morris, who talked all the time.'[16]

Lizzie Siddal

Although Janey dominated Rossetti's later
years, during the 1850s his paintings and
drawings were filled with the image of
Elizabeth Siddal. Jan Marsh's study of her
career reveals her as an aspiring artist and
poet, eager to enter the studios of the young
Pre-Raphaelites, to model and to learn. In
1850, she was working as a dressmaker or
milliner, but hoping to train in one of the
Government Schools of Design, when she
met the Deverell family. Walter Deverell
introduced her to Holman Hunt and
Ruskin, and she then became Rossetti's
pupil. [17]

Lizzie's features were as well-suited to
the Dantesque subjects which Rossetti was
painting at this time, as Janey Morris's dark
and striking looks were appropriate to his
later Venetian works. She was also not con-
ventionally beautiful, being taller than average, with unfashionably red hair, but
her slender figure and refined features conformed to Rossetti's image of Dante's
beloved Beatrice. Georgie Burne-Jones described her when they first met in
1860 as having a 'mass of beautiful deep-red hair…very loosely fastened up',
and her complexion had a 'rose tint'. Her eyes were most striking: they were
'agate colour…wonderfully luminous…her eyelids were deep, but without any
languor or drowsiness, and had the peculiarity of seeming scarcely to veil the
light in her eyes when looking down'.[18]

During the 1850s, Lizzie and Rossetti had a troubled romance, hampered by
her ill-health and his unwillingness to marry. He continually painted and drew
her image in an almost obsessive manner. Christina Rossetti's poem, 'In an
Artist's Studio', written in 1856, commented on the impact of the relationship
upon both parties:

One face looks out from all his canvases,
One selfsame figure sits or walks or leans:
…Not wan with waiting, not with sorrow dim;
Not as she is, but was when hope shone bright;
Not as she is, but as she fills his dream.[19]

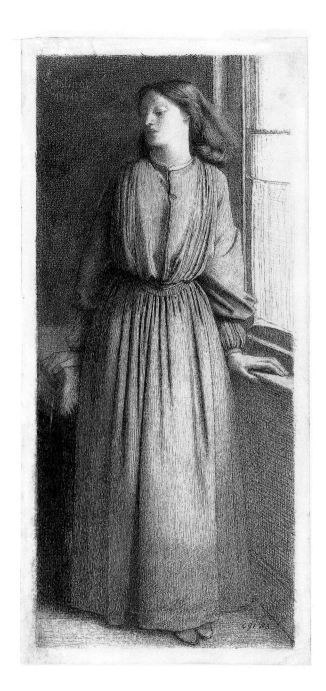

148 Dante Gabriel Rossetti,
Elizabeth Siddal,
pen and black ink, inscribed 'Hastings May 1854',
22.2 × 9.8 cm.
V&A: E.5641–1910.

In the summer of 1855, when Ford Madox Brown visited Rossetti's studio, he was disturbed to see the dozens of drawings of Lizzie. Brown described the fixation with her image as a 'monomania'.[20] One of these tiny drawings (plate 147) reveals the same downcast eyes and luxurious hair admired by Georgie Burne-Jones. Although some of these pictures occasionally allow us to glimpse Lizzie at work on her own paintings, more often she is presented as quiet and static.[21] Several emphasize her physical weakness: she rests in an armchair, or (plate 148) supports herself against a window ledge and table. In the early days of their relationship she had been an adaptable model, holding an uncomfortable kneeling pose for William Holman Hunt in *Valentine Rescuing Sylvia from Proteus* (Birmingham Museum and Art Gallery, 1850–1). However, by 1854 she appeared to be chronically unwell, and in the summer Lizzie and Rossetti went to Hastings in an attempt to improve her health by a change of air.

Lizzie's own talents as an artist were encouraged during this holiday by Barbara Leigh Smith, Anna Howitt and Bessie Parkes, leaders in the emerging women's movement. They helped the couple to find suitable, and separate, rooms, but the closeness of their relationship was made clear in a letter from Rossetti to his mother: 'No one thinks it at all odd my going into the Gug's [a pet name for Lizzie] room to sit there.'[22] The full-length drawing made at this time is a sensitive and intimate portrait. Again there is the averted gaze and lowered eyes, as Rossetti explores the fall of light upon Lizzie's face and body. The weight of her hair, tucked behind her shoulder, is suggested by very fine hatched strokes, and the pleats of her simple dress are carefully recorded. This is not a study for another, more substantial picture, but a finished work, produced during the many hours that they were alone together in Lizzie's lodgings. It is hard to know how far her features have been idealized, as there are very few surviving photographs with which to compare such drawings. However, the straight nose and heavy eyes of this image are closer to the uncompromising face which gazes out of her self-portrait (private collection, oil on canvas, 1853–4) than to Rossetti's softened and luxurious recollection of her appearance in *Beata Beatrix* (Tate Britain, oil on canvas, c.1864–70).

149 Frederick Hollyer,
Georgiana Burne-Jones,
photograph, 1880s,
14.5 × 9.8 cm.
V&A: 2817–1938.

Mistresses, models and mermaids

Burne-Jones divided women into two categories. Those who resembled his wife,
and daughter Margaret, he liked for 'their affection and sympathy and devoted-
ness'[23] (plates 149 and 150). However, he was also attracted by 'the exceedingly
mischievous, the sirens with oat coloured hair'[24], and at times their mischief
threatened to destroy his marriage.

For Burne-Jones, sexual danger and excitement were embodied by Maria
Zambaco, a leading light in London's Greek community. A portrait by Rossetti
(plate 151) emphasizes her expressive eyes and mouth. Having left her husband
in Paris in 1866, she began to sit regularly for several artists, but she developed
an intense relationship with Burne-Jones. In the autumn of 1868, Georgie

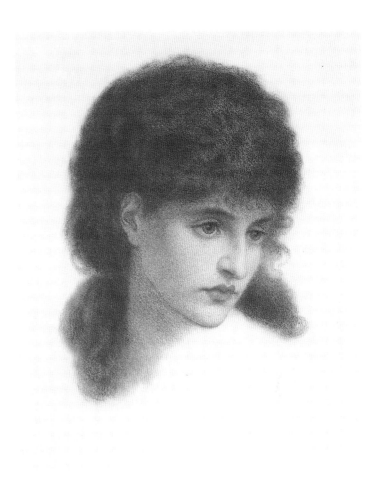

150 Frederick Hollyer,
Margaret Burne-Jones,
photograph, 1880s,
14.8 × 9.8 cm.
V&A: 2818–1938.

151 Dante Gabriel Rossetti,
Portrait of Maria Zambaco,
coloured chalks, late 1860s,
51.6 × 38.9 cm.
V&A: CAI 1149.

discovered that they were having an affair. The situation remained unresolved until the following January. Maria wanted Burne-Jones to run away with her. When he refused to do so, she 'produced a poison bottle and said she would drink it at once'.[25] There was a struggle, the police were called, Burne-Jones fainted, and Maria was led away by one of her Ionides cousins. In Georgie's biography of Burne-Jones, the whole dreadful year of 1869 was expunged.

Burne-Jones never overcame his tendency to become romantically attached to the beautiful young women who sat for him. His later entanglements with these girls, who were often the daughters of his patrons, remained platonic but still ardent. This susceptibility to the lures of female beauty was made manifest in his choice of subjects: he repeatedly painted Merlin's enchantress Nimue, for example.

He was able to play out his fascination with the theme of fatal seduction in *The Depths of the Sea* (plate 152). His sketchbook (plate 153) helps us to trace the development of this image. Although in the V&A drawing the composition was well established, with the mermaid clasping the body of a drowned man, the most captivating element of the picture had not yet emerged. In this early version, the mermaid's eyes are downcast and she seems almost meditative.

While Burne-Jones was working on the oil painting, however, he heard of the death of a young friend, Laura Lyttleton (née Tennant). In her memory, he changed the face of the mermaid to reflect 'some likeness to her strange charm of expression'.[26] As a result, she now gazes out at the viewer, with a half-smile on her lips, and 'a look of triumph that is neither human nor diabolic...almost worthy of Leonardo da Vinci himself'.[27]

To the end of his career, Burne-Jones continued to create ambiguous images of female beauty. In one of his carefully worked drawings (plate 154), he explores the subtle features of a favourite model, Bessie Keen. This is probably a study for the Queen playing the harp beside Arthur's bier, in his final, unfinished project, *The Sleep of Arthur in Avalon* (see plate 81), yet Burne-Jones lavishes attention on the drawing as a work in its own right, in the shading of the face, the movement of the hair, and the glimpse of character in the eyes and mouth.

Despite his sympathy for his young confidantes, and their obvious attachment to him, Burne-Jones could be scathing about the aspirations of women. He disapproved of educating girls, claiming it only made them into 'tenth rate men', said that modern women were 'tiresome...I like women when they're good and kind and pretty – agreeable objects in the landscape of existence', and suggested that 'they don't understand anything about pictures'.[28] Yet he knew from his own experience that women produced works of art for Morris and Company. He was well aware of the input of Janey Morris and her daughter May in the commercial success of the embroideries for the firm. Even Georgie had trained briefly at the Government School of Design, and tried her hand at drawing and wood engraving[29], but was obliged to give up when she

152 Edward Burne-Jones,
The Depths of the Sea,
oil on canvas, 1886,
private collection, courtesy of Julian Hartnoll.

ABOVE LEFT
153 Edward Burne-Jones,
Study for The Depths of the Sea, pencil, c.1885–6,
27.9 × 16.5 cm.
V&A: E.442–1943, p.7.

ABOVE RIGHT
154 Edward Burne-Jones,
Study for a Queen from The Sleep of Arthur in Avalon,
pencil, 1896,
43.2 × 30.48 cm.
V&A: E.2896–1927.

RIGHT
155 Edward Burne-Jones,
May Morris,
pencil, early 1880s,
19.4 × 11.1 cm.
V&A: E.886–1939.

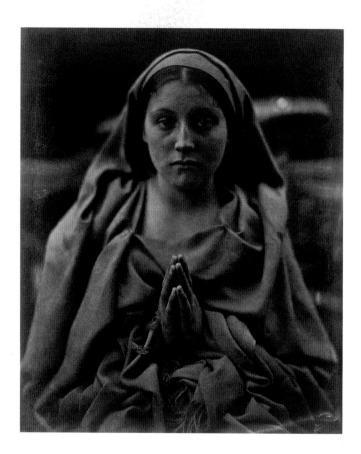

156 Julia Margaret Cameron,
St Agnes,
albumen print, 1864,
26.6 × 21.2 cm.
V&A: 44.771.

became a mother.[30] Other women within the Pre-Raphaelite circle were more successful at pursuing their creative careers. As Prettejohn has made clear, the 'activities of women were no longer accidental, but necessary to the plot' of Pre-Raphaelitism. However, she acknowledges that 'most numerous of all…are the works that were never made'[31], because of family duty, discouragement or death.

Poetry and photographs

Probably the most prolific female artist in the Pre-Raphaelite circle was the photographer Julia Margaret Cameron (1815–79). Given a camera by her son in 1863, she began to make sensitive portraits and to illustrate historical and mythical subjects, choosing themes which lay at the heart of Pre-Raphaelitism: the Arthurian legends, Shakespeare and Tennyson. As the sister of Sara Prinsep, she knew the artists that gathered at Little Holland House in Kensington. The Prinseps were renowned for entertaining the painter G.F. Watts, society 'lions' like Ruskin, Thackeray and Tennyson, and for encouraging younger artists like Burne-Jones.

Cameron's image of *St Agnes* (plate 156) demonstrates her distinctive approach. At a time when many photographers concentrated on perfecting technical clarity, she was more interested in mood. Her soft-focus studies of women have been compared to Rossetti's meditations on female beauty and sensuality. Like Rossetti, many of her sitters have a dreamy, almost entranced appearance; although *St Agnes* is looking out of the photograph, her gaze is drawn to something beyond the viewer, and she will not catch our eye. Although Cameron cannot introduce colour into her work, she does share the fascination with the art of Venice which overtook Pre-Raphaelitism in the 1860s. Even in this image of a saint, Cameron draws attention to her throat and the abundance of her folded drapery.

In many of Cameron's photographs, there is an ambiguous relationship between spirituality and sexuality. Traditionally, girls pray to St Agnes for a vision of their future husbands; she is both a conduit for desire and a symbol of chastity. Cameron's image plays on these dual meanings. The interweaving of spiritual and sexual yearning found in Cameron's work was also explored by another woman in the Pre-Raphaelite circle, Christina Rossetti (1830–94). Their affinity was recognized by her brother, William Michael Rossetti, who sent Cameron an early copy of Christina's *Goblin Market and Other Poems* (1862).[32]

Christina Rossetti had been associated with the PRB from its earliest days.

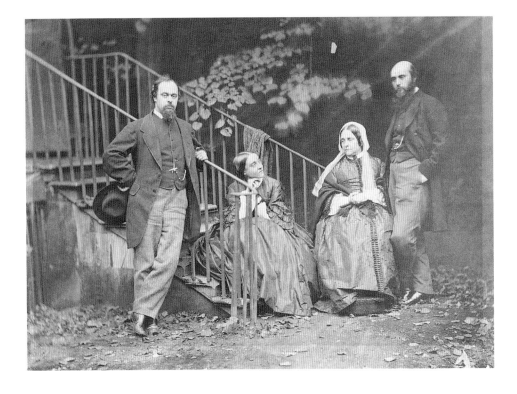

157 *The Rossetti Family*
(L to R: Dante Gabriel, Christina,
Frances (their mother), William
Michael),
photograph by C.L. Dodgson
(Lewis Carroll), 1863,
20.2 × 26.2 cm.
V&A: 801–1928.

158 Dante Gabriel Rossetti,
Portrait of Christina Rossetti,
pencil, 1847,
15 × 11.4 cm.
V&A: E.146–1928.

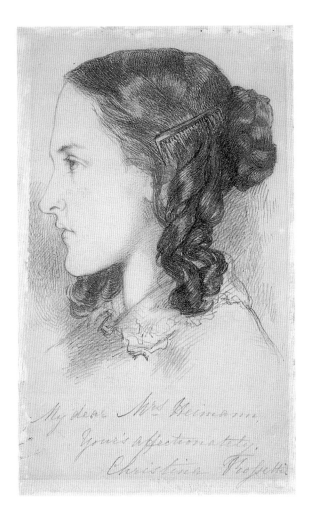

She never attended the meetings of the secret society, but her poetry was published in their magazine, *The Germ*, and her work inspired a number of significant wood engravings. She was also a useful model for her brother, Dante Gabriel, who painted her as the Virgin in *The Girlhood of Mary Virgin* (Tate Britain, oil on canvas, 1848–9). A drawing of her profile by Rossetti (plate 158) reflects her uncompromising character, even in her teens. In 1859, she was able to find an outlet for her religious energy in her work at the St Mary Magdalene Penitentiary, with prostitutes who wanted a fresh start in life. Here she came face to face with real experiences of seduction and salvation, which were retold in fairy-tale form in her poem 'Goblin Market'. Rossetti's narrative describes how two sisters hear the goblins offering their wares. Laura succumbs to the lure of their forbidden fruits, but rather than satisfying her appetite, her craving grows and she sickens. She is saved by her sister Lizzie, who braves the goblin men. They 'squeezed their fruits / Against her mouth to make her eat', but she keeps her lips tightly shut, so instead, the 'juice syrupped all her face, / And lodged in the dimples of her chin'.[33] Laura sucks the pulp from her sister's skin and is revived.

To most mid-Victorians, this would have been read as a straightforward story of Christian morality, suitable for

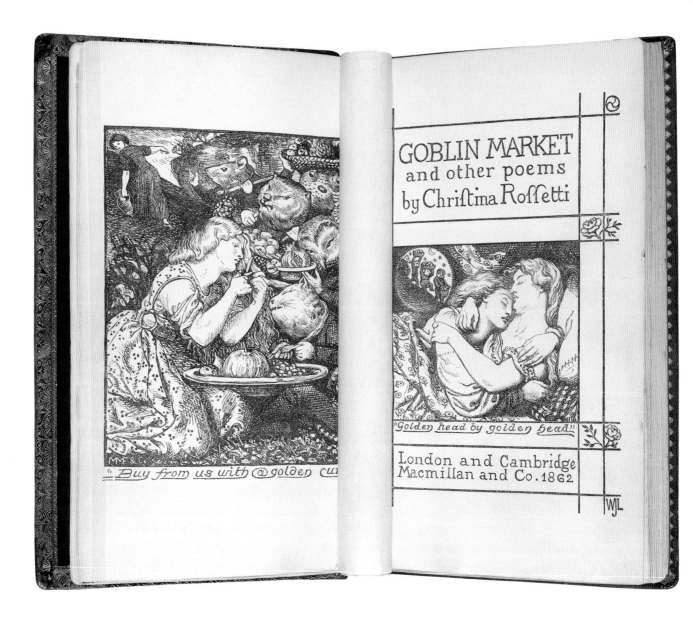

159 Dante Gabriel Rossetti,
Buy from us with a golden curl
and *Golden head by Golden head*,
frontispiece and title page for
'Goblin Market', wood
engravings by Morris, Marshall,
Faulkner and Co., after D.G.
Rossetti, 1862,
11 × 9 cm and 13.2 × 8.1 cm.
V&A: 55.D.15.

children. The fruit clearly relates to Eve's temptation in the Garden of Eden.
Like Christ's body and blood offered in the Eucharist, Laura is redeemed by
Lizzie's self-sacrifice; she is even encouraged by Lizzie to 'Eat me, drink me,
love me.'[34] However, there are other possible readings. One refers to drug
addiction, which eventually killed Christina's sister-in-law, Elizabeth Siddal, who
died on 11 February 1862 from an overdose of the opiate laudanum. There is
also, as Jan Marsh has shown, a 'powerful undercurrent of eroticism that drives
the verse'[35], and Christina herself suggests that the goblins' temptations are sex-
ual, in the poem's references to another girl, Jeanie, who had tasted the fruit.
She died, because she experienced 'joys brides hope to have'[36] – that is, carnal
pleasure.

It is this sexual suggestiveness which is picked up by Dante Gabriel Rossetti
in his designs for the frontispiece and title page (plate 159). He had agreed to
help his sister, in the hope that his illustrations would make 'an exceedingly

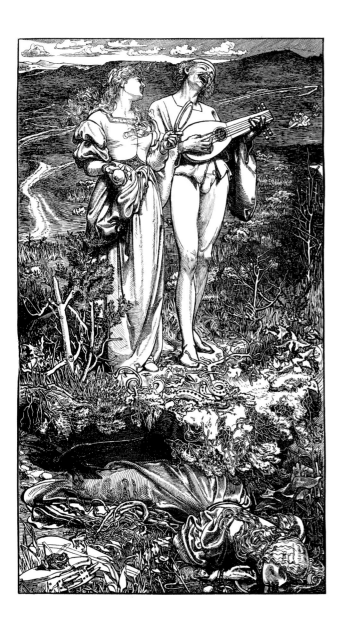

160 Frederick Sandys,
Amor Mundi,
wood engraving, engraved by J. Swain, proof, 1865,
17.5 × 9.8 cm.
V&A: 21764.

pretty little volume and to bring it out as a Christmas book'.[37] In his illustrations, he dwells on the fleshiness of the sisters, especially in *Golden head by Golden head,* where 'cheek to cheek and breast to breast' they lie together in bed.[38] The ample bosom and bare arm, the flowing hair, the touch of hand on throat and shoulder, are carefully delineated. The substantial bodies and voluptuous features of the girls are akin to the models Rossetti used for his most sensual oil paintings of the 1860s, especially Fanny Cornforth. In his other works, Fanny often appears as an allegorical figure of desire. So Christina's poem, seen through the eyes of her brother, seems more closely related to the fallen, and now redeemed, women of the Highgate Penitentiary than most contemporary critics recognized.

The tension between the spirituality and carnality, explored in other poems by Christina, also attracted the attention of her brother's friends. Frederick Sandys produced a memorable illustration to 'Amor Mundi' (plate 160). Written in February 1865, the poem and its illustration appeared in the second issue of *The Shilling Magazine* in June. A young man is seduced into taking the easy, downhill path by a woman with 'lovelocks flowing' and 'swift feet' who proves false: the path they follow is 'hell's own track'.[39] Sandys interprets and embellishes the moral of the verse with the elaborate details of his design. His illustration is filled with serpentine lines, of roots, hair and pleated costume, which threaten to entrap the unsuspecting lutenist. His lover is leading him to the end of the path, where the ground will crumble beneath his feet and cast him down with the corpse that lies in the hollow. Her dead face is pressed against a mirror, a memento of her vain life, like the musical instruments that lie beside her. A snail, a rat, a toad and a carrion crow lurk in the foreground. As with Rossetti's illustrations for 'Goblin Market', Sandys makes explicit references to the sins of the flesh, with a tiny courting couple sitting on the hillside, although this is only one possible reading of Christina's ambiguous verses. The repellent imagery of Sandys' work, and the allure of Dante Gabriel's designs, can overshadow the multi-layered meanings offered by Christina.

However, Christina seems to have accepted Sandys'

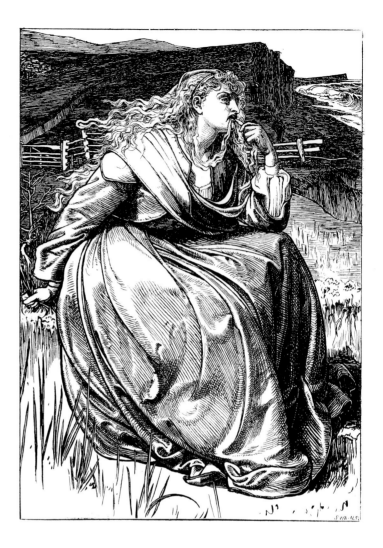

161 Frederick Sandys,
If,
wood engraving, proof on India paper,
engraved by J. Swain, 1866,
15.2 × 10.8 cm.
V&A: E.167–1910.

treatment of her poem, as she agreed with Dante Gabriel's suggestion that he
should also illustrate 'If' (plate 161). Her verses, which tell of a woman's long-
ing for her lover overseas, were published with his design in *The Argosy* in
March 1866. Like many of the Pre-Raphaelite illustrators, Sandys admired the
prints of Albrecht Dürer (1471–1528), and his composition for 'If' pays hom-
age to Dürer's massive female figure in *Melencolia* (woodcut, 1514). Sandys had
already referred to this famous Renaissance print in his illustration for 'Until
her death', published in *Good Words* in 1862, which retained many of the six-
teenth-century details.

Sandys' design for 'If' can be seen as a marker in the development of his art.
It shows him reworking an earlier image, and updating it with contemporary
costume. It is also in this design that Sandys first uses the motif of the woman
biting her hair, to signify troubled sensuality; he returned to this idea, with
vigour, in his images of *Proud Maisie* two years later. His landscape study for
the background of this print (plate 162) sheds further light on the gestation of
his most celebrated works. Sandys made careful studies from life for all the
details of his prints. However, he would often keep these drawings for years

162 Frederick Sandys,
Weybourne Cliff,
black and white chalks on grey
paper, 1 November 1858,
13 × 21.9 cm.
V&A: E.4142–1909.

before making use of them: most of his landscape backgrounds, including this one, were sketched over a few months in Norfolk in 1858, and became 'a repertoire of …motifs that he could draw upon for the rest of his career'.[40]

The tautness of Sandys' images, constructed from these carefully considered drawings, is, to a certain extent, sympathetic to the finely wrought verse by Christina Rossetti which he illustrated. However, both Sandys and Dante Gabriel Rossetti create a concrete vision from her suggestive poetry, and the solidity of their female figures can detract from the delicacy and ambiguity of her yearning women. Christina might have found that Burne-Jones' girls, with their solemn, refined features, could have reflected her intentions more closely, as they step lightly between the earthly and spiritual realms.

However, all three artists, Burne-Jones, Rossetti and Sandys, were more interested in depicting their ideal of female beauty than exploring the characters of real women. By the mid-1860s, they had established a 'type', and sought models who would conform to this image. They may not have been reproducing the conventional prettiness of the Victorian Miss, nor the placid features of Raphael's Virgins, which the early PRB tried so hard to avoid, yet Rossetti's voluptuous allegories, and Burne-Jones' sensitive waifs, were figments of their imagination rather than studies from nature. The aspirations of the women who modelled for these paintings, or who created works of art in their own right, were often obscured by the image constructed by the male artist. The fate of the women of the Pre-Raphaelite circle can sometimes resemble that of the Lady of Shalott. In her own sphere she is a singer and a weaver, but when she becomes subject to the male gaze, her skills are overlooked. In Lancelot's eyes, she is significant only because 'She has a lovely face.'[41]

Jewellery

When May Morris died in October 1938, she left a number of pieces of jewellery to the Museum which had belonged to her mother, Jane. As an accomplished designer herself, she wanted to acknowledge the long-standing relationship between her family and the V&A Museum.

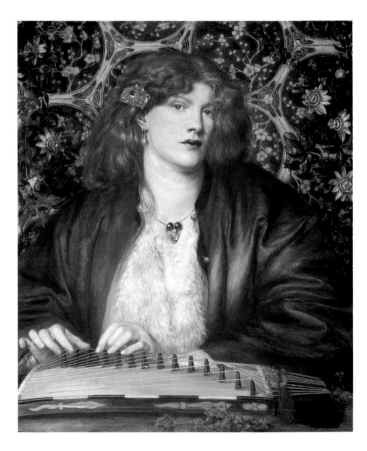

ABOVE

PLATE 163 *Heart brooch*, silver and paste, Eastern European, mid-19th century. V&A: M.40–1939. This brooch was given to Janey Morris by Rossetti. It was worn as a pendant by Fanny Cornforth in the painting *The Blue Bower*, as one of the sensory delights on display, as it nestles against Fanny's throat and brushes against the fur lining of her open bodice.

ABOVE RIGHT

PLATE 164 Dante Gabriel Rossetti, *The Blue Bower*, The Barber Institute of Fine Arts, University of Birmingham / Bridgeman Art Library, oil on canvas, 1865.

RIGHT

PLATE 165 *Belt and hanger*, silver, probably German. V&A: M.34–1939. Rossetti's sonnet for his picture *Astarte Syriaca* (plate 144) describes this floral chain as 'Her two-fold girdle [that] clasps the infinite boon / Of bliss',[1] emphasizing the eroticism of her figure.

PLATE 166 Dante Gabriel Rossetti, *The Beloved*, oil on canvas, 1865–6, Tate Britain.

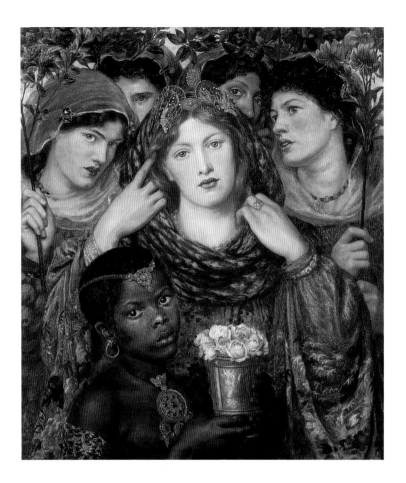

PLATE 167 *Gold chain and ring*, hallmarks for 1858. V&A: M.37 & a-1939. This chain, worn by Jane when she sat for *Mariana* (Aberdeen Museum, oil on canvas, 1870), holds her simple wedding ring.

PLATE 168 *Dragon-headed bangle*, gold and rubies, South Indian or Burmese. V&A: M.39–1939. Janey Morris also owned this bangle, worn by the bride in *The Beloved*. Like the Japanese robe and the black servant in the foreground, it reinforces the colourful exoticism of Rossetti's subject.

135

PLATE 169 Attributed to Edward Burne-Jones, *Floral brooch*, gold, silver and amethyst, probably London, c.1890. V&A: M.29–1999. These intertwined flowers and leaves demonstrate the delicacy and invention also found in Burne-Jones' design for a hawthorn cross for Ruskin's May Queen festival (on loan to the British Museum, four-coloured gold, 1883). His interest in gems was both visual and symbolic, as he explained to his friend Frances Horner: 'Sapphire is truth and I am never without it...Ruby is passion and I need it not...And amethyst is devotion.'[2]

PLATE 170 Attributed to Edward Burne-Jones, *Heart brooch*, made by Child and Child, gold, green-stained ivory and citrine, c.1890. V&A: M.28–1999. Burne-Jones often turned his hand to small, personal pieces for his friends, designing decorated bags, fans and shoes, as well as jewellery. This brooch resembles the green, heart-shaped cufflinks that he wore in the last years of his life.[3]

CHAPTER 8

Religion, Death and the Spirit

Religious images were at the heart of the Pre-Raphaelite story. For the artists, they provided a chance to apply their fresh vision to conventional subjects, and for critics, they were a way of measuring the distance between this new school and the Establishment. In the earliest days of the PRB, the ritualistic treatment of the life of Christ proved extremely controversial. Then, in the 1850s, Holman Hunt created enduring icons for the Church of England. Ecclesiastical patronage in the 1860s was essential for the commercial success of the younger generation; Morris and Company specialized in stained-glass production and church textiles. With the rise of Aestheticism, some artists of the Pre-Raphaelite circle represented alternative spiritualities, with Solomon creating images of Judaism and Eastern Christianity. And there was always the underlying fascination with the relationship between the natural and the supernatural worlds, revealed in pictures of spectres and saints.

From the outset, William Holman Hunt had determined that his art would be uplifting and serious. Throughout his career, he created archaeologically correct, intensely coloured paintings that brought the Victorian public face to face with their Saviour. His position as 'the High Priest of Pre-Raphaelitism'[1] was assured by his most popular picture, *The Light of the World* (Keble College, Oxford, oil on canvas 1853–4), and reinforced by the determined manner in which this painting was marketed. By the end of the century, there were few in Britain who had never seen this image of Christ knocking at the door. In 1860, the painting toured for nineteen months around Britain, to encourage sales of the engraved version (plate 171). Indeed, the reproductions were so commercially successful that the image was often pirated. Then, in 1906, a life-size replica (St Paul's Cathedral, London, oil on canvas, 1900–4) was shown around the British Empire, with an estimated seven million people joining the hushed lines of viewers who filed through the carefully lit exhibition for their encounter with the figure of Christ.

However, when this painting was first shown at the Royal Academy in 1854, it suffered the fate of many early Pre-Raphaelite works. It was criticized for lack of beauty and its heavy symbolism. It was intended to illustrate from 'Revelations' (chapter 3, verse 20): 'Behold, I stand at the door and knock: if any man hear my voice, and open the door, I will come into him, and will sup

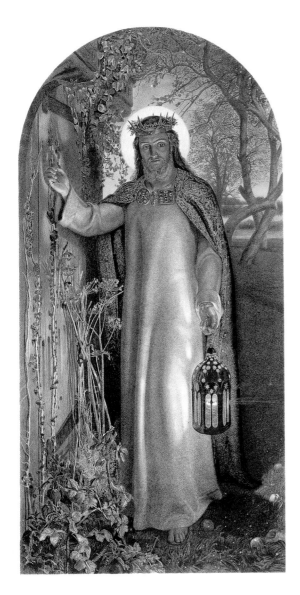

171 William Holman Hunt,
The Light of the World,
engraving and stipple engraving published by
E. Gambart & Co., 1861,
74.3 × 42.5 cm.
V&A: E.135–1970.

with him, and he with me', but the *Art Journal* complained, 'Of the thousands who will see this picture, but few will understand its purpose'[2], and the *Athenaeum* called it 'a most eccentric and mysterious picture'.[3] Yet again, Ruskin's intervention transformed the attitude of the public and press. In a letter to *The Times* of 4 May 1854, he wrote, 'for my own part, I think it one of the very noblest works of sacred art ever produced in this or any other age'.[4] This was high praise indeed. Ruskin's elucidation of the significance of Hunt's finely drawn details helped audiences to understand the picture. As Hunt himself felt compelled to paint this subject 'with what I thought to be a divine command'[5], so he expected his audiences to meditate on the sacred symbolism of his work. He explained, for example, that 'the closed door was the obstinately shut mind'.[6] As the tide of opinion turned in its favour, so the art dealer Gambart became more interested in the painting, and decided to invest £200 in buying the copyright. A complex engraving was commissioned from William Henry Simmons, and the first official version was issued on 30 November 1861. This edition comprised 500 lettered proofs and fifty artists proofs, which cost the substantial sum of eight guineas apiece. Smaller, cheaper engravings were announced in 1865 to meet the increasing demand for a popular print.

Millais

Gambart was not alone in recognizing the potential market for affordable sacred art. The Dalziel brothers were also commissioning religious engravings from Pre-Raphaelite painters; in 1857, together with the publisher Routledge, they asked Millais to design twenty illustrations for *The Parables of Our Lord*. A dozen of these wood engravings were first seen in *Good Words* magazine (1862–3) and were then produced as a gift-book in 1864. Although Millais was always conscientious in his work, the sacred nature of these subjects required extra care, drawing each design 'perhaps a dozen times before I fix [it], and the "Hidden Treasure" I have altered on the wood at least six times'.[7] Unlike Hunt, who made a living from depicting the facts of the Christian faith, Millais approached the Bible stories more subtly. His

172 John Everett Millais,
The Lost Piece of Silver,
wood engraving, proof on India paper, engraved by Dalziel
Brothers, 1863,
33 × 24 cm.
V&A: E.283F–1893.

173 John Everett Millais,
St Agnes of Intercession,
etching, 1850,
14.3 × 22.5 cm.
V&A: E.5150–1910.

son explained that, 'though he seldom went to church…Christianity was with him a living force by which his actions were habitually controlled'[8], and it was this practical presence which he explored in the *Parables*. Rather than overloading the viewer with symbolic details, Millais pared the stories down to their essentials. His ability to capture the dramatic and emotional moment, which he demonstrated in his oil paintings, was refined in these designs. One of the most successful, *The Lost Piece of Silver* (plate 172), was praised for these qualities by Forrest Reid: 'the line has the flowing elastic quality of a water weed streaming in a current; the background is bare of detail'.[9] Millais' handling of light and shade, with the candlelight allowing us to see the face of the stooping woman, is technically accomplished. However, it can also be read in symbolic terms. Both he and Holman Hunt were exploring the scriptural idea of light as an emblem of revelation and salvation.

Millais' exploration of spiritual subjects went much further than the biblical illustrations he prepared for the Dalziels. His work constantly returned to the theme of mortality. Roger Bowdler has shown how Millais addressed the idea '*Ars longa, vita brevis*' (life is short, but art endures) throughout his career, long before he adopted this as his motto when he became a baronet in 1885.[10] We have already noted how the portrait of his grandson, known as *Bubbles* (see plate 24), was intended as a meditation on the ephemeral nature of childhood.

Millais' preoccupation with the boundaries between life and death can be traced in two early works in the V&A's collections. In 1850, he produced an etching that should have been published in the fifth issue of *The Germ*, but the magazine folded after four. Millais' illustration for Dante Gabriel Rossetti's story *St Agnes of Intercession* (plate 173) shows an artist painting the portrait of his dying lover as she is comforted by her two sisters. The heroine of the story, Blanzifiore dall'Ambra, insisted that she should rise from bed and sit to Bucciolo, 'for so, she said, there should still remain something to him whereby to save her in his memory'.[11] Thus she would fulfil Millais' motto, that art remains when life has passed. Millais' delicate handling of the etched line suggests the fragility of the girl's condition, and the painter's pose as he gazes on his beloved gives a sense of urgency to the image. Although the story has a Renaissance setting, Millais avoids

overplaying the historical detail, and focuses, even at this early stage in his career, on the emotional interaction. He manages to create tension by the limited gestures of the group. Rossetti's later version of a very similar subject, now entitled *Bonifazio's Mistress* (Birmingham Museums and Art Gallery, pencil, pen and ink, c.1856, 19.3 x 16.8 cm) is more dramatic, as he depicts the moment when the girl dies, contrasting her lively painted image with the closed eyes and swoon of approaching death.

By 1853, Millais had moved on to depict an encounter between lovers now separated by death. In *A Ghost appearing at a Wedding Ceremony* (plate 174), Millais explores the borderland between the visible and supernatural worlds. A bride sees the spectre of a former sweetheart, mournfully clutching his broken heart, rising up behind her bridegroom. She shrinks back, refusing to accept the wedding ring; the drawing is inscribed: 'I won't, I don't.'

Although some parts of the picture are well defined, especially the faces of the central characters, other sections remain sketchy. In this respect, the drawing differs from other designs to which it is related. In 1853–4, Millais explored the subjects of both marriage and death in a series of drawings, most of which are more highly finished than this, and are signed and dated by the artist, unlike the V&A's example. These include *Married for Love* (plate 175) and *The Dying Man* (Yale Center for British Art, pen and sepia ink with wash, 1853–4, 19.7 x 24.4 cm). It seems that Ruskin may have suggested the tale of the ghostly apparition to Millais[12], and some critics have read the image as referring to the blighted marriage of Ruskin and Effie. Perhaps the subject became too painful to pursue, and, as a result, the drawing was

RIGHT ABOVE
174 John Everett Millais,
A Ghost appearing at a Wedding Ceremony,
pencil, pen and black and sepia inks, 1853,
29.5 × 28.3 cm. V&A: E.244–1947.

RIGHT
175 John Everett Millais,
Married for Love,
pen and black and sepia inks, 1853,
24.7 × 17.8 cm. © Copyright The British Museum.

176 Dante Gabriel Rossetti,
Study for the Blessed Damozel,
black and red chalk on pale green paper,
c.1873,
83.8 × 71.1 cm.
V&A: E.262–1946.

never completed. However, taken together, this sequence of drawings demonstrates Millais' interest in the vagaries of contemporary life, and his dexterity in describing emotion through finely wrought black and white images. These were the qualities that later enabled him to create such astute illustrations for Trollope and others.

The Blessed Damozel

The subject of longing from beyond the grave remained a favourite among the Pre-Raphaelites and their circle, largely thanks to the impact of Dante Gabriel Rossetti's poem 'The Blessed Damozel'. Originally written in 1848, the poem was published in *The Germ* in 1850, but Rossetti continued to revise it until 1881. It gained a certain notoriety when the manuscript for this and other early poems was placed in Lizzie Siddal's coffin by Rossetti, and buried with her, only to be exhumed in 1869.[13] Rossetti admitted that the poem was partly a response to Edgar Allen Poe's 'The Raven', a poem which fascinated him in the late 1840s: 'I saw that Poe had done the utmost it was possible to do with the grief of the lover on earth, and so I determined to reverse the conditions and give utterance to the yearning of the loved one in heaven.'[14]

Rossetti also tackled this subject in his painting. In 1871, he was commissioned by his patron William Graham to create a visual version, and his *Study for the Blessed Damozel* (plate 176) [15] demonstrates the ambiguity of physical desire felt in the spiritual sphere, which runs through the subject. The medium of red chalk sets the tone, as it emphasizes the soft surfaces of the Damozel's body. The verses which Rossetti chooses to illustrate also focus on the sensual longing of the girl, undiminished even in Heaven. As she looks out, she sees 'the souls mounting up to God…like thin flames', but she is represented in far more physical terms: 'her bosom must have made / The bar she leaned on warm'.[16] The model for this picture, Alexa Wilding, was also associated with some of Rossetti's most sensuous works, including the nude *Venus Verticordia* (The Russell-Cotes Art Gallery and Museum, Bournemouth, oil on canvas, 1864–8). The finished oil painting is even more overt in stressing the physical aspects of this tale, as Rossetti fills the background with embracing couples, whose presence highlights the loneliness of the Damozel.

Simeon Solomon

This elision of sacred and sensual was a feature of the Aestheticism that developed among Rossetti's associates in the 1860s and 1870s. Simeon Solomon, for example, increasingly used religious imagery as a starting point for more

esoteric subjects, notably his unconventional sexuality. Solomon had established his reputation with illustrations of Jewish customs, published in *The Leisure Hour* in 1866. Unlike his brother Abraham and sister Rebecca, both professional painters, Simeon Solomon emphasized his Jewish background by concentrating on subjects from the Old Testament. The V&A's collection contains not only works such as *Isaac and Rebekah* (V&A: P.46–1925, watercolour, 1863, 29 × 20 cm), but also photographs of Solomon's designs, recorded by Frederick Hollyer. These show how he was exploring central Jewish texts, including the 'Story of Ruth' (plate 177), and a sequence of eight images from 'Song of Songs'. In *His pavilion over me was Love* (chapter 2, verse 4) (plate 178), Solomon dwells on the physical desire expressed in the 'Song of Songs' rather than the more symbolic readings of this scripture. He returns to the triangular relationship which was so blatantly displayed in *The Bride, Bridegroom and Sad Love* (see plate 39), with the bridegroom here reclining in the arms of a haloed male angel, while his bride leans against him, her face hidden. Solomon refuses to make a strong distinction between the features and bodies of his male and female figures in this series. The soft, overlapping lines of their legs and sinuous drapery adds to the confusion. The dreamy pose of the bridegroom and the loving look of the angel who supports him create an impression of languid sensuality, with an emphasis on the relationship between the two male figures. The drifting, entwined bodies also echo another tale of illicit passion depicted by Rossetti: Paolo and Francesca, condemned by Dante to be tossed in the winds of Hell for their adultery.

Even when Solomon illustrated the story of a

LEFT ABOVE
177 After Simeon Solomon, *Story of Ruth*, title page, photograph by Frederick Hollyer, 1879, 27.8 × 18.4 cm. V&A: 2808–1901.

LEFT BELOW
178 After Simeon Solomon, *His pavilion over me was Love*, chapter 2, verse 4, 'Song of Songs', photograph by Frederick Hollyer, photographed 1878, 22.3 × 18.1 cm. V&A: 276–1931.

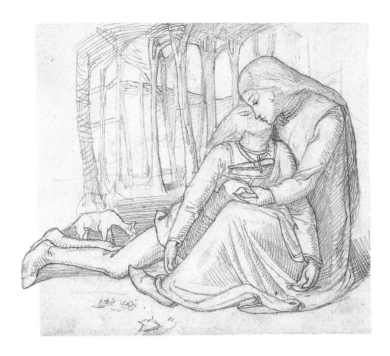

179 Simeon Solomon,
St Margaret of Cortona and her dead lover,
pencil, c.1860,
12.5 × 13.6 cm.
V&A: E.5175–1919.

medieval saint, Margaret of Cortona, he chose to focus on her status as a fallen woman rather than her later role as penitent and visionary. *St Margaret of Cortona and her dead lover* (plate 179) was probably conceived for Mrs Jameson's *Lives of the Minor Saints*. In traditional iconography, St Margaret was often shown with the dog which led her to her murdered lover, but this image of the saint, without a halo, embracing his dead body, is extremely unconventional.[17] The angularity of the figures and their awkward poses, defying classical standards of composition, are typical of Solomon's earlier style. In his later work he tended to soften the outlines, frequently using pastel and watercolour rather than pen or pencil. This shift in style and medium was also found in Rossetti's pictures of the 1860s. However, while Rossetti was using these new techniques to redefine his ideal of female beauty, Solomon was concentrating on the male figure. As in the Old Testament series, the ostensible theme of many of these studies was religious devotion, but Solomon was subverting the subject.

In his *Priest of the Orthodox Church* (plate 180), Solomon appropriates Rossetti's devices for constructing the image of the ideal woman, unattainable but adored, and transfers these onto a young man. He is isolated, surrounded by decorative, eclectic accessories, dressed in a richly coloured, exotic costume. Above all, his remote gaze, with its suggestion of a trance, allows the viewer to project emotion onto him. The androgyny associated with Aestheticism, and criticized in the work of Burne-Jones, is here taken to even greater lengths. This image of the male priest deliberately contradicts the emphasis on the 'healthy and manful Christianity'[18] which was being preached to young Victorian men. Instead, Solomon draws on the older Greek traditions of worship of the male body, encouraged by writers like Walter Pater. Pater's descriptions of a statue of a *Discobolus*, a young male athlete, focus on the 'inexpressive expression (look into, look at the curves of, the blossomlike cavity of the opened mouth)…beautiful but not altogether virile'.[19] Solomon's priests and ancient gods are to be enjoyed in the same way.

Solomon exploited this confusion of spiritual and physical desire in many of his works, but few were as controversial as his watercolour *Amor Sacramentum* (1868). This picture, reputedly owned by Oscar Wilde, is now lost, but the V&A's collections include a photograph of the work (plate 181). Love himself, clad in a leopard-skin loincloth, holds a budding staff, or thyrsus, one of the attributes of Bacchus. His other hand is wrapped in a cloak, as if he were a priest holding a monstrance, but instead of displaying the body of Christ (in the

form of the consecrated wafer), he exposes a glowing male angel. Love's feminized features and long limbs are presented to the gaze of the audience for their delight, and the ancient Greek temple behind the figure provides a legitimate context for the exploration of male beauty.

Solomon is also deliberately invoking Renaissance images of St John the Baptist, with the attributes of animal skin and staff, and especially Leonardo da Vinci's vision of the saint, now in the Louvre. This picture by Leonardo was also admired by Pater. He describes the 'naked figure…whose delicate brown flesh and woman's hair no one would go out into the wilderness to seek' and who has 'a strange likeness to the *Bacchus* which hangs near it'. Pater suggests that Leonardo only regarded his sacred subjects as a pretext for an exploration of profane sensations, 'as the starting-point of a train of sentiment, subtle and vague as a piece of music'.[20] Pater and Solomon moved in the same artistic set. Indeed, Pater was one of the few friends who remained loyal to Solomon after his conviction. So it is surely not too far-fetched to link the intertwining of St John the Baptist, Bacchus and male/male desire in Pater's essay, with his knowledge of Solomon's painting, created the year before.

Although Solomon produced desirable images for the clandestine homosexual circles of late Victorian London, in his early career he was also working in the mainstream art market. He was commissioned to provide illustrations for one of the most ambitious religious publishing projects, the Dalziels' *Bible Gallery*, where his designs would be seen alongside those by Hunt and other leading artists. Solomon's designs for wood engraving were rarely as fluent as those of his contemporaries like Burne-Jones. After a hesitant start (see plate 69), Burne-Jones had gained in confidence, and his designs for the *Bible Gallery* fully justify Hunt's encouragement to the Dalziel brothers to employ him: 'He is perhaps the most remarkable of all the younger men of the profession for talent…he has had much practice in working with the

RIGHT ABOVE

180 After Simeon Solomon, *Priest of the Orthodox Church*, photograph by Frederick Hollyer, drawn 1867–8, 23.5 × 17 cm. V&A: 2818–1905.

RIGHT BELOW

181 After Simeon Solomon, *Amor Sacramentum*, photograph by Frederick Hollyer, drawn 1868, 24.8 x 14.8 cm. V&A: 2819–1905.

point both with pencil and pen-and-ink on paper, and so would have no difficulty with the material.'[21]

It can help us to understand the awkwardness of wood engraving if we look at some of the drawings onto the block which have survived in the V&A's collection. Burne-Jones' design for *Going into the ark* (plate 182) was transferred, probably by the artist himself, onto the wood, but was never cut.[22] It shows Noah being mocked by merry-makers on the eve of the deluge. The setting sun is highlighted with Chinese white, and fine lines indicate the last rays of light, which will shortly be obscured by rain clouds. Burne-Jones' careful manipulation of the medium makes the most of the delicate detailing which the print could show, like the grass sprinkled with daisies, and the sceptical expressions of the revellers, without obscuring the narrative.

Ford Madox Brown

Burne-Jones used the studies he had made for the Dalziels' *Bible Gallery* as the starting point for larger-scale works,[23] and many other artists followed suit. Ford Madox Brown, for example, always reserved the right to rework his book illustrations as oil paintings when he was negotiating with publishers. Having hit upon a successful composition, he wanted the option to sell it in a variety of media. One version of *Elijah and the Widow's Son* (plate 183) in the V&A's collection was made in 1868 for his Manchester patron Frederick Craven, who only collected pictures in water-colour. It is based on his illustration for the *Bible Gallery*.[24] In this work Brown has retained the bright sunlit colours and archaeological exactness of early Pre-Raphaelitism. When he exhibited an oil painting of the same subject in 1865, he followed Hunt's practice of providing comprehensive notes on the historical and religious symbolism of his picture. So he drew attention to the accuracy of the costume 'devised from the study of Egyptian combined with Assyrian, and other nearly contemporary remains', and explained the significance of the shadow of the swallow returning to its nest in a bottle. This is an emblem of 'the return of the soul to the body'.[25]

While Brown remained true to the original Pre-Raphaelite approach, most of the other artists in this circle had moved on. As a result, the *Bible Gallery* project was ultimately a commercial failure, despite the involvement of leading artists. The discrepancy between the styles of the contributors was just too great. Eventually published in 1881, the volume was also twenty years too late. New printing technologies were superseding wood engraving, and, more importantly, the religious enthusiasm of the mid-Victorians was a thing of the past.

182 Edward Burne-Jones,
Going into the ark,
pen and ink, and Chinese white on boxwood, 1863,
17.8 × 13.3 cm.
V&A: 1069–1884.

RIGHT
183 Ford Madox Brown,
Elijah and the Widow's Son,
watercolour, 1868,
94 × 62.2 cm.
V&A: 268–1895.

However, while it lasted, the market for sacred art was very lucrative. On one level, it generated a healthy readership for uplifting family magazines, such as *Good Words for the Young*. At the top end of the business, the boom in church-building and restoration, largely funded by private sponsors, offered unprecedented opportunities for church furnishers. In the 1860s, this trend made it possible for William Morris and his colleagues to set up a successful company supplying ecclesiastical textiles and stained glass, and many artists in the Pre-Raphaelite circle benefited from these commissions.

Stained glass

Rossetti, for example, regularly contributed designs for stained glass. His cartoon for *The Sermon on the Mount* (plate 184) demonstrates how the artists of the firm collaborated to create the finished window. Rossetti produced the figure drawings using friends and family as models, and then a tracing of the image was submitted to Morris. It was Morris's job to divide up the design into workable units of glass by adding the lead lines. He acted as a translator, conveying the idea of the designer to the glass-maker. By 1862, Morris, Marshall, Faulkner and Co. were employing a dozen men and boys in their own glass workshop in Red Lion Square, London, so Morris was able to oversee the complete manufacturing process.

The success of this part of the firm's business can be gauged by the 130 stained-glass designs commissioned from Ford Madox Brown. These included a series of windows for St Oswald's Church, Durham. The cartoon for *St Oswald receiving Bishop Aidan, the missionary to the Northumbrians* (plate 185) shows Brown's distinctive style, before the design has been broken down into sections by Morris. Brown's figures in these designs are drawn with bold outlines, so that his narratives remain legible even though they are full of incident and decorative detail.

Sadly Morris fell out with both Rossetti and Brown in 1874 over the running of the firm, and their contributions to its stained-glass production ceased. [26] However, his partnership with Burne-Jones remained solid; they were still working side by side until Morris's death in 1896. Burne-Jones was a hugely prolific designer for Morris and Co., but his first attempts at stained glass were manufactured by James Powell and Sons, Whitefriars. A cartoon for *The Good Shepherd* (plate 186) is characteristic of his early unconventional approach to this medium. Powell's had asked Rossetti to supply some designs, but he recommended his young friend instead. Burne-Jones emphasized the two-dimensionality of the glass, breaking down the background into coloured bands rather than attempting to create depth. He simplified the figure drawing, concentrating on the firm grasp of Christ's pierced hands and his determined stride forward. The naivety of the style is echoed in the directness of the symbolism: Christ is the Good Shepherd, bringing home the lost sheep. Both Rossetti and Ruskin were charmed by the design. Rossetti was particularly taken by the

6

ABOVE
187 Edward Burne-Jones,
Cartoon for the Good Shepherd, pencil, design for stained glass for
St Martin's Church, Brampton, Cumberland, 1870s,
26.2 × 14.6 cm. V&A: E.1613–1926.

RIGHT
188 Edward Burne-Jones,
Cartoon for Adam and Eve after the Fall, watercolour and ink, design
for stained glass for Bradfield College, 1858,
215 × 48.5 cm. V&A: E.1319–1920.

FAR RIGHT
189 After Edward Burne-Jones,
Cartoon for Last Judgement, photograph with tempera and chalks,
design for St Philip's Cathedral, Birmingham, 1896,
26.4 × 102.9 cm. V&A: 1000–1901.

sheep 'chewing some vine leaves which are wound round his hat – a lovely idea is it not? A loaf and a bottle of wine, the sacred elements, hang at His girdle.'[27]

The immediacy of this image of the Good Shepherd established Burne-Jones' reputation as a designer of stained glass. He returned to the same subject in 1880 as the focal point of an elaborate chancel window for St Martin's Church, Brampton, Cumberland. A preparatory drawing (plate 187) shows how Burne-Jones' style evolved in the intervening years. Christ is no longer represented as a down-to-earth shepherd, complete with peaked hat and wine flask. All the quirky symbolic details have been removed, and now Christ is represented as an elongated, classical figure, placed at a distance from his worshippers. The complex folds of drapery provide the only decorative element in this new vision.

His earliest working drawings for glass, such as *Adam and Eve after the Fall* (plate 188), had been a patchwork, with extra slips of paper pasted over the main image. This technique contributed to the impression of a broken surface, echoing the lead lines holding together the sections of coloured glass in the finished window. As his career progressed, Burne-Jones increasingly emphasized this idea of disruption in his designs. So the drapery of *The Good Shepherd* of 1880, the most prominent aspect of the preparatory drawing, became a cascade of carefully modulated shards of glass. And by the 1890s, when he created the *Last Judgement* scene for the West Window of St Philip's Cathedral in Birmingham, this tendency to fragment the figures had driven away all vestiges of naturalism. From the 1870s, Burne-Jones often used photographic enlargements of his drawings, which he then worked over with tempera and chalk to assist the craftsmen, and one of these coloured photographs for the *Last Judgement* window has been preserved by the Museum (plate 189). This object differs from the completed stained glass in two important ways. Firstly, it is much more subdued in colour, lacking the intense reds and blues of the window, and secondly, the web of lead lines is not yet indicated. However,

the photograph does capture the extraordinary linear style that is the climax of Burne-Jones' stained-glass designs. Jagged folds of drapery and toppling buildings overwhelm the crowded figures. Burne-Jones imagines the Apocalypse in terms of artistic abstraction.

Of course, this deliberate rejection of naturalism looked backwards as much as it looked forwards. Burne-Jones had long been fascinated by the simplified forms of Byzantine art, and his over-tall figures, ranks of angels and angular drapery had their counterparts in the famous fifth and sixth-century mosaics of Venice and Ravenna. These mosaics fulfilled two of Burne-Jones' strongest desires in art. They represented the electric moment when the classical world collided with the emergence of medieval spirituality. They were also built into the architecture of the ancient churches. 'I never could understand but a picture painted in the place it's intended to fill,' Burne-Jones told Rooke in 1897. He 'never really cared for anything but architecture and the arts that connect with it'.[28]

Mosaics

Burne Jones' work in stained glass allowed him to explore the relationship between architecture and the figurative arts. However, he yearned for more drama. He and Ruskin had talked about creating a chapel decorated with 'hierarchies and symbols and gods'[29], and in 1881, it seemed that this fantasy might be realized. The American expatriate community in Rome had commissioned G.E. Street to build the first Protestant church in the city. The Romanesque style of St Paul's Within-the-Walls (1872–6) was the ideal backdrop for mosaics, and in 1881, Burne-Jones was offered the chance to decorate the apse. His first design was for the *Heavenly Jerusalem*. He imagined Christ enthroned before the walls of Heaven, flanked by his archangels; the niche where Satan once sat at Christ's right hand is empty.[30] The mosaic was unveiled on Christmas Day 1885, after many months of discussion with the craftsmen of the Venezia-Murano Company, who had to reconstruct Burne-Jones' ideas using thousands of tiny tesserae. He sent Rooke to Italy to oversee the work, with instructions that the design must be 'VISIBLE, INTELLIGIBLE at a distance…that the wings shall be shaded gold colour…the hair dark, the faces sweetly pale'.[31]

With the proven success of this first mosaic, he was able to begin further decorations, including an *Annunciation* (1886–94) and a large *Earthly Paradise*, completed after his death by Rooke (1886–1907). He also created a highly original Crucifixion scene known as *The Tree of Life* (1886–94), with Adam and Eve replacing the traditional figures of St John and the Virgin. As this mosaic was to be installed in the second chancel arch, Burne-Jones had to adapt his design to the shape of the architecture. In 1888, he produced several large coloured sketches that he later displayed in his drawing room at home, among them a watercolour and gouache version of the *Tree of Life* (plate 190), which was bought by the Museum soon after Burne-Jones' death. He was particularly

190 Edward Burne-Jones, *Tree of Life: study for American Episcopal Church mosaics*, watercolour and gouache, 1888, 181 × 242 cm. V&A: 584–1898.

pleased with what he called 'that design of Christ (the man and woman with the fruits of the earth) [as] it said as much as anything I have ever done'.[32] The pain of the crucified Christ is replaced by a meditation on the promise of Resurrection, reflected in the vitality of the natural world, with the wheat-sheaves and lilies. These elements also provide symbolic references to the Last Judgement and to the Annunciation. But the most astonishing aspect here is the tree that has supplanted the Cross. Its sinewy form pushes out of the ground with extraordinary energy, and the swirling branches seem to prefigure the whipping line of *fin-de-siècle* Art Nouveau.

These mosaics came closest to his dream of 'big things to do and vast spaces and for common people to see them and say Oh! – only Oh!'.[33] Sadly, he never travelled to Italy to view them in situ, and could only imagine their impact.

When Burne-Jones tried to explain his approach to religious subjects to his young friend Frances Horner, he told her that he delighted in 'the Mystical part' of Christianity.[34] This was certainly borne out in the book-bindings which he designed for her. A preparatory drawing for a vellum binding for the

191 Edward Burne-Jones,
Sapientia,
design for the cover of the *Apocrypha,*
pencil, sketchbook, 1879,
26.2 × 14.6 cm.
V&A: E.1613–1926, p.26R.

192 Edward Burne-Jones,
Memorial for Laura Lyttleton,
gilded and coloured plaster, c.1886,
180.7 × 70.1 cm.
V&A: P.85–1938.

Apocrypha appears in one of the V&A's sketchbooks (plate 191). Burne-Jones' allegory of Wisdom is a beautiful woman, enthroned upon the earth with stars above her head, holding a tablet with verses from 'Ecclesiasticus' 24: 'I am the mother of fair love, and fear, and knowledge, and holy hope.' Such fine bindings reminded Burne-Jones of his early love of medieval manuscripts, and as a result, his figure of Wisdom is imposing, static and belongs to the Age of Faith rather than the Age of Reason.

Several of Burne-Jones' most contemplative works, including this book-binding, were produced to commemorate his friendships with attractive young women. When Frances married in 1883, Burne-Jones was saddened that he would no longer be able to make 'Heavens and Paradises for her prayer-books, Virtues and Vices for her necklace-boxes'.[35] Another young friend, Laura Lyttleton (née Tennant), was the inspiration for an unusual memorial tablet. She died in childbirth in 1886, and Burne-Jones volunteered to design a monument for St Andrews Church, Mells. The original memorial was plain white, but Burne-Jones produced a second version which remained on display in his home. In this gilded and coloured tablet (plate 192), Burne-Jones returned to the arcane symbolism of the early church, with a peacock and an olive branch bursting through the grave as emblems of the Resurrection. Although his sculptural works are limited, he experimented with this medium like many of his contemporaries, including Leighton and G.F. Watts, and as well as producing gesso designs for furniture and friezes, he created funeral monuments for his valued patrons, William Graham and Frederick Leyland.[36]

The choice of the peacock as the central motif reflected the current Aesthetic fondness for the decorative qualities of peacock feathers – they were printed on textiles or displayed in blue-and-white vases. However, by adopting this ancient symbol of new life, Burne-Jones was also reinventing conventional Christian images so that his generation could experience them afresh. In the same way that the Crucifixion became in his hands *The Tree of Life*, so with this memorial, the peacock transformed the grave into a site of beauty.

In this private commission, Burne-Jones worked in his idiosyncratic classical style. However, his tapestry designs for Morris and Co. returned to the medieval manner associated with the firm. It was also more appropriate for the medium, reflecting the historical origins of the craft. In his design for the *Adoration of the Magi* tapestry, woven for the chapel of Exeter College, Oxford, Burne-Jones' debt to the Gothic world was made explicit. A sketchbook in the museum (plate 193) shows how he had copied details from the *Adoration of the Lamb* altarpiece by Van Eyck in Ghent, carefully studying the Virgin Mary's crown, and these notes were remembered when he began work on the tapestry some twenty years later. The distinctive design of lilies and roses reappears in the crown placed at the feet of the Virgin and Child by the eldest of the wise men. The importance of this decorative object as a homage to Van Eyck becomes clearer when we realize that most of the clothing patterns and

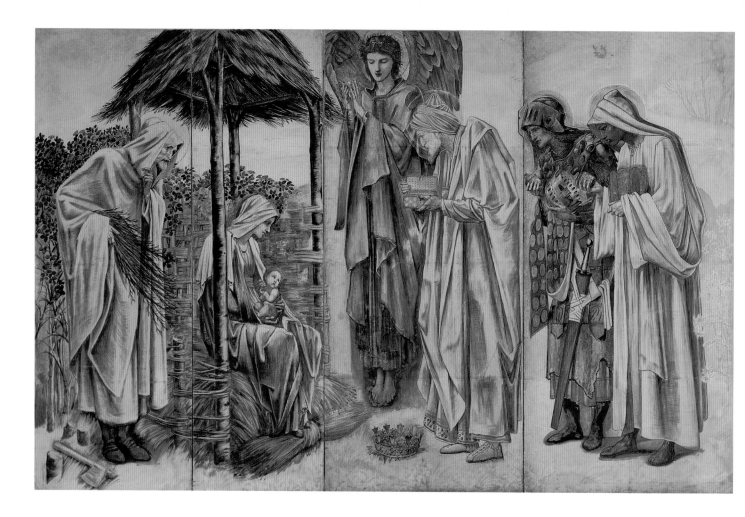

193 Edward Burne-Jones,
Studies after Van Eyck, c.1858–67,
pencil and watercolour,
19.1 × 26.4 cm.
V&A: E.4–1955, p.84.

background for this tapestry were added by Morris. Burne-Jones made sure that the crown was carefully established in all its details in preparatory studies for the work, well before his colleagues had begun ornamenting the robes of the figures.

Another study for this tapestry, a full-size photographic enlargement of Burne-Jones' drawing coloured by the artist (plate 194), includes the Van Eyck crown, and shows how the complete design was translated for the craftsmen. It was so large that it had to be blown up in four separate sections, and then Burne-Jones painted over the photograph with watercolour. This technique, also used by Morris and Co. for stained glass since the 1870s, meant that the artist's outlines could be faithfully transferred onto a much larger scale. So the company was not afraid to apply the latest technology to ancient crafts, if it allowed the finished object to reflect the original intentions of the artist more closely. This enlargement was used in the tapestry studio, and was then offered as a gift to the Museum in 1919 by Morris and Co., as they said that they should not be weaving any further versions of the design.[37] Burne-Jones himself was so pleased with the subject that he produced

LEFT

194 After Edward Burne-Jones
with details added by the artist,
*Cartoon for the Adoration of the
Magi tapestry*, photographic
paper heightened with
bodycolour and watercolour,
1888,
240 × 376 cm.
V&A: E.5012–1919.

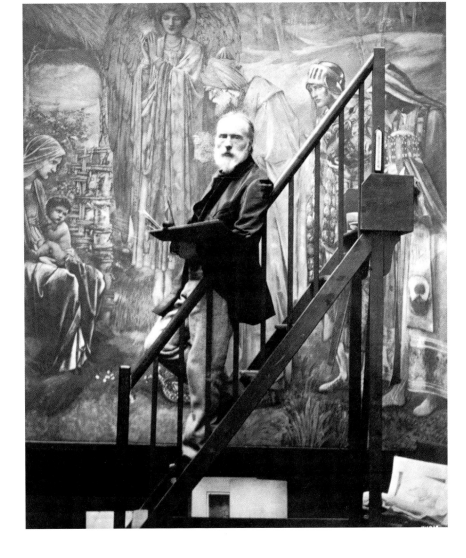

195 Barbara Leighton,
Edward Burne-Jones working on
The Star of Bethlehem,
photograph, 1890,
32.8 × 27.5 cm.
V&A: Ph.11–1939.

196 Edward Burne-Jones,
Study for
The Star of Bethlehem,
1887, pencil,
10.2 × 17.2 cm.
V&A: E.9–1955, p.89.

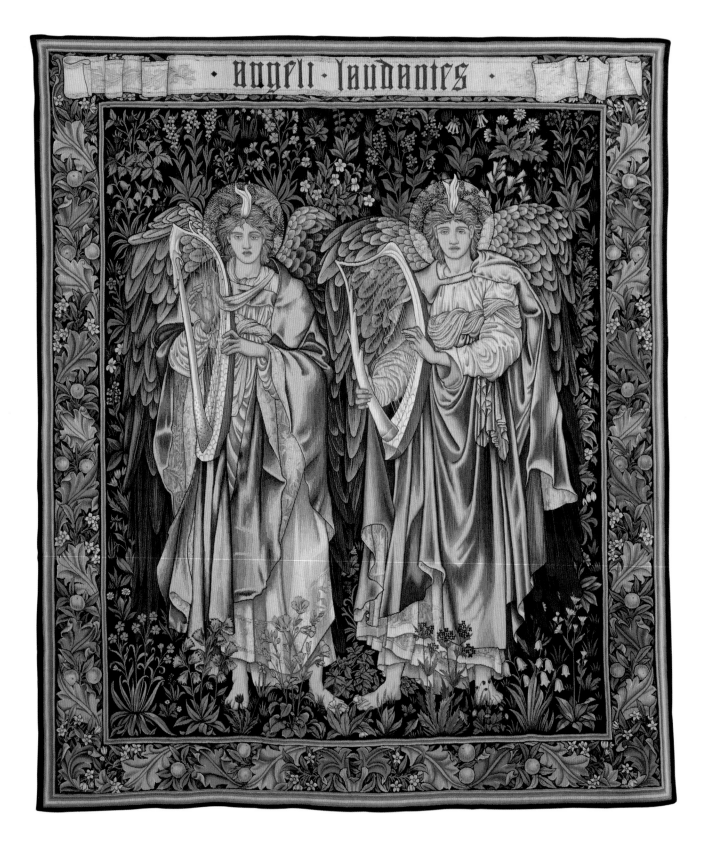

197 Designed by Henry Dearle with figures by Edward Burne-Jones, *Angeli Laudantes*, woven at Merton Abbey, wool, silk and mohair in a cotton warp, 1894, 237.5 × 202 cm. V&A: 153–1898.

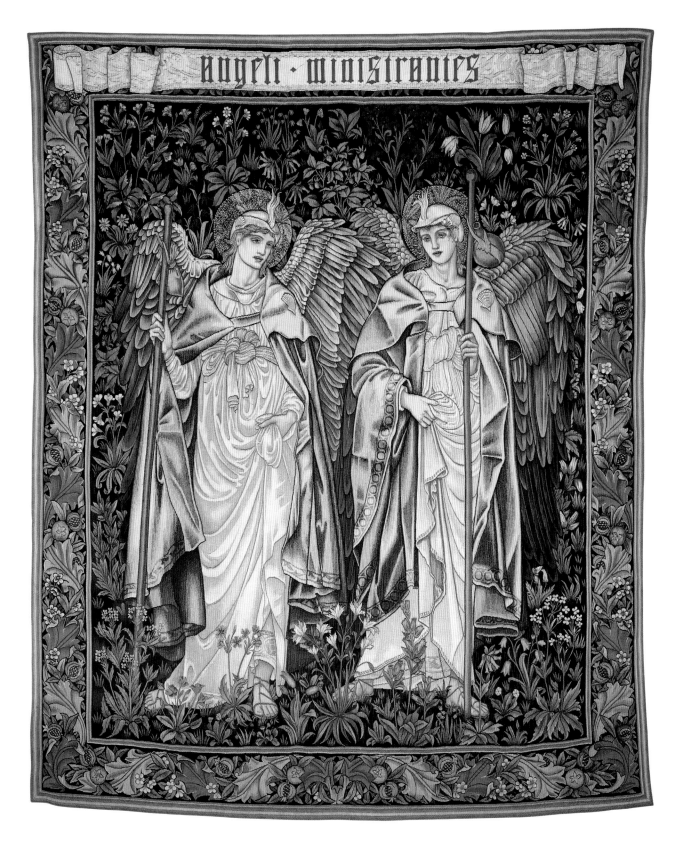

198 Designed by Henry Dearle with figures by Edward Burne-Jones,
Angeli Ministrantes, woven at Merton Abbey, wool, silk and mohair in a
cotton warp, 1894, 241.5 × 200 cm. V&A: T.459–1993.

a massive watercolour copy in the last years of his life, now in Birmingham City Museum and Art Gallery.

This image of the Incarnation as an encounter between ancient wisdom and the vulnerable Christ Child reflected Burne-Jones' somewhat unorthodox response to the Anglicanism of his youth. Certainly, when he was asked by a young visitor to his studio whether he believed the story of the Nativity, he replied, 'It is too beautiful not to be true.'[38] Unlike many of his contemporaries, most notably Holman Hunt, but also Madox Brown, he had no archaeological interest in the Holy Land, and made no attempt to recreate the physical reality of Christ's life on earth. For Burne-Jones, religious faith was not bound to specific times or places. Instead, in his work it was expressed in the most beautiful forms he could find, which included quotations from Byzantine or late medieval sources rather than in the more historically accurate details unearthed by Holman Hunt.

In Burne-Jones' eyes, the spiritual world was constantly overlapping with the world of men, so his angelic figures were just as real as his saints and sinners. He demonstrated the interconnectedness of this world and the next by filling his pictures with angels: cherubs with chubby legs, stern warriors guarding the gate of the Garden of Eden, and gracious hermaphrodites like the *Star of Bethlehem* itself. His studies for the Nativity scene reveal how the intervention of God, in the figure of the Star, became increasingly important in his interpretation of the ancient story. In his early sketch of the subject (plate 196), the Star was an onlooker, standing behind the Holy Family, but this figure eventually became the central player in the Gospel drama.

Burne-Jones' conversation revealed how often he dwelt on a vision of paradise, where he hoped to hear the angels sound their trumpets every morning.[39] So it is unsurprising that his imagination should have been stirred by the project to create stained-glass windows for Salisbury Cathedral, showing angels praising God and ministering to his people. These designs for *Angeli Laudantes* and *Angeli Ministrantes*, first produced in 1877–8, were translated in the 1890s into figures for tapestry (plates 197 and 198). Henry Dearle added the borders and *mille-fleurs* backgrounds, making a visual connection to the medieval heyday of tapestry weaving.[40]

Throughout his career, Burne-Jones followed the example of the Middle Ages by presenting the Bible stories to worshippers not through oil paintings, but through the decorative arts of stained glass, textiles and mosaics. He worked on a grand scale, with vibrant colours that were legible to congregations as they sat in their pews. Despite his Anglican upbringing, Burne-Jones longed to re-create the spectacle of the pre-Reformation church, with incense, bells and pools of coloured light. Together with his friend Morris, and the teams of weavers, glass-blowers and printers employed by the firm, he was able to bring his visions of saints and angels to the heart of the Victorian city.

CHAPTER 9

Music

Among the paintings bequeathed to the V&A by Constantine Ionides, *The Mill* (plate 199) is one of Burne-Jones' finest evocations of music and mood. He had long been preoccupied with the conjunction of soft sound, still waters and slowly moving girls, and this was his most sustained attempt to resolve these subjects. Even Henry James was perplexed by the work: 'Suffice it that three very pretty young women...are slowly dancing together in a little green garden, on the edge of a mill-pond...I have not the least idea who the young women are, nor what period of history, what time and place, the painter had in his mind.'[1] The young women, in fact, would have been well known to the original owner of the painting, as they are Aglaia Coronio, Maria Zambaco and Marie Spartali, beauties from the Greek community in London. But alongside these idealized portraits of real women, Burne-Jones added an androgynous musician, who appears almost as a revenant or saint. The arch above the musician's head creates the effect of a halo, outlining a sliver of the evening sky.

199 Edward Burne-Jones,
The Mill,
oil on canvas with stamped
decoration, 1870–1882,
90.8 × 197.5 cm.
V&A: CAI8.

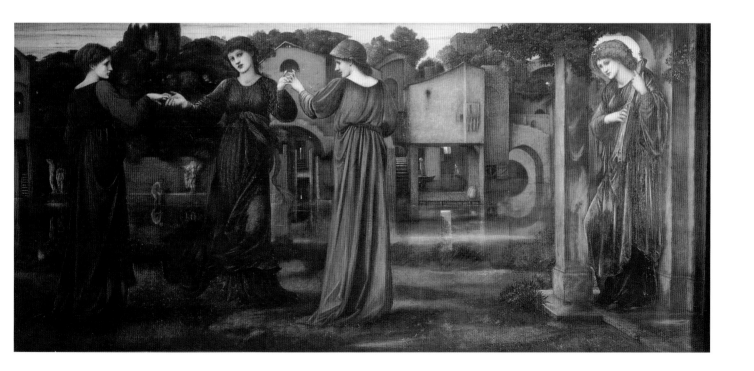

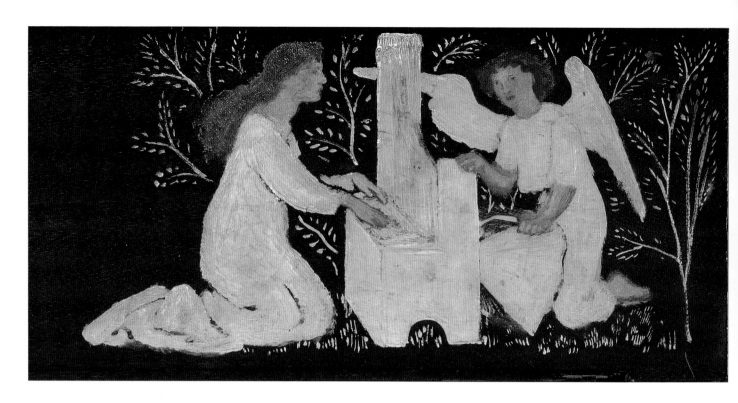

200 Edward Burne-Jones,
Le Chant d'Amour,
oil on American walnut piano,
monochrome, 1863–4.
V&A: W.43–1926.

The women appear to dance to the sound of a bell harp which is delicately plucked, but Burne-Jones would have known that the instrument was almost silent, for he depicted it without the resonating sound-board.[2]

As Henry James pointed out, aesthetic appeal is more important in this painting than historical accuracy. *The Times* agreed that 'It is a work which has no counterpart in the actually existing order of things.'[3] It is full of ambiguity, not least in the choice of title. The mill itself is relegated to the background, while the viewer's attention is drawn instead to the pacing girls. Their restrained actions belie the picture's erotic tension. As nineteenth-century commentators associated music with sensuality, so the implied sound here creates a charged atmosphere. This was recognized by one reviewer of Burne-Jones' work, who described how 'music excites the bare nerves of emotion more acutely than any other stimulant'.[4] This tension is enhanced by the juxtaposition of the dancing women and the tiny figures of nude men bathing in the millpond behind them. As there is no other narrative, the viewer is encouraged to consider the relationship between the two groups. Music-making and dancing traditionally signify courtship, partly through the emotional pull of music, but also because they offer an opportunity for displaying the body. So the music and dancing suggest a potential erotic encounter. Of course, as we have already seen in the work of both Burne-Jones and Whistler, musical themes can also encompass feelings of nostalgia and, when combined with the twilight setting of this image, certainly encourage us to reflect on the passing of youth and beauty. However, it is not too far-fetched to read the musician here as a wingless allegory of Love, who is contemplating the effect of his playing on the young women. He seems to be related to that other figure of Love in Burne-Jones' various treatments of *Le Chant d'Amour*, in which the artist overtly links music and desire.

Burne-Jones' earliest version of this subject is found underneath the lid of the piano that he and Georgie were given as a wedding present (plate 200). Painted in monochrome, it shows a young woman kneeling at a portative organ, while Love himself works the bellows. The floral patterning behind the figures reinforces the ornamental quality of the image, suitable for its position on a piece of furniture. In his later watercolour (Museum of Fine Arts, Boston, 1865) and oil (Metropolitan Museum of Art, New York, 1868–77) versions, Burne-Jones added a listening knight, but initially the object of the girl's yearning song was absent. This creates an element of uncertainty in the interpretation of this earlier work. The small decorative organ is the traditional attribute of St Cecilia, and some of Burne-Jones' contemporaries would certainly have read the image in this way. Julia Margaret Cameron's photographic tableau, for example, shows the saint holding a tiny portative organ (plate 201). Burne-Jones blurs the boundaries between the sacred and secular, so the winged figure could represent an angel, although we know from the later treatments of the subject that he was dwelling on the romantic aspect of music.

This confusion of religious devotion and desire was probably influenced by one of Rossetti's illustrations for Tennyson's 'Palace of Art' (plate 202), which Burne-Jones admired. Rossetti's controversial design depicted St Cecilia in a sensual embrace with the angel who should be pumping her organ. The ostensible subject of angelic inspiration has been subverted, so that the saint is represented in a state of voluptuous abandon, with her hair loosened and her throat exposed. Burne-Jones avoids the

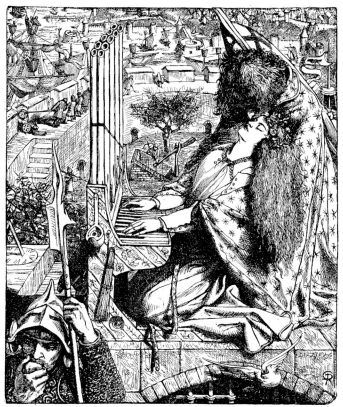

LEFT ABOVE
201 Julia Margaret Cameron, *St Cecilia*,
albumen print, 1860s, 25.4 × 20 cm. V&A: 45–155.

LEFT
202 Dante Gabriel Rossetti, *Palace of Art*,
wood engraving, proof on India paper, for *Poems by Alfred Tennyson*, published by Moxon, 1857, 13.4 × 7.9 cm.
V&A: E.29–1910.

203 Designed by Edward Burne-Jones,
Orpheus and the Muses plate, made by William de Morgan, c.1880, lustreware.
V&A: Circ.363–1961.

physicality of Rossetti's vision but retains the multiple meanings of music-making in this piano decoration.

By 1865, when he came to paint the watercolour version, the choice of title for *Le Chant d'Amour* determined an unambiguously sensual reading of the image. This title was perhaps suggested by Georgie, who was fond of old French songs, and who probably sang the Breton *chanson*: '*Hélas! je sais un chant d'amour,/ Triste ou gai, tour à tour.*'[5] Burne-Jones' association of music with feminine charm was no doubt encouraged by his wife's enjoyment of the piano, and her singing of 'music of a rare sort, and not of the modern...school'.[6] But he was not unusual in his belief that 'Music is women's art because it is purely emotional...[It] belongs to them entirely.'[7] Occasionally in his work we catch a glimpse of a male musician, like Orpheus with his lyre, painted on a lustreware plate (plate 203). Yet here, as in *The Mill*, the musician is a feminized figure, playing for the delight of dancing women. The Muses who circle the rim carry an undulating streamer that appears as a visible echo of a rising and falling tune, and their twisting bodies set up a continuous moving rhythm. While Orpheus calmly plucks his harp, these goddesses are transformed into a visual equivalent for music in the design. Such an intimate connection between music and the sensitive female body was a cause for concern among some mid-nineteenth-century commentators, like Sarah Ellis. She suggested that certain girls 'may be said to be imbued with music as an instinct...they live entirely in an atmosphere of sound'[8], and she warned them of the emotional dangers of being overwhelmed, as the Muses are by Orpheus's playing.

Mrs Ellis was particularly worried about the impact of the piano on domestic life. Although she encouraged girls to learn to play, in order to soothe their tired parents or entertain their friends, she was aware of the dangers of display. At evening parties, both the young women and the instruments themselves were on show. While Mrs Ellis fretted about girls who tried to attract attention by their flirtatious performances, Burne-Jones was bothered by the ostentatious decoration of the grand pianos they were playing. He wrote to his colleague Kate Faulkner, 'I have been wanting for years to reform pianos, since they are as it were the very altar of homes, and a second hearth to people.'[9] His idea was to return to the shape of the eighteenth-century harpsichord, with a trestle stand instead of bulbous legs, and 'reshaping the curved side into the older and more graceful outline'.[10] Together with W.A.S. Benson, he produced a design that was manufactured by Messrs Broadwood, who 'built a beautifully toned instrument in an oak case of the desired shape, stained of a good green'[11] for Georgie to play. His efforts also attracted the attention of his patrons. In 1883, Alexander Ionides commissioned a decorated piano that would ornament his house at 1 Holland Park (plate 204). Although some felt that the pattern of lilies, pomegranates and birds 'may be art, but it would look horrid in a drawing room'[12], this lavish design was entirely appropriate for the grand interiors of the Ionides house.

204 *Grand piano*, designed by Edward Burne-Jones and Kate Faulkner,
decorated by Kate Faulkner, manufactured by Broadwood, oak, stained
and decorated with silvered and gilt gesso, 1884–5.
V&A: W.23–1927.

ABOVE
205 Edward Burne-Jones,
The Garden of the Hesperides,
coloured and gilded gesso,
1880–1,
78.5 × 168 cm.
V&A: Circ.525–1953.

RIGHT
206 Edward Burne-Jones,
*studies of ancient Greek
instruments and sundial*, pencil,
after 1867,
18.7 × 26.7 cm.
V&A: E.6–1955, p.40.

The inspiration for the gesso work created by Kate Faulkner came from musical instruments in the South Kensington Museum, which Burne-Jones suggested she should study.[13] We know from his sketchbooks (V&A: E.10–1955) that he looked at the Engels collection on show in the Museum; he certainly made notes of a bell cittern, a viola d'amore and a crwth. But his interest in archaic instruments was not purely visual. As students, he and Morris had joined a plainsong society, and his fondness for early music continued throughout his career. Burne-Jones was a patron of Dolmetsch's workshops, and commissioned a harpsichord for his daughter Margaret. He told Rooke that 'he loved the precise and antique sound' of it, and 'its sharp clean twang'.[14] He clearly had an ear for such instruments, as well as a fascination with their shape and decoration.

However, as we have seen with the bell harp, he was willing to deviate from authenticity in order to fit his aesthetic ideal. He scoured books like Pierre Bouillon's *Musée des Antiques* (1821–7), illustrating remnants of ancient Greece and Rome, for decorative details to enliven his work. Having found an image of a lyre, for example (plate 206), he then elongated its shape for an idiosyncratic treatment of *The Garden of the Hesperides* (plate 205). He made the instrument

as tall as the kneeling girl who plucks it. Although evidently derived from a classical source, Burne-Jones exercised considerable freedom in manipulating the lyre to fit his decorative purpose. Perhaps there is a parallel with his treatment of the original myth itself on this panel. The three daughters of Hesperus, who tend the dragon Ladon and guard the golden apples of Hera, have been reduced to two, apparently to provide a better compositional balance. The work was never intended as a narrative painting; it was made in bas-relief as an over-mantel for a cottage in Walton-on-Thames.[15] So, both in the detail of the lyre, and in the picture as a whole, Burne-Jones used classical sources as a starting point for his imagination, but then adapted them to create a stylized piece of ornament.

If this approach to antiquity was typical of the Aesthetic movement, then so was Burne-Jones' use of a musical subject as a pretext for exploring colour and form, and suppressing narrative. Some Aesthetic artists like Burne-Jones and Whistler were interested in the French theories of correspondences between different art-forms, especially music, poetry and painting. These theories, put forward by Charles Baudelaire and Théophile Gautier, encouraged art to contemplate art, avoiding the traditional themes of Academic painting. As Whistler put it, art should 'stand alone, and appeal to the artistic sense of eye or ear, without confounding this with emotions entirely foreign to it, as devotion, pity, love, patriotism and the like'.[16] In Burne-Jones' art, this tendency was expressed in his self-conscious rejection of archaeological accuracy and story-telling. Instead, his designs dwell on mood, compositional rhythm and carefully modulated colour – those aspects of painting most closely linked to music.

Conclusion

The Pre-Raphaelite collections in the V&A are one of the Museum's best-kept secrets. Although the William Morris exhibition of 1996 helped to raise awareness, it was only able to concentrate on one aspect of the movement, and work by many of the Pre-Raphaelite Brotherhood and their followers remains dispersed around the Museum. Some objects have recently been brought together in the British Galleries, others can be tracked down in the tapestry courts or musical instrument galleries, and many more are in the archives of the Print Room. As a result, it can be difficult to get an overview of these works. Do these paintings, prints, sideboards and stained-glass windows represent a coherent artistic endeavour?

We have to remember that some of the objects were made fifty years apart, and that they range in style from Holman Hunt's hypnotic realism to Burne-Jones' Aestheticism. Even so, there are four threads that bind them together. Firstly, they were made by artists who saw the value of the decorative arts, and who were just as willing to design a panel of stained glass as an oil painting. Secondly, they challenged the conventional notions of beauty, initially by the naturalism, and then by the sensuality or androgyny of their figure painting. Thirdly, they demonstrate an enduring affection for the art of the past. Finally, these objects were made by a group of friends, who studied, worked, read books and travelled together; they even shared lovers. Some of these friendships may have been short-lived, but they drove the movement forward. The conjunction of two such different personalities as Rossetti and Holman Hunt, for example, was bound to be electric.

For others, like Morris and Burne-Jones, their college friendship produced a life-long project to reform the decorative arts. They spurred each other on to create 'works of a genuine and beautiful character'.[1] It may be argued that Morris concentrated more on the genuine, while Burne-Jones pursued the beautiful, but their art reflected a shared passion for the Middle Ages. In their imaginations, medieval legends, landscapes, worship and craft were woven together.

But this intimate knowledge of the past was itself a by-product of the modernity of these artists. The prosperity of industrialized Victorian society enabled archaeologists, literary scholars, historians and connoisseurs to examine self-consciously the evidence of Britain's past. They wanted to understand the development of culture, just as scientists wanted to understand the mechanism of evolution. Pre-Raphaelite art was moulded by the obsessive knowledge-gathering that produced, on one level, engravings of medieval murals from Pisa, and on another, encyclopaedic warehouses of art, like the South Kensington Museum. This Museum's attempt to collect and catalogue the very best examples of design from the dawn of Christianity, and from across the Empire, was so ambitious that it could only have been conceived by the Victorians. Morris spoke for many of his friends when he acknowledged his 'feeling of gratitude for the immense service which the collections at the South Kensington Museum had been to him personally as a designer'.[2] It was one aspect of contemporary culture that the Pre-Raphaelites were not going to challenge.

NOTES

Introduction

1 J.W. Mackail, *The Life of William Morris* (London, New York and Bombay, 1901), vol.1, p.149.
2 V&A registered papers, relating to acquisition of paintings by Burne-Jones, P.108–192 & P.109–1920.
3 Georgiana Burne-Jones, *Memorials of Edward Burne-Jones* (2 vols) (1904; this edition, London, 1993), vol.2, p.6.
4 Thomas Rooke, typewritten notes of conversations with Burne-Jones, V&A Museum, NAL, Wednesday 26 May, 1897, p.396.
5 Many recent studies evolved from the Tate Gallery's substantial 1984 exhibition, *The Pre-Raphaelites*. Elizabeth Prettejohn's book, *The Art of the Pre-Raphaelites* (London, 2000), is particularly helpful, but deals exclusively with the fine arts, and does not integrate the decorative art works.

CHAPTER 1
The Pre-Raphaelite Brotherhood

1 John Guille Millais, *The Life and Letters of John Everett Millais, President of the Royal Academy* (London, 1899), quoting William Holman Hunt, vol.1, p.49.
2 *British Quarterly Review*, 1852, p.201.
3 William Holman Hunt, *Pre-Raphaelitism and the Pre-Raphaelite Brotherhood* (London, 1905), vol.1, p.49.
4 Ibid., vol.1, p.207.
5 Ibid., vol.1, p.190.
6 E.T. Cook and Alexander Wedderburn, eds, *The Works of John Ruskin, 1903–1912*, letter of 28 December 1882, vol.37, pp.427–8.
7 Hunt, op.cit., vol.1, p.73.
8 Millais, op.cit., vol.1, p.61.
9 Kenneth Clark, ed., *Ruskin Today* (London, 1964), from Modern Painters V, preface, p.56.
10 Ibid., from Praeterita, p.28.
11 Alfred, Lord Tennyson, *Poems of Tennyson, 1830–1870* (Oxford, 1912; reprinted 1943), p.179.
12 John Ruskin, *The Stones of Venice* (J.G. Links, ed.) (London, 1960), 'On the Nature of Gothic', p.172.
13 Ibid., p.165.
14 Ibid., p.175.
15 Cook and Wedderburn, op.cit., from Modern Painters II, vol.3, p.624.
16 Prettejohn, op.cit., p.63.

17 *British Quarterly Review*, 1852, p.197.
18 Hunt, op.cit., vol.1, p.87.
19 Geoffrey Moore, ed., *Edgar Allan Poe, The illustrated poets* (London, 1988), p.41.
20 Hunt, op.cit., vol.1, p.105.
21 Millais, op.cit., vol.1, p.49.
22 William Michael Rossetti, ed., *Dante Gabriel Rossetti: his family letters, with a memoir* (London, 1895), vol.1, p.135.
23 The National Gallery acquired Giovanni Bellini's *Portrait of the Doge Leonardo Loredan* (1501–4) in 1844, and two wings from an altarpiece by Lorenzo Monaco (c.1407–9) in 1848, but very few other works of this period could have been seen in public in London until the mid-1850s.
24 Hunt, op.cit., vol.1, pp130–1.
25 Ibid., p.132.
26 J.B. Bullen, *The Pre-Raphaelite Body: Fear and Desire in painting, poetry and criticism* (Oxford, 1998), p.11.
27 Ralph N.Wornum, 'Modern Moves in Art', *Art Journal*, 12, 1850, quoted in Bullen, op.cit., p.10.
28 Frank Stone, *The Athenaeum*, 1850, p.591.
29 Charles Dickens, 'Old Lamps for New Ones', *Household Words* (London, 1850), pp264–5.
30 Quoted by Hunt, op.cit., vol.1, p.205.
31 Ruskin, quoted in Millais, op.cit., vol.1, p.111.
32 Quoted by Paul Barlow in 'Pre-Raphaelitism and Post-Raphaelitism: the articulation of fantasy and the problem of pictorial space' in Marcia Pointon, *Pre-Raphaelites Reviewed* (Manchester, 1989), p.68.
33 Rossetti, quoted in Rodney Engen, *Pre-Raphaelite Prints: the Graphic Art of Millais, Holman Hunt, Rossetti and their followers* (London, 1995), p.102.
34 Georgiana Burne-Jones, op.cit., vol.1, pp.119–20.
35 Paul Goldman, 1996, quoted in *The Age of Rossetti, Burne-Jones and Watts: Symbolism in Britain 1860–1910*, Andrew Wilton and Robert Upstone, eds (London, 1997), p.37.
36 Rossetti, quoted in Engen, op.cit., p.93.
37 Ibid., p.94.

'The Child' Millais

1 Debra N. Mancoff, 'John Everett Millais: Caught between the myths', in Debra N. Mancoff, ed., *John Everett Millais. Beyond the Pre-Raphaelite Brotherhood* (Yale, 2001), p.8.
2 Hunt, op.cit., vol.1, p.58.
3 *Art Union* (London, 1846), p.184.

CHAPTER 2
The Next Generation

1 Georgiana Burne-Jones, op.cit., vol.1, pp128–9.
2 Hunt, op.cit., vol.1, p.xiii.
3 Millais, op.cit., vol.1, p.55.
4 Hunt, op.cit., vol.1, p.219.
5 Millais, op.cit., vol.1, p.217.
6 Mancoff, op.cit., p.3.
7 Burne-Jones, quoted by William Sharp, *Fortnightly Review* (March 1886), p.303.
8 The full title of this painting, *A Huguenot, on St Bartholomew's Day, refusing to shield himself from danger by wearing the Roman Catholic badge*, gives the background to this scene. In 1572, as French Catholics prepare to massacre thousands of Protestants (Huguenots), a Catholic girl tries to persuade her Protestant lover to hide his faith and save himself. The immediate inspiration for this subject was Meyerbeer's opera *Les Huguenots*, which had been performed regularly at Covent Garden from 1848.
9 Millais, op.cit., vol.1, p.172
10 Ibid., vol.2, p.1.
11 Hunt, op.cit., vol.1, p.79.
12 Millais, op.cit., vol.1, p.52.
13 Letter to Hunt, 11 November 1852, quoted in *The Pre-Raphaelites*, Tate Gallery (London, 1984), p.108.
14 Ibid., p.108.
15 Millais, op.cit., vol.1, p.184. According to the *Illustrated London News*, this painting attracted 'a larger crowd of admirers in his little corner in the Middle Room than all the Academicians put together'.
16 Millais, op.cit., vol.1, p.258.
17 Quoted in Mancoff, op.cit., p.3.
18 Millais, op.cit., vol.2, p.223.
19 *Art Journal* (London, 1876), p.231.
20 Hunt quoted by Millais, op.cit., vol.1, p.405.
21 The pendant to this etching, which was also the subject of several oil paintings, is *The Abundance of Egypt* (V&A: 245), making the link to the biblical account of twelve years of plenty and twelve years of famine even clearer.
22 Ibid., p.403.
23 Letter to Thomas Combe, 12 February 1860, quoted in *The Age of Rossetti, Burne-Jones and Watts: Symbolism in Britain*, Tate Gallery (London, 1997), p.97.
24 Hunt described his erstwhile friend as 'courteous, gentle and winsome, generous in compliment, rich in interest in the pursuit of others' and 'he has the redeeming grace of genius'. Hunt, op.cit., vol.1, pp.145 and 220.

25 Rooke, op.cit., p.104.
26 Letter to Cormell Price, July 1856, *The letters of William Morris to his Friends and Family* (Philip Henderson, ed.) (London, 1950), p.17.
27 Ibid., p.16.
28 Ibid., 22 January 1897, p.325.
29 Georgiana Burne-Jones, op.cit., vol.1, p.104.
30 J.W. Mackail, op. cit.
31 Georgiana Burne-Jones, op.cit., vol.1., p.97.
32 Ibid., vol.2, p.306.
33 Quoted in *William Morris* (Linda Parry, ed.), exhibition catalogue, Victoria and Albert Museum (London, 1996), p.99.
34 Letter to Cormell Price, July 1856, *The letters of William Morris*, op.cit., p.17.
35 Letter to Thomas Combe, 12 February 1860, quoted in *The Age of Rossetti, Burne-Jones and Watts: Symbolism in Britain*, op.cit., p.97.

The Green Dining Room
1 They are related to a painting based on one of the window designs, *The Garland* (Cecil French bequest, Hammersmith and Fulham Council, gouache, 1866). See figures 267–271 in A. Charles Sewter, *The Stained Glass of William Morris and his Circle* (New Haven and London, 1974).

CHAPTER 3
Towards Aestheticism
1 Tom Taylor, *The Times*, 9 May 1866, p.6, quoted in Stephen Wildman and John Christian, *Edward Burne-Jones: Victorian Artist-Dreamer*, exhibition catalogue, Metropolitan Museum of Art (New York, 1998), p.100.
2 Cook and Wedderburn, op.cit, vol.7, p.xl.
3 Ibid., vol.29, 'Fors Clavigera', letter 76, p.89.
4 'Shirley', *Fraser's Magazine* (Edinburgh, 1870), p.609.
5 George Price Boyce, quoted in Virginia Surtees, *The Paintings and Drawings of Dante Gabriel Rossetti (1828–1882): A Catalogue Raisonné* (Oxford, 1971), p.15.
6 F.W.H. Myers, 'Rossetti and the Religion of Beauty', *Cornhill Magazine* (London, February 1883), p.219.
7 Robert Buchanan, 'The Fleshly School of Poetry: Mr. D.G. Rossetti', *Contemporary Review* (London, 1871).
8 Buchanan, quoted in *The Age of Rossetti, Burne-Jones and Watts*, op.cit., p.45.

9 Rooke, op.cit., p.17.
10 'Exhibition of Works at the New Gallery', *Edinburgh Review* (January 1899), p.36.
11 Bullen, op.cit., p.168.
12 'Society of Painters in Watercolours', *Art Journal* (London, 1869), p.173, quoted in Bullen, op.cit., p.159.
13 Swinburne, quoted in *The Age of Rossetti, Burne-Jones and Watts*, op.cit., p.142.
14 Georgiana Burne-Jones, op.cit., vol.1, p.260.
15 Bullen, op.cit., p.159.
16 Walter Pater, Preface, *Studies in the History of the Renaissance* (originally published 1873: this edition, London, 1935), p.viii.
17 Ibid., pp220–1.
18 Sharp, *Fortnightly Review*, August 1898, n.s. no.380, p.300.
19 Burne-Jones was especially distressed by Ruskin's views on Michelangelo, whom he described as 'the chief captain in evil' in the High Renaissance in an Oxford lecture in 1870. Ruskin, quoted by Martin Harrison and Bill Waters, *Burne-Jones* (London 1973; this edition, 1989), p.104.
20 Ruskin, quoted by Richard Dorment and Margaret F. Macdonald, *James McNeill Whistler*, Tate Gallery, exhibition catalogue (London, 1994), p.136.
21 Rooke, op.cit., pp.87–8.
22 James Abbott McNeill Whistler, *The Gentle Art of Making Enemies* (1885; this edition, New York, 1967), p.144.
23 Georgiana Burne-Jones, op.cit., vol.1, p.207.
24 Swinburne, quoted in *James McNeill Whistler*, op.cit., p.79.
25 Quoted in *James McNeill Whistler*, op.cit., p.85.
26 Ibid., p.19.
27 Theodore Child, quoted by Linda Merrill in *The Peacock Room: a cultural biography* (New Haven, 1998), p.179.
28 *Edinburgh Review*, January 1899, p.37.

CHAPTER 4
The Natural World
1 John Ruskin, Pre-Raphaelitism pamphlet, 1851, quoted by Allen Staley in *The Pre-Raphaelite Landscape* (Oxford, 1973), p.17.
2 *The Good Harvest of 1854* was given to the Museum as part of the bequest by the Rev. Chauncey Hare Townshend in 1869. The bequest included '40 Old Master paintings, 45 Modern English paintings, 103 foreign paintings and 189

watercolours', according to a memo of 1 July 1869.
3 Millais, letter of 28 January 1851, quoted in *The Pre-Raphaelites*, Tate Gallery, op.cit., p.86.
4 William Morris, letter to Cormell Price, 10 August 1855, Avranches, Normandy, in Mackail, op.cit.,vol.1, p.74.
5 For a more detailed discussion of the manufacture and acquisition of this tapestry, see *William Morris*, V&A, op.cit., pp288–9.
6 Mackail, op.cit., vol.1, p.314.

The Flower Book
1 Georgiana Burne-Jones, op.cit., vol.2, pp119–120.
2 Georgiana Burne-Jones, introduction to *The Flower Book*, facsimile, the Fine Art Society (London, 1905), unpaginated.

CHAPTER 5
The Painter of Modern Life
1 John Ashton, ed., 'The Bridge of Sighs', *The poetical works of Thomas Hood* (London, n.d.), p.605.
2 William Acton, quoted by E.M. Sigsworth and T.J. Wyke, 'Victorian prostitution and venereal disease', in Martha Vicinus, ed., *Suffer and be still: women in the Victorian age* (Indiana, 1972; this edition, London, 1980), p.80.
3 'The Magdalen's friend and female homes intelligencer', 1860, quoted by Kate Flint, 'Reading the Awakening Conscience Rightly', in *Pre-Raphaelites Reviewed*, op.cit., p.56.
4 Charles Baudelaire, *The Painter of Modern Life and other essays*, transl. and ed. Jonathan Mayne (London, 1964; this edition, 1995), p.9.
5 Quoted in *Whistler*, Tate Gallery, op.cit., p.103.
6 Whistler in a letter to Fantin-Latour, Ibid., p.104.
7 The poem, by Sarah Doudney, and Sandys' illustration, were first published in *The Churchman's Family Magazine*, vol.2, 1863, p.91.
8 Anthony Trollope, quoted by Paul Goldman, *Victorian Illustrated Books, 1850–1870: the heyday of wood-engraving*, British Museum Press (London, 1994), p.84.
9 Millais, op.cit., vol.1, p.360.
10 L. Housman, 1896, quoted by Eric de Maré, *The Victorian Woodblock Illustrators* (London, 1980), p.105.

CHAPTER 6
Legends and Literature
1 J.A.M. Whistler, *The Gentle Art of*

Making Enemies (1892; reprinted New York, 1967), p.126.

2 *The Pre-Raphaelites*, Tate Gallery, op.cit., p.74.

3 Prettejohn, op.cit., p.12.

4 Rossetti, quoted by Christine Poulson, 'Death and the Maiden: the Lady of Shalott and the Pre-Raphaelites' in *Re-framing the Pre-Raphaelites* (Aldershot, 1996), p.175.

5 Maré, op.cit., p.100.

6 William Holman Hunt, quoted by Engen, op.cit., p.100.

7 Edgar Allen Poe, in 'The Philosophy of Composition', 1846, quoted by Poulson, op.cit., p.185.

8 Quoted in Engen, op.cit., p.102.

9 Rooke, op.cit., p.103.

10 Georgiana Burne-Jones, *Memorials*, op.cit., vol.I, p116.

11 Ibid., p.117.

12 Quoted by Michael Bartram, *The Pre-Raphaelite Camera: Aspects of Victorian photography* (London, 1985), p.142.

13 Edward Clifford, in a letter dated 28 April 1896 encouraging the Museum to acquire the painting from the collection of the late Mr Leathart, via the Goupil Gallery, V&A registered papers. It was bought for £800. The V&A also holds a pencil study of the figure of Merlin, E. 2854–1927, 31.5 × 14.6 cm.

14 F.G. Stephens, review in the *Athenaeum*, 14 January 1893, p.58.

15 Burne-Jones, in a letter to Helen Gaskell, 1893, quoted in *Edward Burne-Jones: Victorian Artist-Dreamer*, op.cit., p.171.

16 Ibid., vol.II, p.278.

17 Rooke, op.cit., p.68, 5 December 1895.

18 Georgiana Burne-Jones, *Memorials*, op.cit., vol.II, p.278.

19 W.R. Lethaby, quoted in *William Morris*, V&A, op.cit., p.332.

20 Robert Catterson-Smith, quoted in *William Morris*, Ibid., p.334.

21 Letter to Swinburne, quoted by D. Robinson in *William Morris, Edward Burne-Jones and the Kelmscott Chaucer* (London, 1982), p.24.

22 Ford Madox Hueffer, 'Sir Edward Burne-Jones', *Contemporary Review*, no.392, August 1898, p.193.

23 *William Morris*, V&A, op.cit., p.186.

24 In addition, Chaucer's description of the Pilgrim outside the Garden of Idleness, where he encounters the female allegories of Love and Beauty, Largesse and Richesse, and Courtesie and Fraunchise, enabled Burne-Jones to create an elaborate procession of paired figures that seems to evolve from his *Goode Wimmen* panels.

25 Georgiana Burne-Jones, *Memorials*, op.cit., vol.II, p.217.

26 *The Riverside Chaucer* (Oxford, 1887), *The Romaunt of the Rose*, l.128.

27 Note for 4 August 1921, V&A, departmental artist's file.

28 *Burne-Jones Talking*, op.cit., p.20.

29 Georgiana Burne-Jones, *Memorials*, op.cit., vol.II, p.296.

30 Malcolm Bell, *The Studio*, XVI, 1899, p.178.

31 *The Riverside Chaucer*, op.cit., p.179.

32 Rossetti sold the painting to Constantine Ionides in 1880 for 300 guineas.

33 Harry Quilter, for instance, complained that 'it is difficult, if not impossible to tell…in either painter's work [Burne-Jones or Botticelli], the sex of the person represented'. Quoted in J.B. Bullen, *The Pre-Raphaelite Body*, op.cit., p.191.

34 The finished embroidery was exhibited at the Fifth Arts and Crafts Exhibition in 1896, and is now in St Andrew's Church, Mells, near Burne-Jones' memorial tablet for Laura Lyttleton.

35 Henry Holiday, quoted on website of National Museums and Galleries on Merseyside.

36 *Edinburgh Review*, January 1899, op.cit., p.34 & p.37.

37 Ibid., p.36.

38 Georgiana Burne-Jones, *Memorials*, op.cit., vol.II, p.224.

39 Rooke, op.cit., p.57.

40 Ibid., Wed 6 July, 1896, p.266.

41 Another smaller oil painting of this subject was exhibited in 1881, and is now in Birmingham Museums and Art Gallery.

42 Elizabeth Prettejohn, 'Walter Pater and Aesthetic Painting', in *After the Pre-Raphaelites*, op.cit., p.37.

The Quest for the Holy Grail

1 Georgiana Burne-Jones, *Memorials*, op.cit., vol.II, p.208.

CHAPTER 7
Women

1 F.W.H. Myers, 'Rossetti and the Religion of Beauty', *Cornhill Magazine*, February 1883, p.220.

2 The title and Millais' action refer to the classical legend of the 'Judgement of Paris', who had to choose which of the ancient goddesses was the fairest.

3 Violet Hunt, quoted by A.R. Dufty in *Morris Embroideries, the prototypes* (London 1985), p.8.

4 Ibid., p.9.

5 Rooke, op.cit., p.19.

6 Henry James, quoted by Andrea Rose in *Pre-Raphaelite Portraits* (Oxford, 1981), p.98.

7 D.G. Rossetti, sonnet for the frame of *Astarte Syriaca*, quoted in *The Pre-Raphaelites*, Tate Gallery, op.cit., p.226.

8 Griselda Pollock's 'Woman as sign: Psychoanalytic readings', discussed by Lynne Pearce in *Woman/image/text: Readings in Pre-Raphaelite Art and Literature* (Toronto, 1991), p.14.

9 Constantine Ionides was one of the leading figures in the Greek community in London. He was a generous patron of Rossetti and his associates, and, on his death in June 1900, the South Kensington Museum received a substantial bequest, including paintings and drawings by Rossetti and Burne-Jones, as well as French artists, notably Degas, Millet, Corot and Daumier. The terms of the bequest specified that the paintings had to be shown together, and should not be exhibited outside the Museum.

10 The poet and adventurer Wilfrid Scawen Blunt, who became Janey Morris's lover in the 1880s, described Kelmscott as 'a romantic but most uncomfortable house, with all the rooms opening into each other and difficult to be alone in…Rossetti seemed a constant presence there, for it was there that he and Janey had had their time of love some 14 years before'. Peter Faulkner, ed., *Jane Morris to Wilfrid Scawen Blunt* (Exeter, 1986,) p.31.

11 Quoted by Julia Atkins, 'Rossetti's *The Day Dream*: the patron's great-granddaughter charts the creation of this painting,' *V&A Album*, Spring 1989, p.34.

12 Henry James, quoted in *Pre-Raphaelite Portraits*, op.cit., p.98.

13 Song IX from 'The House of Life' sequence, *Rossetti: Poems and Translations 1850–1870* (Oxford, 1913; this edition 1968), p.138.

14 Ruskin, quoted in *The Age of Rossetti, Burne-Jones and Watts*, op.cit., p.153.

15 *The Daily Telegraph* 1900, quoted by Julia Atkins, op.cit., p.38.

16 Quoted by E.P. Thompson in *William Morris: Romantic to Revolutionary* (New York, 1955; this edition, 1976), p.168.

17 *Sheffield Telegraph*, 28 February 1862, reprinted by Jan Marsh, *The Legend of Elizabeth Siddal* (London, 1989), p.157.

18 Georgiana Burne-Jones, *Memorials*, op.cit., vol.1, pp218–19.

19 *The Legend of Elizabeth Siddal*, op.cit., p.57.

20 Ford Madox Brown, diary 6 August 1855, quoted in *The Pre-Raphaelites*, Tate Gallery, op.cit., p.273.

21 There is one drawing in the V&A's collection, attributed to Elizabeth Siddal (E.3003–1911, *St Cecilia*), but Jan Marsh, curator of an exhibition of her work at the Ruskin Gallery, Sheffield, 1991, does not accept that this is by Siddal. See *The Legend of Elizabeth Siddal*, op.cit., p.236.

22 Ibid., p.168.

23 Rooke, op.cit., 4 April 1896, p.184.

24 Ibid., 18 March 1897, p.361.

25 Rosalind Howard, quoted by Judith Flanders in *A Circle of Sisters: Alice Kipling, Georgiana Burne-Jones, Agnes Poynter and Louisa Baldwin* (London, 2001), p.122.

26 Georgiana Burne-Jones, *Memorials*, op.cit., vol.II, p.166.

27 *The Times*, 8 May 1886, p.8, quoted in *Edward Burne-Jones: Victorian Artist-Dreamer*, op.cit., p.265.

28 Rooke, op.cit., p.24, p.445 & p.184.

29 *Circle of Sisters*, op.cit., p.68.

30 Burne-Jones apparently agreed with Ruskin who advised Georgie to 'Keep your rooms tidy and baby happy and then after that as much wood work as you've time and liking for.' 22 November 1861, Cook and Wedderburn, op.cit., Letters 1, pp.393–4.

31 Prettejohn, *The Art of the Pre-Raphaelites*, op.cit., p.69.

32 Jan Marsh, *Christina Rossetti: a literary biography* (London, 1995), p.283.

33 Christina Rossetti, *Goblin Market* (London, 1996), p.38 & 39.

34 Ibid., p.40.

35 Marsh, op.cit., p.232.

36 *Goblin Market*, op.cit, p.34.

37 Letter to Christina Rossetti from her publisher Macmillan, 28 October 1862, quoted in *Christina Rossetti: a literary biography*, op.cit., p.277. Dante Gabriel was legendary for his delays in fulfilling commissions, and he missed the Christmas deadline. The book was not ready for publication until April 1862.

38 *Goblin Market*, op.cit, p.30.

39 *Amor Mundi*, in *Christina Rossetti: the illustrated poets* (Oxford, 1986), pp.21–2.

40 Betty Elzea, ed., *Frederick Sandys, 1829–1904. A catalogue raisonné* (Norfolk, 2001), p.13.

41 'The Lady of Shalott', *The poems of Tennyson 1830–1870* (Oxford, 1912; this edition, 1943), p.58

Sandys' Women: 'She grows as a flower does'

1 Ruskin, 'Of Queen's Gardens', *Sesame and Lilies* (London, 1960; first published 1864), p.66.

2 For a full discussion of the various versions, see Elzea, ed., op.cit., pp.193–6. The V&A also owns another version, *Proud Maisie III* (V&A: E.1253–1948, black and red chalks on buff paper, 36.8 × 27 cm, inscribed with signature and title), which was possibly owned by Murray Marks.

3 Ibid., p.194.

4 Betty Elzea, ed. op. cit., p.258.

5 'The Spectacular Rise – and Sad Decline – of Frederick Sandys', by Douglas E. Schoenerr, ibid., p.10.

Jewellery

1 D.G. Rossetti, sonnet for the frame of *Astarte Syriaca*, quoted in *The Pre-Raphaelites*, Tate Gallery, op.cit., p.226.

2 Georgiana Burne-Jones, *Memorials*, op.cit., p.223–4.

3 See illustration, Harrison and Waters, op.cit., p.154.

CHAPTER 8
Religion, Death and the Spirit

1 Caroline Fox, 1860, quoted by Jeremy Maas in *Holman Hunt and the Light of the World* (London and Berkeley), 1984, p.92.

2 Ibid., p.61.

3 Engen, op.cit, p.43.

4 *Holman Hunt and the Light of the World*, op.cit., p.63.

5 Holman Hunt to William Bell Scott, 19 August 1883, quoted Ibid., p.14.

6 Ibid., p.43.

7 Millais, quoted in Engen, op.cit., p.105. Millais was amply rewarded for his work, being paid £20 per drawing.

8 Millais, op.cit., vol.II, p.312.

9 Forrest Reid, *The Illustrators of the Sixties* (1928), quoted by Engen, op.cit., p.105.

10 Roger Bowdler, 'Ars Longa, Vita Brevis': Life, Death and John Everett Millais', in Mancoff, op.cit., p.207.

11 D.G. Rossetti, *St Agnes of Intercession*, quoted by Engen, op.cit., p.30.

12 *The Pre-Raphaelites*, Tate Gallery, op.cit., p.263.

13 See *The Legend of Elizabeth Siddal*, op.cit., p.23.

14 *The Age of Rossetti, Burne-Jones and Watts*, op.cit., p.192.

15 The drawing was originally owned by William Graham, and remained in his collection until his death (Christie's, 3 April 1886, lot 96, £149).

16 D.G. Rossetti, *Poems and Translations, 1850–1870*, op.cit., p.2.

17 St Margaret of Cortona, the patron of female penitents, ran away from home to become the mistress of a nobleman when she was eighteen years old. She remained with him for nine years, and bore him a son, but he was murdered in 1273. When her father refused to take her home, she entered a Franciscan convent, where she became renowned for her severe forms of penitence and her visions of Christ. She died in 1297 and was canonized in 1728.

18 Charles Kingsley, quoted by Colin Cruise in ' "Lovely devils": Simeon Solomon and Pre-Raphaelite masculinity', in *Re-framing the Pre-Raphaelites*, op.cit., p.201.

19 Pater, quoted Ibid., p.204.

20 'Leonardo da Vinci', 1869, in *Studies in the History of the Renaissance*, op.cit., pp.109–10.

21 Harrison and Waters, op.cit., p.72.

22 Burne-Jones was commissioned to make designs for *Ezekiel and the Boiling Pot*, *The Eve of the Deluge*, *The Return of the Dove to the Ark*, *Christ in the Garden* and *The Seven Days of Creation*, but only the Ezekiel subject was used in the finished publication.

23 Burne-Jones translated the *Days of Creation* into stained glass and painted versions.

24 The original drawing for this illustration is also in the V&A's collection (V&A: D.326–1893, *Elijah and the Widow's Son*, pen and ink, c.1862). It is based on 'I Kings' chapter 17, verse 23, in which Elijah restores a young boy to life. His body has already been prepared for burial, and is wrapped in a shroud, and garlanded with flowers.

25 Quoted in *The Pre-Raphaelites*, Tate Gallery, op.cit., p.203.

26 For details of the re-establishment of the firm as Morris and Company in 1875, see *William Morris*, V&A, op.cit., p51.

27 Rossetti quoted in *Edward Burne-Jones: Victorian Artist-Dreamer*, op.cit., pp.56–7.

28 Rooke, op.cit., Saturday 12 June, 1897, p.412.

29 Burne-Jones' letter to Ruskin, quoted by Richard Dorment in 'Burne-Jones's Roman Mosaics', *Burlington Magazine*, February 1978, CXX, p.73.

30 See V&A: 365–1895, Edward Burne-Jones, *Model of Heavenly Jerusalem*

design for apse, plaster and wood, with tempera and gilding, 1881–5, 61 × 100 cm., neg. M1667.

31 Georgiana Burne-Jones, *Memorials*, op.cit., vol.II, pp142–144.

32 Rooke, op.cit., p.22.

33 Georgiana Burne-Jones, *Memorials*, op.cit., vol.II, p.13.

34 Letter from Burne-Jones to Frances Horner (née Graham), June 1886, quoted in *Edward Burne-Jones: Victorian Artist-Dreamer*, op.cit., p.243.

35 Ibid., p.243.

36 He also produced other coloured plaster reliefs for domestic interiors, which explored subjects from the ancient, rather than the medieval, world. These included a frieze of *Cupid and Psyche*, Birmingham City Museum and Art Gallery, and *The Garden of the Hesperides*, V&A: Circ.525-1953.

37 A copy of this tapestry was woven for the poet Wilfrid Scawen Blunt in 1904, and both versions cost £525.

38 Georgiana Burne-Jones, *Memorials*, op.cit., vol.II, p.209.

39 Ibid., vol.II, p.348.

40 For details of acquisition, see *William Morris*, V&A, op.cit., p.290.

CHAPTER 9
Music

1 Henry James, quoted in *Edward Burne-Jones: Victorian Artist-Dreamer*, op.cit., p.251.

2 Burne-Jones deliberately commissioned this bell harp to be made as a studio prop without the sounding-board. It appears in several of his paintings, including *Love among the ruins* (oil on canvas, 1870–3, private collection) and *The Golden Stairs* (oil on canvas, 1876–80, Tate Britain). It was possibly based on an instrument in the South Kensington Museums (V&A: 240–1882).

3 *The Times*, 8 May 1882, noted in V&A object file.

4 *Edinburgh Review*, January 1899, p.32, review of the Exhibition of Works of Edward Burne-Jones at the New Gallery, 1898–9.

5 See Ford Madox Hueffer, 'Sir Edward Burne-Jones', *Contemporary Review*, no.392, August 1898, p.186, who writes of Georgie: 'to her love of music, and particularly for the old French songs, of the "Echos du Temps Passé" we may trace the inspiration of pictures like the *Chant d'Amour*'.

6 Charles Eliot Norton, quoted in *Edward Burne-Jones: Victorian Artist-*

Dreamer, op.cit., p.99.

7 Rooke, op.cit., p.302, Mon. 7 December, 1896.

8 Sarah Ellis, *The Daughters of England* (London, 1842), p.132.

9 Georgiana Burne-Jones, *Memorials*, op.cit., vol.II, p.111.

10 Michael I. Wilson, 'The Case of the Victorian Piano', *Victoria and Albert Museum Yearbook* (London, 1972), p.141.

11 Georgiana Burne-Jones, *Memorials*, op.cit., vol.II, p.112.

12 Michael I. Wilson, op.cit., p.145.

13 Georgiana Burne-Jones, *Memorials*, op.cit., vol.II, p.111.

14 Mary Lago, *Burne-Jones talking: His conversations 1865–1898 preserved by his studio assistant Thomas Rooke* (London, 1982), p.12.

15 The gesso panel was given by Miss Katherine Lewis, who wrote to the Museum in February 1952, 'In 1880 or 1881 my parents took a house at Walton-on-Thames called Ashley Cottage. It was the dower house of Ashley Park belonging to the Sassoons. In any case Burne-Jones made the panel for that room and it hung over the fire place and the walls were covered with blue linen, which I have often heard my mother say was dyed by William Morris with his own hands.' The same donor also gave the Orpheus plate (Circ. 363–1961) to the Museum in a bequest.

16 *The Gentle Art of Making Enemies*, op.cit., 'The Red Rag', p.127.

Conclusion

1 From the prospectus for Morris, Marshall, Faulkner and Co., 1862, quoted by J.W. Mackail, op.cit., vol.I, p.151.

2 Ibid., vol.I, p.374.

SELECT BIBLIOGRAPHY

Atkins, Julia, 'Rossetti's *The Day Dream*: the patron's great-granddaughter charts the creation of this painting', *V&A Album* (Spring 1989)

Bartram, Michael, *The Pre-Raphaelite Camera: Aspects of Victorian Photography* (London, 1985)

Baudelaire, Charles, *The Painter of Modern Life and other essays*, transl. and ed. Jonathan Mayne (London, 1964; new edition, 1995)

Bullen, J.B., *The Pre-Raphaelite Body: Fear and Desire in painting, poetry and criticism* (Oxford, 1998)

Burne-Jones, Georgiana, *Memorials of Edward Burne-Jones* (1904; new edition, London, 1993)

Cook, E.T. and Wedderburn, Alexander, eds, *The Works of John Ruskin* (London, 1903–12)

Dorment, Richard and Macdonald, Margaret F., eds, *James McNeill Whistler*, Tate Gallery exhibition catalogue (London, 1994)

Elzea, Betty, ed., *Frederick Sandys, 1829–1904, A catalogue raisonné* (Norfolk, 2001)

Engen, Rodney, *Pre-Raphaelite Prints: the Graphic Art of Millais, Holman Hunt, Rossetti and their followers* (London, 1995)

Flanders, Judith, *A Circle of Sisters: Alice Kipling, Georgiana Burne-Jones, Agnes Poynter and Louisa Baldwin* (London, 2001)

Goldman, Paul, *Victorian Illustrated Books, 1850–1870: the heyday of wood-engraving* (London, 1994)

Harding, Ellen, ed., *Re-framing the Pre-Raphaelites: historical and theoretical essays* (Aldershot, 1996)

Harrison, Martin and Waters, Bill, *Burne-Jones* (London, 1973; new edition, 1989)

Henderson, Philip, ed., *The letters of William Morris to his Friends and Family* (London, 1950)

Holman Hunt, William, *Pre-Raphaelitism and the Pre-Raphaelite Brotherhood* (London, 1905)

Lago, Mary, *Burne-Jones talking: His conversations 1865–1898 preserved by his studio assistant Thomas Rooke* (London, 1982)

Maas, Jeremy, *Holman Hunt and the Light of the World* (London and Berkeley, 1984)

Mackail, J.W., *The Life of William Morris* (London, New York and Bombay, 1899; reprinted 1901)

Mancoff, Debra N., ed., *John Everett Millais. Beyond the Pre-Raphaelite Brotherhood* (Yale, 2001)

de Maré, Eric, *The Victorian Woodblock Illustrators* (London, 1980)

Marsh, Jan, *The Legend of Elizabeth Siddal* (London, 1989)

Marsh, Jan, *Christina Rossetti: a literary biography* (London, 1995)

Merrill, Linda, *The Peacock Room: a cultural biography* (Yale, 1998)

Millais, John Guille, *The Life and Letters of John Everett Millais, President of the Royal Academy* (London, 1899)

Parry, Linda, ed., *William Morris*, Victoria and Albert Museum exhibition catalogue (London, 1996)

Pater, Walter, *Studies in the History of the Renaissance* (London, 1873)

Pointon, Marcia, ed., *Pre-Raphaelites Reviewed* (Manchester, 1989)

Prettejohn, Elizabeth, ed., *After the Pre-Raphaelites: Art and Aestheticism in Victorian England* (Manchester, 1999)

Prettejohn, Elizabeth, *The Art of the Pre-Raphaelites* (London, 2000)

Rose, Andrea, *Pre-Raphaelite Portraits* (Oxford, 1981)

Rossetti, William Michael, ed., *Dante Gabriel Rossetti: his family letters, with a memoir* (London, 1895)

Royal Academy of Arts, *Frederic Leighton*, exhibition catalogue (London, 1996)

Sewter, A. Charles, *The Stained Glass of William Morris and his Circle* (Yale, 1974)

Spencer-Longhurst, Paul, *The Blue Bower: Rossetti in the 1860s* (London, 2000)

Staley, Allen, *The Pre-Raphaelite Landscape* (Oxford, 1973)

Surtees, Virginia, *The Paintings and Drawings of Dante Gabriel Rossetti (1828–1882): A Catalogue Raisonné* (Oxford, 1971)

Tate Gallery, *The Pre-Raphaelites*, exhibition catalogue (London, 1984)

Vicinus, Martha, ed., *Suffer and be still: women in the Victorian age* (Indiana, 1972; new edition, London, 1980)

Whistler, J.A.M., *The Gentle Art of Making Enemies* (New York 1892, reprinted 1967)

Wildman, Stephen and Christian, John, eds, *Edward Burne-Jones: Victorian Artist-Dreamer*, Metropolitan Museum of Art exhibition catalogue (New York, 1998)

Wilton, Andrew and Upstone, Robert, eds, *The Age of Rossetti, Burne-Jones and Watts: Symbolism in Britain*, Tate Gallery exhibition catalogue (London, 1997)

INDEX